Dedalus European Classics
General Editor: Mike Mitchell

Sparrow, Temptation and Cavalleria Rusticana

Giovanni Verga

Sparrow, Temptation and Cavalleria Rusticana

Translated by Christine Donougher
and D.H. Lawrence

and with an afterword and chronology
by Eric Lane

Dedalus

eastengland|arts

Published in the UK by Dedalus Ltd, Langford Lodge, St Judith's Lane, Sawtry,
Cambs, PE28 5XE
email: DedalusLimited@compuserve.com
www.dedalusbooks.com

ISBN 1 903517 09 5

Dedalus is distributed in the United States by SCB Distributors,
15608 South New Century Drive, Gardena, California 90248
email: info@scbdistributors.com web site: www.scbdistributors.com

Dedalus is distributed in Australia & New Zealand by Peribo Pty Ltd,
58 Beaumont Road, Mount Kuring-gai N.S.W. 2080
email: peribo@bigpond.com

Dedalus is distributed in Canada by Marginal Distribution,
Unit 102, 277 George Street North, Peterborough, Ontario, KJ9 3G9
email: marginal@marginalbook.com web site: www.marginal.com

Publishing History
Sparrow first published by Dedalus in 1994
Cavalleria Rusticana first published by Dedalus in 1987
Sparrow, Temptation and Cavalleria Rusticana first published by Dedalus in 2002

Sparrow translation copyright © Christine Donougher 1994
Temptation (& Other Stories) translation copyright © Christine Donougher 2002

Typeset by RefineCatch Ltd, Bungay, Suffolk, UK
Printed in Finland by WS Bookwell

A C.I.P. listing for this book is available on request.

THE TRANSLATORS

Christine Donougher

Christine Donougher was born in England in 1954. She read English and French at Cambridge and after a career in publishing is now a freelance translator and editor. Her translation of *The Book of Nights* won the 1992 Scott Moncrieff Translation Prize. Her translations from French for Dedalus are: four novels by Sylvie Germain, *The Book of Nights*, *Night of Amber*, *Days of Anger* and *The Book of Tobias*, *Enigma* by Rezvani, *The Experience of the Night* by Marcel Béalu, *Le Calvaire* by Octave Mirbeau, *Tales from the Saragossa Manuscript* by Jan Potocki and *The Land of Darkness* by Daniel Arsand. Her translation from Italian for Dedalus are *Senso (and Other Stories)*, *Sparrow* and *Temptation (and Other Stories)*.

D.H. Lawrence

Born in 1885 Lawrence is considered one of the greatest twentieth-century English novelists. He also published several volumes of short stories, criticism, travel writing and poetry. He spent several years in Italy in the 1920s and translated Verga's novel *Mastro Don Gesualdo*, and several collections of Verga's short stories and two of his plays into English. Although not Verga's first English translator he can be said to have introduced Verga into English. His lifelong battle against tuberculosis ended with his premature death in 1930.

CONTENTS

CHRONOLOGY

1840 2 September. Giovanni Verga was born in Catania, Sicily. His family were landowners and members of the minor nobility.

1848/9 Year of Revolutions in Italy.

1857 Wrote his first novel, 'Amore e Patria' (unpublished).

1858 Enrols as a student of law at Catania University.

1859 Beginning of the Italian War of Independence.

1860 Insurrections in Sicily in April are followed by the arrival of Garibaldi and his volunteers who take Sicily from the Bourbons.
Verga joins the National Guard founded after the arrival of Garibaldi. He is one of the founders and the editor of the weekly political magazine Roma degli Italiani.

1861 The Bourbons are forced out of Naples, and Garibaldi surrenders Naples and Sicily to Victor Emanuel, the Piedmontese king. In plebiscites the people of Southern Italy vote to be part of the newly formed Italian Kingdom under Victor Emanuel.
Verge abandons his legal studies and publishes his first novel, 'I Carbonari della Montagna,' at his own expense.

1863 His patriotic novel, 'Sulle lagune', is published in a magazine.
His father dies.

1864	Florence becomes the new capital of Italy, replacing Turin.
1865	Verga's first visit to Florence. He becomes a frequent visitor and takes up permanent residence in 1869.
1866	20 July, naval battle at Lissa. The Austrians retreat from Venice which becomes part of Italy. His novel, 'Una Peccatrice' is published.
1869	Settles in Florence, where he meets Luigi Capuana, the realist writer and theorist. Begins an affair with the 18-year-old Giselda Foljanesi.
1870	Rome is taken, and becomes the Italian capital in 1871.
1871	Zola's 'La Fortune de Rougon', the first book in the Rougon-Macquart cycle, is published. Zola's theories and Naturalism become increasingly important and controversial in Italy. Verga publishes 'Storia di una capinera', which is an immediate success.
1872	Goes to live in Milan, where he spends most of the next 20 years. Frequents the literary salons of the city, making a name for himself in the capital of Italian publishing. Giselda Foljanesi marries the Catanese poet Mario Rapisardi.
1873	'Eva' is published, and is criticized for its immorality.
1874/6	'Tigre Reale', 'Eros', and the novella 'Nedda' are published.

1877	'L'Assommoir' of Zola is published and has an overwhelming influence in Italy. Verga publishes his collected short stories, 'Primavera e altri racconti.'
1878	His mother dies, to whom he was greatly attached.
1880	'Vita dei Campi' is published. Visits Giselda Foljanesi.
1881	'I Malavoglia' is published. Verga is disappointed by its lack of success. Begins an affair with countess Dina Castellazi, who is married and in her twenties. It lasts most of his life.
1883	Goes to Paris, and visits Zola at Médan. Also goes to London. Publishes 'Novelle Rusticane' and the novel 'Il Marito di Elena', and 'Per le Vie'. Visits Catania where he sees Giselda Foljanesi. In December Rapisardi discovers a compromising letter from Verga to his wife, and so Giselda is forced to leave and settle in Florence.
1884	The play of 'Cavalleria Rusticana' is put on with great success in Turin, with Eleonora Dusa playing Santuzza. The end of Verga's affair with Giselda Foljanesi.
1886–7	Passes most of his time at Rome. The publication of a French translation of 'I Malavoglia' is without success.
1888	Returns to live in Sicily.
1889	'Mastro Don Gesualdo' is published and is an immediate success. D'Annunzio publishes his novel, 'Il Piacere'.

1890	Mascagni's one act opera of 'Cavalleria Rusticana' is put on and enjoys an overwhelming success. Verga sues Mascagni and Sonzogno for his share of the royalties. First English translation of 'I Malavoglia'.
1891	Publishes a volume of stories, 'I Ricordi del capitano d'Arce'. Wins his case in the Court of Appeal, getting 143,000 lire (which was a large sum then and put an end to the financial problems which had beset him).
1895	Goes with Capuana to visit Zola in Rome.
1896	The defeat at Adua puts an end to Italy's colonial expansion. Verga criticizes the demonstrations against the war. Begins writing the third novel in his 'I Vinti' cycle, 'La Duchessa di Leyra', but never completes it.
1898	There are riots in Milan, after the price of bread is increased, which are violently put down by the army. Verga applauds their actions as a defence of society and its institutions.
1900–3	Various of his plays are put on, but Verga's energies turn away from his writing to managing his business interests and living quietly in Sicily.
1915	Declares himself in favour of Italian involvement in WW1, and anti-pacificism.
1920	His eightieth birthday is celebrated in Rome and Catania. In November he becomes a senator.
1922	27 January Verga dies in Catania. Mussolini comes to power.

1925/8 D. H. Lawrence translates 'Mastro Don Gesualdo', 'Vita dei Campi' and 'Novelle Rusticane' into English.

1947 Luchino Visconti's film of 'I Malavoglia' called 'La Terra Trema'.

1950 Eric Mosbacher's translation of 'I Malavoglia'.

1964 Raymond Rosenthal's American translation of 'I Malavoglia'.

1984 Dedalus publishes the D. H. Lawrence translations of 'Mastro Don Gesualdo' and 'Novelle Rusticane' (Short Sicilian Novels)

1985 Judith Landry's translation of 'I Malavoglia'.

1987 Dedalus publishes the D. H. Lawrence translation of 'Vita dei Campi' under the title of 'Cavalleria Rusticana'.

1991 New Dedalus edition of 'I Malavoglia'.

1994 First English translation of 'La Storia di una Capinera' by Christine Donougher published as 'Sparrow (the Story of a Songbird)'.
 Franco Zeffirelli's film of 'La Storia di una Capinera' called 'Sparrow'.
 New edition of 'Novelle Rusticane' (Short Sicilian Novels).

1999/ New editions of 'Mastro Don Gesualdo' and 'I
2000 Malavoglia'.

2002 Revised versions of 'Sparrow' and 'Cavalleria Rusticana' with five new stories published under the title of 'Sparrow, Temptation and Cavalleria Rusticana'.

THE SPARROW

translated by
Christine Donougher

Epistolary preface to the first edition of *Storia di una Capinera*, written by Francesco Dall'Ongaro and addressed to Caterina Percoto.

My dearest friend,
A year ago, a young Sicilian, of gentle manner and demeanour, entrusted me with some pages, asking me to read through them, and to offer an opinion on the sad story they contained.

They were the letters of a young Sicilian nun, written to a friend and companion. I thought at first of sending those pages, telling of a life of sorrow and abnegation, to you with your knowledge of this subject. But then I was so moved by the letters, or rather by the facts they vividly describe, that I couldn't put them down until I'd read them all, the last one causing even an experienced writer like me to shed genuine tears.

This was how I expressed my opinion: instead of sending you the manuscript as it was, I gave it to our friend Lampunani to print, and in order that he might give the widest circulation to the emotion that had overwhelmed my own heart at that first reading.

Now you can read the letters, published in this handsome volume that you might wish to preface with your good wishes to the author, who joins forces with us.

Francesco Dall'Ongaro

Rome, 25 November, 1871

Caterina Percoto's response and verdict, expressed in a letter to Verga dated 2 March 1872:

Dear Sir,
Your lovely Sparrow owes her success to the skill of your pen, which makes me feel I'm in Sicily, and deals so compassionately with one of the worst afflictions suffered by those of my sex in our society. Here, in the Veneto, thanks to the Code Napoleon, the dismal practice of sacrificing our poor young girls to monastic life has ceased for some time now, but the barbaric custom of raising women for enclosed orders still continues.

You, who are young and blessed with a gift for words so engaging, so true, so effective, will be our champion. Italy will be grateful to you, and Dall'Ongaro and I will be very happy to have been among the first to recognize you as one of our most talented writers.

<div style="text-align: right;">Caterina Percoto</div>

I had seen a poor songbird locked in a cage: it was fearful, sad, ailing, with a look of terror in its eye. It cowered in a corner of its cage, and when it heard the cheerful song of the other little birds twittering in the green meadow or the azure sky, it watched them with what seemed a tearful gaze. But it dared not rebel, it dared not break the wire that held it captive, poor creature. Yet its captors loved it – they were sweet children, who toyed with its sorrow, and recompensed it for its melancholy with breadcrumbs and kind words. The poor songbird tried to resign itself. It was not ill-natured, it did not even mean to reproach them with its sorrow, for it tried to peck sadly at the odd seed or breadcrumb; it could not swallow them. After two days it tucked its head under its wing and the next day it was found stone-dead in its prison.

The poor songbird had died! Yet its bowl was full. It had died because within that tiny body was something that needed not only grain to live on, and that suffered from something other than hunger and thirst.

The mother of those two children that had been the poor little bird's innocent but merciless executioners told me the story of an unhappy girl whose body had been imprisoned within the walls of a convent, and whose spirit had been tortured by superstition and love – one of those intimate stories that pass unnoticed every day – the story of a shy and tender heart, of one who had loved and wept and prayed, without daring to let her tears be seen or her prayers heard, who had eventually withdrawn into her sorrow and died. And I thought then of the poor songbird that would gaze at the sky through the bars of its prison, that would not sing, that would peck sadly at its grain, that had tucked its head under its wing and died.

That is why I have called it *Storia di una Capinera* – The Story of a Songbird.

Monte Ilice, 3 September 1854

My dear Marianna,

I promised to write to you, and, you see, I'm keeping my promise! In the three weeks I've spent here, running about the countryside – alone! all alone, mind you! – from dawn till dusk, sitting on the grass beneath these huge chestnut trees, listening to the birds singing with happiness, as they hop about, like me, giving thanks to the good Lord, I haven't found a moment, not a single moment, to tell you that I love you a hundred times more, now that I'm far away from you, and don't have you beside me every hour of the day, as I used to, there, in the convent. How happy I should be if you were here with me, gathering wild flowers, chasing butterflies, daydreaming in the shade of these trees when the sun beats down, and strolling arm in arm on these lovely evenings, by moonlight, with no other sound but the droning of insects – a melodious sound to me, because it means that I'm in the countryside, out in the open air – and the song of that melancholy bird I don't know the name of, but which brings the sweetest tears to my eyes when I stand at my window at night, listening to it. How beautiful the countryside is, Marianna! If only you were here with me! If only you could see these mountains, in the moonshine or at sunrise, and the ample shade of the woods, and the azure-blue of the sky, and the green of the vines hidden in the valleys, all around the little houses, and the deep-blue of the sea glistening far away in the distance, and all these villages climbing up the sides of the mountains – big mountains that seem tiny beside our majestic old Etna! If only you could see how beautiful our Mount Etna is at close quarters! From the belvedere at the convent, it appeared to be a huge, isolated peak, always snow-capped. Now I can count the tops of all the little mountains around it. I can see its deep valleys and wooded slopes, its proud summit on which the snow, reaching down into the gullies, marks out great brown patches.

Everything here is beautiful – the air, the light, the sky, the trees, mountains and valleys, and the sea! When I thank the Lord for all these beautiful things, I do so with a word, a tear, a look, alone in the middle of the countryside, kneeling on the moss in the woods, or sitting on the grass. I think that the good Lord must be more pleased, because I thank him with my whole heart, and my thoughts are not imprisoned beneath the dark vault of the chancel, but reach up into the lofty shade of these trees, and out into all the vastness of this sky and these horizons. They call us God's chosen, because we're destined to be wedded to the Lord, but did not the good Lord create all these beautiful things for everybody? And why should his brides be deprived of them?

Oh goodness! How happy I am! Do you remember Rosalia, who tried to convince us that the world outside the convent had greater charms? We couldn't imagine it, do you recall? And we laughed at her! If I hadn't been out of the convent, I'd never have believed it possible that Rosalia was right. Our world was so restricted: the little altar, those poor flowers, deprived of fresh air, languishing in their vases, the belvedere from which we could see a mass of rooftops, and then away in the distance, as though in a magic lantern, the countryside, the sea, and all the beautiful things that God created. And there was our little garden, a hundred paces from end to end, and purposely arranged, it seemed, so that the walls of the convent could be seen above the trees, where we were allowed to stroll for an hour under the supervision of the novice mistress, but without being able to run about and enjoy ourselves. And that was all!

And, you know . . . I'm not sure that we were right not to give a little more thought to our families. It's true, I've had the greatest misfortune of all the postulants, because I lost my mother. But I feel now that I love my papa much more than I love Mother Superior, my sisters and my confessor. I feel that I love my dear papa with more trust and greater fondness, even though I can't claim to have had close contact with him for more than three weeks. You know that I was put inside the convent before I had even turned seven, when I was left on

my own by my poor mama. They said they were giving me another family, and other mamas who would love me . . . Yes, that's true . . . But the love I feel for my father makes me realize how very different my poor mother's affection would have been.

You can't imagine the feeling inside me when my dear papa wishes me good morning and gives me a hug. As you know, Marianna, no one there ever used to hug us. It's against the rule . . . Yet I can't see what's wrong with feeling so loved.

My stepmother is an excellent woman, because she's only concerned about Giuditta and Gigi, and lets me run about the vineyards as I please. My God! If she forbade me, as she forbids her children, to go skipping across the fields, in case they should fall, or catch sunstroke – I'd be very unhappy, wouldn't I? But she's probably kinder and more lenient with me because she knows that I won't be able to enjoy these pleasures for long, and that I'll be going back to being shut up inside again . . .

But don't let's think of such horrible things. Now I'm cheerful and happy, and I'm amazed at how everyone's afraid of the cholera and curses it . . . Thank goodness for the cholera that brought me here, into the countryside! If only it would go on all year!

No, that's wrong! Forgive me, Marianna. Who knows how many poor people are in tears while I laugh and have fun? My God! I must be really perverse if I can't be happy except when everyone else is suffering. Don't tell me that I'm wicked. I only want to be like everyone else, nothing more, and to enjoy these blessings that the Lord has given to us all – fresh air, light, freedom!

See how sad my letter's become, without my noticing. Don't pay any attention, Marianna. Skip right over that bit, which I shall put a big cross through, like so . . . Now, to make up for that, I'll show you round our lovely little house.

You've never been to Monte Ilice, poor thing! What ever were your parents thinking of, taking you off to Mascalucia? A village, with houses backing on to other houses, streets, and

churches – we've seen far too much of that! You should have come here, to the country, in the mountains, where to get to the nearest house you have to run through vineyards, jump across ditches, climb over walls, where there's no sound of carriages, or of bells ringing, nor voices of strangers, of any outsiders. Such is the countryside! We live in a pretty little house on the hillside, among vineyards, on the edge of the chestnut grove. It's a tiny little house, but so airy, and bright, and gay. From every door and window you can see the countryside, mountains, trees, and sky, and not just walls, those grim, blackened walls! In front there's a little lawn and a group of chestnut trees that cover the roof with an umbrella of branches and leaves, in which little birds twitter all the blessed day, without ever tiring. I have a sweet little room, that my bed only just fits into, with a wonderful window looking out over the chestnut grove. My sister Giuditta sleeps in a lovely big room next to mine, but I wouldn't swop my little box, as papa jokingly calls it, for that lovely room of hers. Anyway, she needs plenty of space for all her dresses and hats, while I have only to fold my tunic on a stool at the foot of my bed, and I'm done. But at night, when I listen at the window to all those leaves rustling, and amid the shadows that take on fantastic shapes I glimpse a moonbeam slipping through the branches like a white ghost, and when I listen to that nightingale trilling away in the distance, my head is filled with such imaginings, with such dreams and enchantments, that if I weren't afraid, I'd gladly stay at the window until daybreak.

On the far side of the lawn there's a pretty cottage with a roof of straw and rushes, where the steward's little family lives. If only you could see it – you'd see how tiny it is, and yet so clean, and how neat and tidy everything is there! The baby's cradle, the straw mattress, the work-table! I'd swop my little room for that cottage. I think that family, living together on those few square feet of land, must love each other all the more and be much happier; that in that limited space all their feelings must be deeper, and more absolute; that to a heart overwhelmed and almost bewildered by the daily spectacle of that vast horizon, it must be a joy and a comfort to withdraw

into itself, to take refuge in its affections, within the confines of a small space, among the few objects that form the most intimate part of its identity, and that it must feel more complete in being near to them.

What is all this? What ever am I writing, Marianna? You'll be laughing at me and calling me a female Saint Augustine. My dear friend, forgive me. My heart's so full that I succumb, without realizing it, to the need to impart to you all the new emotions that I'm experiencing. During the first few days after I left the convent and came here, I was overawed, dazed, in a dream, as though transplanted to another world. I was disturbed and confused by everything. Imagine someone born blind, and who by a miracle starts to see! Now I've grown familiar with all these new impressions. Now my heart feels lighter, and my soul purer. I talk to myself, and I examine my conscience – not the timid, fearful way we used to in the convent, full of repentance and remorse; I examine it with contentment and happiness, praising the Lord for these blessings, and with the sense of being raised up to Him by the shedding of a tear, or by simply gazing at the moon and the starry firmament.

My God! Could this joyfulness be a sin? Could the Lord possibly be offended to see that rather than the convent, rather than silence, solitude and contemplation, I prefer the countryside, fresh air, and my family! If our kind-hearted old confessor were here, perhaps he could resolve my perplexity and dispel my confusion, perhaps he could advise and comfort me . . . Whenever these doubts assail me, whenever I'm tormented by these uncertainties, I pray to the Lord for His enlightenment, help and guidance. Will you also pray for me, Marianna?

Meanwhile, I give Him praise and thanks and glory, I entreat Him to let me die here, or, if I must take my solemn vows and renounce these blessings for ever, to give me the strength and willingness and resignation to shut myself away in the convent and dedicate myself utterly to Him alone. I'll not be worthy of such grace; I'll be a sinner . . . but when, at nightfall, I see the steward's wife reciting the rosary, seated by

the hearth on which her husband's soup is cooking, with her eldest boy on her lap and her baby asleep in the cradle that she rocks with her foot, I think the prayers of that woman – calm, serene and full of gratitude for the good Lord's bounty – must rise up to Him much purer than mine, which are full of misgivings, anxieties and yearnings that ill become me as a postulant, and that I can't completely defend myself against.

Look what a long letter I've written to you! Now, don't be cross with me any more, and send me back an even longer letter than mine. Tell me about yourself and your parents, your pleasures and your little troubles, as we used to every day in the convent, in recreation time, with our arms around each other. You see, I feel as though I've had a long chat with you, holding hands, just as before, and that you've been listening with that cheerful and mischievous little smile on your lips, as usual. So chat to me, send a good four pages (I shan't settle for any less, mind!) telling me everything you would have said to me. Give me all your news. Tell me what you see, what you think, how you spend the time, whether you're bored, or enjoying yourself, whether you're contented, and as happy as I am – whether you ever think of your friend Maria. Tell me the colour of your dress, because I know that you have one, now that you're a real young lady! Tell me whether you have lovely flowers in your garden, whether Mascalucia has chestnut trees, as we do here, and whether you took part in the grape harvest. You talk, and I'll listen. Don't keep me waiting on tenterhooks for too long.

Farewell, farewell, my dear Marianna, my beloved sister. I send you a hundred kisses, on condition that you return them.

<div align="right">Yours,

Maria</div>

Dear Marianna,

The only news we're getting here is bad news, and all we see are frightened faces. The cholera is rampant in Catania. There's general terror and desolation.

Otherwise, were it not for these faces, and these fears, what more blessed life could there be than the one we live here? Papa goes hunting, or accompanies me on long walks when I might be afraid of getting lost in the woods. My little brother Gigi runs about, yelling and shouting, and climbs trees, and is always tearing his clothes, and mama . . . (Marianna, if you only knew how difficult it is for me to call my stepmother by this sweet name! It's as though I'm wronging the memory of my poor mother . . . And yet this is what I must call her!) . . . mama scolds him, and gives him sweets and kisses and smacks, and mends his clothes and cleans them, umpteen times a day. She does nothing but sew and cosset her children – lucky things! And often while she's keeping an eye on the cooking, or on the maid who prepares the meal, she reproaches me for being useless, and not even able to cook . . . Unfortunately, it's true. She's right. I do nothing but go running through the fields, picking wild flowers, and listening to the birds sing-ing . . . at my age! Do you know, I'm nearly twenty? It makes me feel ashamed of myself. But my dear papa doesn't have the heart to get cross with me – he can only kiss me and say, 'Poor child! Let her enjoy these few days of freedom!'

Tears come to my eyes whenever I think of my poor mama resting in the churchyard in Catania. But I think of her more often here, because I feel a stranger in my father's house. It's nobody's fault. They're not used to seeing me and having me under their feet – that's all. Anyway, if my stepmother tells me off for being useless, she has her reasons; it's for my own good, and after all I am at fault.

Not being a madcap like me, my sister's not very effusive,

but she loves me and doesn't complain about the inconvenience I cause her by occupying this small room where my trestle-bed has been squeezed in – before, she used it as a dressing-room, and now all her boxes and clothing are cluttering up her bedroom.

Gigi is still the sweet little boy that you knew, as happy and boisterous as ever. He flings his arms round my neck twenty times a day, and consoles me with a kiss when his mother shouts at me on account of his torn clothes. But is it my fault I wasn't taught at the convent how to mend things? It really should be my job. Giuditta's a young lady, and anyway she's far too busy all day long with her wardrobe and arranging her hair, and she's right to spend so much time on them because pretty dresses and ribbons suit her so well, you'd think they were meant for her . . . And besides, she has a rich dowry from her mother – as you know, my papa is only a very humble clerk. So what else should she be thinking of at her age? While she was trying on a new dress, the day before yesterday, she looked so beautiful that I asked if I could kiss her! She quite rightly said no, so as not to get the material creased. What a silly goose I am, Marianna! As though her dress were like my dowdy twill tunic that's never in any danger of creasing!

Oh, what a blessing it is to have a family! In the evening, when papa locks the door, I feel an indescribable contentment, as though the ties binding me to my loved ones in the intimacy of home life were drawn tighter. Yet what a gloomy sense of sadness all we poor recluses used to feel – do you remember? – at the rattling of the porter's bunch of keys and the grating of the locks! Then with a wringing of my heart, my thoughts would fly to the poor wretches in prison. I've confessed to this a hundred times, and done a hundred penances for it, but I just can't help it. Here, in the morning, when I'm wakened by the twittering of the little birds fighting over the breadcrumbs I leave out for them on the windowsill, before I open my eyes my very first thought is of the happiness of being with my family, close to my father, my little brother, and Giuditta, who will kiss me and wish me good morning;

knowing that I shan't have any offices to recite, or contemplation to do, or silences to observe, and that as soon as I've jumped out of bed, I'll open my window to let in that balmy air, that ray of sunshine, that rustling of leaves, and that birdsong; that I'll be able to go out alone, whenever I want, to run and skip wherever I please, and that I won't encounter any austere faces, or black robes, or dark corridors . . . Marianna, I've a terrible sin to confess to you! If only I could have a lovely coffee-coloured petticoat – not with a hoop, I don't mean that! – but a petticoat that wasn't black, in which I could run about and climb over walls, that didn't keep reminding me, as this ugly tunic does, that, once the cholera has passed, the convent awaits me back in Catania . . .

Let's not think about that! I'm a reckless madcap! Forgive me, my dear Marianna, I was only joking. But I haven't yet told you that I have a sweet little bird, a bright and lively pet sparrow that's very fond of me and answers to my call. He comes flying to take titbits from my hands, nibbles my fingers and playfully ruffles my hair. Actually, he has a rather sad story, to begin with: papa brought him to me wrapped in a handkerchief, and the handkerchief was stained with blood. It was probably the first time that the poor little thing had tried to fly, and a gun-shot had injured his wing. Fortunately, it wasn't a serious injury. What nasty, barbaric pastimes men have! At the sight of that blood, and the sound of that cheeping – the poor little thing must have been in great pain – I wept in sympathy, and I even began to blame my dear papa. Everyone was laughing at me, even Gigi. I bathed the wing, but I wasn't hopeful that the poor little thing would survive. Yet here he is, hopping about now, making a great racket! Sometimes he's still troubled by his injury, and comes and nestles in my lap, cheeping and dragging his wing, as though trying to share his pain with me. I comfort him with kisses, stroke him, and feed him breadcrumbs and grain, then he spryly goes off and settles on my windowsill, and turns to me, chirping, flapping his wings and stretching out his neck, with his mouth wide open.

The day before yesterday, a big ugly cat gave me a great scare. Carino (that's what I call my sparrow) was on the table,

playfully mixing up all the cards – he's a great prankster! – getting them into a muddle, and twittering constantly. Then the little rascal would turn to look at me with his small, bright eyes, as though he enjoyed teasing me. All of a sudden, with a single bound, that big black cat was on the table, reaching out its paw to seize him. I screamed, and poor Carino screeched as well, and was very quick to take refuge with me. I don't know how I managed to hide him in my hands, under my apron, but we were both trembling. The whole household came running at my cry. My stepmother scolded me for having needlessly frightened her, and told me that I was too old for such child-ishness, and that if the cat had caught Carino, it would only have been doing as it ought to. Giuditta was laughing, and that naughty little boy, Gigi, kept urging the cat to snatch the little bird out of my lap. I could feel him in my hands quivering from the great fright he'd been given, and his heart was beat-ing furiously. I'd sooner have died than surrender him! Ever since that day, I never forget to lock the door of my room, where I leave Carino. I hate that cat!

On the other hand, I really love the steward's dog, which is a great big farm-dog that's completely black, and stands so high. At first he really terrified me with his snarling, but now he's very affectionate towards me: he wags his tail and licks my hand, and rubs his sides against my tunic, telling me with those intelligent eyes of his that he loves me. In fact, he's my guard-ian. He accompanies me on my walks, and always stays close to me. He runs on ahead to explore the ground, then comes bounding back, wagging his tail and barking happily. When I call him, he knows that it's time for our walk (this happens twenty times a day), and you should see how he barks and jumps up and fawns on me!

I've told you all about my dog and my sparrow, about that horrible cat, and I still haven't mentioned that we have coun-try neighbours who often come to visit, and that we spend almost every evening playing games together, and that we go for lovely walks at sunset. They live in a house not far from us, at the bottom of the valley – you can see it from my window. Their name is Valentini – do you know them? Papa and

mama say they're very nice people. They have a daughter, Annetta, who's almost my age, and she and I are good friends. Not like you and me, though! You needn't be jealous, because I love you much more, and I want you to love me much more than all your other friends. When will you write back? Last time, you kept me waiting two whole weeks. See how quickly I reply, and what a long letter I've written. If you keep me waiting another fortnight to tell me that you return my love and the hundreds of kisses I send you, then I'll love my new friend more than you. So, be warned!

P.S. I forgot to tell you that, apart from Annetta, the Valentini also have a son, a young man who has often come with his sister, and whose name is Antonio, but they call him Nino.

Marianna, why aren't you here to come for walks, and have fun, and enjoy yourself with us? Why can't I hug you and say to you at every moment: Isn't this beautiful? Isn't that fun?. . . and let you see how happy I am – my goodness, as happy as anyone could ever wish to be. So imagine if you were here!

Yesterday as the sun was going down, we went for a lovely walk in the chestnut grove with the Valentini. How beautiful the grove is! If only you could have seen it, Marianna: a delicious shade, a few dying rays of sunlight filtering through the leaves, a perpetual, low-pitched sighing of the topmost branches, birds singing, and now and again a deep and solemn silence. You might almost feel afraid, beneath that huge vault of branches, among those endlessly crisscrossing paths, if even your fear weren't so pleasant. The dry leaves scrunched under our footsteps. Occasionally, some startled bird would take flight, shaking the few leaves that were hiding it and causing a sudden rustle. Our fine dog, Vigilante, ran blithely on ahead, barking after frightened blackbirds. Annetta, Gigi and Giuditta walked arm in arm, singing to themselves. Signor Nino followed them, with his rifle slung across his shoulder. The rest of the group were left far behind, and they kept shouting to us not to go so fast, because it was a tiring climb. Signor Nino also has a fine dog, a splendid gun-dog, with long ears and black spots all over. It's called Ali, and has already struck up a close friendship with Vigilante. At every step, Giuditta and Annetta in their long dresses would get caught in the undergrowth. Not me, though, I assure you! I run and skip, and never falter, and nor do the hedgerows leave any mark on my tunic. Signor Nino came up to me and told me to take care not to fall, he was afraid for me, poor fellow! If I hadn't been so embarrassed, I'd almost have challenged that young man to a race! Giuditta continually complained of feeling tired. What's wrong with these women, Marianna? They

can't walk ten paces without the need of a man's arm, and without catching their clothes on every bramble! Thank goodness for my tunic! Signor Nino repeatedly offered me his arm – as if I had any need of it, indeed! I'm sure he was just trying to annoy me, otherwise why didn't he offer his arm to my sister, who was complaining about the climb – she was the one that needed it.

What a magnificent sight when we reached the top of the mountain! The chestnut grove doesn't extend all the way up, and from the summit you get an unimpeded view of the horizon. The sun was setting on one side, and the moon rising on the other, two different kinds of twilight at either extremity, with the snows of Etna seemingly ablaze, and a few gossamer cloudlets floating through the blueness of the firmament like snowflakes, with the smell of all that flourishing mountain vegetation, amid a solemn silence; you could see the sea in the distance, turning silver in the first glimmer of moonlight, and Catania, like a pale patch upon the shore, and the vast plain behind bound by chains of azure mountains, with the bright, winding course of the Simeto snaking across it. And then gradually, rising towards us, were all those gardens and vineyards, those villages sending us the distant sound of the angelus, and Etna's proud peak reaching towards the sky, its valleys already quite black, its snows gleaming in the last rays of sunshine, its woods rustling and murmuring and quivering. Marianna, there are times when I feel like weeping, and clasping hands with everyone around me, when I'd be incapable of uttering a single word, and my mind is crowded with thoughts . . . Honestly, I don't know how I didn't clasp hands with Signor Nino, who was standing next to me! What a crazy fool I am!

I think everyone must have felt what I was feeling, because no one spoke. Even Signor Nino, who's always cheerful, as you know, also remained silent . . .

Then we went running down the hill again, shouting and laughing, frightening the birds (who then did the same to us, by taking flight with a sudden flurry among the leaves), and playing hide-and-seek among the trees, even though our

parents shouted themselves hoarse, telling us not to run. Ali and Vigilante joined in the fun, jumping and barking with joy. Here and there, amid those dark shadows, a moonbeam filtered through the branches, shedding its silvery light on the treetrunks, and casting weird shadows on the dead leaves that carpeted the ground. Signor Nino, too, no more nor less than the rest of us, ran like a child, like a madman. Two or three times, I overtook him, which left me feeling very proud. Can you imagine, beating a man! And since it was dark among the trees and he couldn't see me blush, I didn't feel embarrassed. And when I'd left all the others behind . . . including him . . . I stood there, panting, unable to catch my breath, but totally elated, and I wasn't scared of being alone in the dark, because I could hear their voices and the sound of the dogs barking . . . and, after all, Signor Nino had that splendid shot-gun slung across his shoulder.

And what a pleasure it was, too, as we came out of the woods, to be greeted by the lights of our cottage. Do you have any idea what a gladdening sight it is, in the silence and the darkness of the countryside, to see in the distance those illuminated windows, that welcoming light, which guides you, leads you, and makes you think of home, and of all the quiet joys of family life?

You can't imagine how friendly we've become with the Valentini over the past week. They're such nice people! It's as though we've been friends for decades. Annetta is a kind-hearted girl and doesn't laugh at my tunic and my strange convent ways. We're in one another's company from morning till night, going for walks, chatting, playing cards, having lunch together, and sometimes dinner as well. Would you believe that I've learned to play cards, too? For heaven's sake, don't tell anyone! Though I'm not very good yet, and I nearly always lose, Signor Nino is always ready to help me, to offer his advice and guidance, and he doesn't mind not playing himself. When I go back to the convent, I promise you, I'll forget all about card games.

My God, the convent! That's the only cloud darkening these bright horizons. But let's not think about that right now,

Marianna, let's be cheerful and happy, and let God's will be done!

And while we're here, enjoying ourselves, safe and untroubled, and out of harm's way, think of all those poor people grieving and suffering! all that misery! all those tears! all those victims! The news that reaches us here, every four or five days, is very sad. May God have mercy on the many who are afflicted!

There are such fears and apprehensions! The peasants here believe in poisoners, in poisonous rays, and heaven knows what else ... Poor wretches! They're like me, when I'm afraid, I see ghosts! That's why every night, in the valleys, on the mountains, all around, you see flares and torches, and you hear the continual sound of gunfire, as though they were trying to scare off cunning wolves, or human savages! It's sad, but at night, in the darkness and the silence, amid this general tumult, it's also terrifying.

Now I'm sad too, aren't I? And only a moment ago I was happy, telling you how we've been enjoying ourselves. You say that you're having fun too, and that you're in good company. I believe you, but I bet it's not as good as ours. You also say that you won't be returning to the convent – lucky you! But that means I'll have to go back without you! Right now, I want to be happy. God will take care of the future! Carino is better – he's grown much bigger, and even a little naughty. He's lively, chirpy and bright, and he has such a loud voice! If I let him, I think he'd be fearless enough to stand up to the cat. Poor Vigilante was given such a nasty beating by the steward that he came yelping to tell me his troubles. I petted him, and I've always some tasty titbit to give him, and now he remains at the door of my room.

I don't think there's anything I've forgotten to tell you. Write me a long letter soon. Tell me that you love me, and send your love as well to my friend Annetta, who sends you hers.

Goodbye, goodbye, goodbye.

If you knew, Marianna, if you only knew . . . The terrible sin I've committed . . . My God! How am I going to summon up the courage to tell you? Don't tell me off! I'll confess to no one else but you – but only in a whisper, mind, and all in a fluster . . . Don't look me in the face! Hold me tight and listen.

I've been dancing! Can you imagine? I've been dancing! But listen . . . don't shout at me! There was no one watching – only papa, Giuditta, Gigi, mama, Annetta, the Valentini . . . and Signor Nino . . . In fact, he was the one I danced with . . . Listen, I'll explain . . . you'll see that it wasn't my fault . . . I wasn't to blame . . . they forced me . . .

Yesterday evening the Valentini brought their harmonium. Annetta played, and then Giuditta. Everyone was dancing – Annetta, Giuditta, and even Gigi a little. My sister's bed had to be dismantled to make room for a dance floor. After Giuditta had finished dancing, Signor Nino came and invited me. I felt my face burning, and I wished I were a hundred feet below the ground. I stammered, not knowing what to say. I refused, repeatedly, I swear to you. Everyone was laughing and clapping. Papa came and took me by the hand. He gave me a hug and said there was no great harm in my dancing as well, and he too was laughing. It was no use my trying to explain I didn't even know how to dance, I hadn't been taught that either at the convent. Signor Nino volunteered to teach me. I couldn't see clearly any more, I felt dizzy, my ears were ringing, and my legs were trembling. I let myself be led, I let myself be dragged along, without the least idea of what they were doing with me. It was excruciating, Marianna . . . Yet, when he took me by the hand.. when he put his arm around my waist . . . it seemed to me that his hand was hot, that every vein of my blood was on fire, and that an icy chill was flooding into my heart! But at the same time I felt comforted. My heart

was pounding, feeling that other heart beating against it. Everyone must have been laughing at me. You're laughing, too. Even I can laugh at myself now. How many young women of our age have not danced a dozen times at least? I wonder whether at first they went through the same experience as I did? But afterwards I confess that the music, those happy faces, the words of encouragement he whispered in my ear, his hand that held mine almost dispelled my confusion, even shame . . . Poor Marianna, don't be cross with me. I very nearly felt happy . . .

My dear Marianna, forgive me! I shan't do it again. Anyway, I hope they leave me alone now. They've made enough fun of my tunic and my awkwardness . . . including him . . . Signor Nino . . . But no! I'm sure he didn't want to make me dance just to laugh at me . . . He meant to please me . . . and in fact he was being too kind to me, to a poor postulant who didn't know how to move, who stumbled at every step, and was overcome with dizziness . . . and he dances so well! If you'd seen him dancing with Giuditta – she certainly knows how to dance!

Afterwards we played a little music. Annetta and Giuditta sang a few theatrical songs. Then they absolutely insisted that I sang as well . . . Tell me, what on earth could I have sung, apart from *Salve Regina*? Well, they said they'd even settle for *Salve Regina*. They were surely trying to tease me by making me sing, and my papa most of all! In the choir, as you well know, we sing almost in darkness, behind screens, with a veil over our face, among those that we know very well. But to sing in public, in front of so many people! Signor Nino was there, too! Yet I was obliged to sing – not the words, mind, only the tune. My voice was quavering, and I could hardly breathe, but they were very kind and didn't laugh, in fact they applauded. Apparently they thought the music of *Salva Regina* was really beautiful. I could see that Signor Nino was very touched by it. And the way he was looking at me, when he's usually so cheerful and light-hearted.

I've told you everything that I've been doing, and thinking, and all the fun I've been having, and all the terrible sins I've

committed, even at the risk of being lectured by you. I wouldn't have dared to confess them to our saintly old chaplain . . . but if I didn't tell you everything, my dearest sister, if I didn't open my heart to you, and confide in you, I think all these things would oppress me. I need to have a long chat with you about them, to recall all the details, to ponder over them, and to talk to myself about them, to see them written down on paper, to dream about them . . . There are moments when all these thoughts are seething in my mind, making me feel dizzy, befuddled and dazed.

I'm mad. These new sensations must be too violent for me, after the peace and quiet of the convent that I'm used to. I'm glad to be able to talk about them to you at least, and to share with you what I cannot contain in my own heart.

Write to me, write soon. Don't take too long to reply. Comfort me, talk to your poor friend who's troubled and perturbed by all this disturbance and novelty, and all these new impressions, and who trembles like a little bird, frightened even by curious onlookers who certainly have no intention of hurting it, but do so just by gathering round to watch.

I want to cry, and laugh, and sing, I want to be happy. I need a letter from you. I need to talk to you, do you understand? Hug me, Marianna . . . If only I could weep and bury my face in your shoulder!

Thursday was a lovely day! It was papa's name-day! I don't need to tell you that everyone in our little family was up at dawn, and our little house was filled with joy and happiness. Mama had already had a turkey's neck wrung, and was supervising preparations for the meal. Giuditta gave my father a beautiful silk cap, which she'd embroidered in secret as a surprise. I could only give a bunch of wild flowers I picked at daybreak and that were still wet with dew. It was a very humble little posy, but my dear kind papa was just as pleased with my present as he was with my sister's, and he hugged us both with tears in his eyes. Our friends arrived as soon as it was light, preceded by cheerful cries, shots fired into the air, and Ali's barking. What festiveness! The Valentini, too, brought flowers, but real garden flowers that they had ordered specially from Viagrande. My poor little bunch looked very modest beside those splendid blooms. They also gave us a fine hare killed the day before. Signor Valentini never goes hunting, but his son does . . . Mama appreciated the hare more than the flowers. And I confess that in the past few days I've become almost reconciled with hunters . . . It must be a matter of getting used to them . . . And what can we women possibly understand of pastimes like these that men take such pleasure in? Papa invited our friends to eat with us. It was a wonderful day! Everyone was very good-humoured, and they all sang, and laughed, and even danced – I didn't, mind you.

After the meal, we went for our usual walk. It was a beautiful evening. But I don't know why, I wasn't as bright and cheerful as everyone else, and as I'd been before. I liked hearing the quiet rustle of falling leaves, the sighing of the trees, the distant call of a barn owl, I liked feeling scared in the darkest shadows and being on my own, away from the others, and tears gradually misted my eyes.

What is the mystery inside us, Marianna? I should have

been so happy that day, when everyone else was. I can't explain this strangeness even to myself. It's probably my funny little brain that's more suited to the quietness of the convent, and feeling out of place here is unsettled and disturbed, and even a little crazy.

Goodbye for now. I'll write again soon. This is a short, even skimpy, letter, although I ought to be sending a nice long one telling you lots more – all the foolish things that pass through my mind, all the things that I can't chat to you about face to face. But what can I say? I haven't the heart for it today. I feel tired and listless, and my thoughts are confused. Till tomorrow then.

You must be cross with me for not having replied to your letter, and you're right to be, Marianna, but I'm already cross with myself. I don't know what's wrong with me, I just don't know . . . The smallest task, the least activity makes me tired . . . Go ahead and scold me . . . I'm a real lazy-bones. I wish I could spend all day long sitting in the shade of the chestnut trees, and all night staring up at the sky. Everything that had most charm now bores me. I no longer have any desire to go for walks in the chestnut grove, or to sing, I can't laugh any more – everything irritates me. Your poor friend Maria is feeling very sad! Even I don't know why. Perhaps the Good Lord wanted to show me how transient are the joys and pleasures that don't belong to life inside the convent. Oh God, there are moments when I'm almost afraid of myself . . . because even my prayers are distracted . . . God, forgive me, and comfort me! God, sustain me!

Carino has almost ceased to be tame, because for many days now I haven't been playing with him any more. He flies away from me! Have I really become so disagreeable? Vigilante doesn't show me the same affection that he used to, because I don't pay attention to him, and he realizes that he's being a nuisance.

Do you think I could be ill, Marianna? Between you and me, I almost wish I were ill, because then there'd be a reason for all this boredom and tiredness, and they wouldn't frighten me.

But you're well, and happy, and light-hearted – you must write to me, write often. Love me a hundred times better, because I'm in more need of your love and you're much dearer to me now, and the only sweet feeling left to me is a great fondness for my loved ones, for everyone I know, and as you can imagine, for you too!

2 November

I'm convinced, Marianna, that all this worldly tumult, all these powerful sensations, and these pleasures are extremely bad for us poor, weak, faint-hearted souls. We're humble little flowers accustomed to the gentle protection of the hothouse, and destroyed by fresh air.

Do you remember when I wrote to you two months ago and told you how bright and cheerful I felt? How avid for joy my heart was, and how it treasured every new emotion? How I thanked the good Lord and praised him for all these wonderful sensations that my heart was opening up to? It's true, Marianna! Alas, it's true what the nuns kept telling us, and what Father Anselmo said repeatedly from the pulpit: that the real, lasting joys are the calm, serene joys of the convent. I can't explain why, but the joys of the world are not always the same. I know from experience . . . I feel so differently now! Everything makes me feel tired, oppresses me, and bothers me . . . I find everything a cause of unease, and anxiety . . . and even dismay. I'm scared by the very fact that I can't account for the sudden fits of insane, almost delirious joy and for the unpredictable sadnesses that overwhelm me. I feel unhappy among all these gifts from the Creator for which I once used to glorify Him . . .

I wish I could return within those blessed convent walls. I wish I could kneel in the chancel and cling to the feet of Jesus on that Cross. I wish I could kiss you, and bury my face on your shoulder, and shed the tears gathered in my heart.

Don't laugh at me, Marianna, pity me instead. Pity me, because I feel so sad, and I can't understand my sadness, I don't know the reason for it – maybe I'm wicked and ungrateful to the good Lord who has showered so many blessings on me; ungrateful to my dear papa who tries to dispel my sadness with countless endearments; ungrateful to my family and friends . . .

I can't write any more. I feel like crying. I've spent nearly all night long at the window, staring into the intense darkness, which seemed to me full of ghosts, and listening to the distant sound of the dogs whining, and the drone of nocturnal insects . . . and I wasn't afraid!

If only I could throw my arms around you and weep! I wish you'd write! Write to me! That's all I can say.

10 November

My dear Marianna, you say that you're worried about me, about my state of mind. You ask lots of questions that make no sense to me, embarrassing questions that I don't know how to answer. You want countless explanations for things I don't understand myself. If you were here, if we could confide in each other, arm in arm, under the trees, in the deepest shade, perhaps you – being a young lady now, who won't be going back to the convent again, and have some experience of the world – perhaps you might be able to answer my questions and resolve my doubts; you could comfort and reassure me. But what can I tell you?

Even your questions worry and disturb me . . . Why do you ask the reason for my not having mentioned the Valentini in the letters that I've written recently, which have been so dejected, whereas I used to tell you so much about them in my earlier letters, which were so cheerful. Why have you pointed out that while Signor Nino's name crops up repeatedly at first, it seems to have been carefully avoided latterly? How did you notice? I wasn't aware of it myself . . . And, God knows, I couldn't tell you why! But you're right, and you've made me realize that even now it's taken a great effort to write that name . . . And you've probably noticed that my hand was trembling . . . And if you could see my face!

Now, I'll tell everything . . . I'll place my heart in your hands. You'll be better than me at interrogating and analysing it, for I haven't any idea . . . You can tell me what I must do to overcome this illness that's afflicting me, and how to return to being light-hearted and carefree and happy. You'll open your arms to me . . .

I don't know what's troubling me, but it must be something bad, because I've been reluctant to confide in you, I feel almost guilty, and I'm overcome with shame, anxiety,

an inexplicable fear, as if I had some secret to hide from everybody, and everyone were staring at me trying to discover it.

What is that secret? My God, even I couldn't say . . . I'll tell you everything, everything! If you can detect it, you must tell me, and I promise to master it, if it's a wickedness or temptation. I promise to be good, and pray to God to give me strength and enlightenment, to help me . . .

I've analysed everything myself to see what this wickedness might be, where this trouble might stem from. I've examined all my feelings, and thoughts, and even the way I've been spending my time, the people I speak to, the things I see . . . I can't find anything, except . . . But you'll think I'm mad, and laugh at me.

When I've written before I've told you that we've become very close friends with the Valentini. Annetta is like another Marianna to me . . . But you've made me think that her brother has a certain effect on me . . . It's true: I'd almost say that he frightens me.

No, I'm not being nasty, Marianna! Don't blame me for it! It's just some eccentricity, some foolishness, I'm sure. I realize that it's wrong of me, and I try not to let it get the better of me . . . because he's such a kind young man, and always so considerate towards me . . . But I can't explain the feeling he produces in me . . . It's not dislike or hostility . . . and yet I'm afraid of him . . . and every time I meet him I blush, and turn pale, I tremble, and wish I could escape.

But then he talks to me, I listen, and stay with him . . . I don't know why . . . I feel unable to separate myself from him . . . and I think of Father Anselmo, talking to us from the pulpit about the lure of the evil spirit, and I'm scared . . .

My God! I'm not saying that they're the same thing . . . It's just a comparison. I wish I could explain to you the effect he has on me

He's very polite to everyone, though, including me . . . and I'm not rude to him, I swear! I'm grateful for his tact and kindness . . .

When we happened to find ourselves alone the other

day, after the famous dance, he said to me, 'Thank you, signorina.'

'What for?'

'For being good enough to dance with me. If you only knew how happy it made me!'

And he said this in such a way that I felt completely disconcerted. My God, how men exaggerate their compliments! But I don't know why he said this in a very low voice, and I thought he even blushed . . . and perhaps that's why I blushed, too . . . and I didn't know what to reply . . .

You see how thoughtful he can be, to please me. Another time he said to me, 'How well that tunic suits you!' That's what he said! My ugly black tunic! I couldn't explain why, but I think I felt very pleased. I reddened and stammered and didn't know where to put myself.

You'll say that I'm mad, and you're right, because it certainly can't be his good manners that so disturb me.

So why am I embarrassed whenever I hear his voice? When I find him staring at me, why do I suddenly feel the blood rushing to my face, and a kind of shiver in my heart?

Do you know, Marianna, I think I've found the explanation for all this. In the convent we've been taught to think of men in general and young men in particular in such a way that we can't encounter one without being thrown into complete confusion. For why is it that my sister, Giuditta, who, after all, is younger than me, never feels in the least embarrassed talking to him? Why on the contrary can she laugh and joke and have long, frank talks with him, without blushing, whereas I think I'd die if I had to do the same? And yet . . . God forgive me . . . I think that because of this I sometimes have a feeling towards my sister that resembles jealousy . . .

O God! Call me back to you, in the convent, where there is peace, silence and composure. Calm my spirit and illuminate my mind!

16 November

On Monday I met him in the chestnut grove. Fortunately, Gigi was with me. He had his shot-gun over his shoulder, and we heard him singing to himself long before he became aware of our presence. You don't know what a sweet voice he has! I recognized it immediately: my heart felt as though it would burst from my breast, and I wanted to run away, to escape, because of that same old ridiculous fluster . . . His dog, Ali, saw us first, and came running up to us, barking joyfully. So, really and truly, we had to stay . . . although I'd turned scarlet and was trembling all over . . . He must have noticed my agitation. He came up and held out his hand. I had to give him mine, for it's customary here to shake hands, even with men, which doesn't seem right to me . . . he was bound to realize that my poor hand was trembling.

To return home, we had to go through the densest part of the wood, and on the edge of it, which is very rocky, there were a lot of briars and brambles. He wanted to accompany me and lend me his arm. I was trembling so much that he said, 'Lean on me properly, signorina, you're stumbling at every step.'

This was true. We went quite a long way in silence, and as we walked, I kicked the dry leaves lying on the ground, so that he couldn't hear the beating of my heart. He must have taken pity on my embarrassment, because he tried to break the silence by saying, 'What a lovely day! What a pleasant walk it's been!' And he sighed . . . Actually, Gigi complained that I was treading on his heels . . . Then we sat on a low wall by the vineyard, and he settled himself beside me. All I could see was the butt of his gun, casting bizarre shadows on the ground. Ali came and rested his big head on my lap, laughing at me with his beautiful, vivacious eyes. I stroked him, and he showed his thanks by wagging his tail. His master said to me, 'You see how affectionate towards you Ali is? Don't you love him?'

I don't know why this very innocent question completely flustered me, and I felt that I loved poor Ali immensely. And he, too, stroked his dog . . . and then our hands met, and I felt that mine was trembling. My own silence embarrassed me. I tried to think of a reply, and all I could stammer out was, 'You have such a fine dog, signor!'

He didn't say anything else, and sighed. Why did he sigh? He must have felt unhappy, too, poor thing! In fact, I thought he'd been looking more dispirited in the last few days . . . and that moment when he sighed, I felt a great tenderness towards him, and no longer my usual dismay, but such an amicable feeling that I wished I were a man like him, a friend of his, or a brother, so that I could throw my arms around his neck and ask him what was wrong, so that I could comfort him, or at least share his troubles with him.

Oh, yes! these are terrible sins! And imagine how painful it will be to confess them! And I have an even greater sin on my conscience . . . a keen desire to know what was making him so sad . . . We women are so curious . . . But of course I dared not ask him.

Since then I've seen him only in the evening, with his family. I don't venture out on my own any more. I sew idly at my window, and every day that I hear his voice, or hear him whistling for his dog, up in the woods, or that I see a figure moving swiftly through the clumps of trees in the distance, my heart beats the way it did when we sat beside each other in silence, with our hands resting on that fine dog's head.

Every time I meet him, I feel the same confusion, and so I try to avoid any encounter. But there are times when I can't escape, you see . . . and I have to hide my discomfort and stay. When he looks at me, my heart leaps, and I wish I could die to hide my blushes. I feel as though all eyes are fixed on me, wondering why I'm blushing . . . and I . . . O God! I couldn't say . . . I don't know! But I take the first chance I can to seek refuge in my little room and bury my burning face in my pillows, and cry . . . I don't know why but crying seems to make me feel better and relieve me of a great burden.

But the day before yesterday, as I was drying my eyes, I saw

a figure at the window. It was him – with his elbows resting on the windowsill, with his face cupped in his hands. You can imagine how I felt! He was also very agitated. He tried to smile, and it was such a sad smile that I thought he was weeping. Then he stammered, 'Why do you keep running away, signorina?' I wished the ground would open up and swallow me. Fortunately my sister appeared. It cost me an extraordinary effort to calm myself, or rather to force my face to lie, and I went out and joined the rest of the party, who were enjoying themselves out on the lawn. Giuditta was with him, talking and laughing, at her ease – she wasn't trembling!

Oh, the convent, the convent! That's what I need, that's the place for me. Outside there's nothing but confusion and dismay.

You see . . . they'll think I'm ill-mannered . . . he most of all! God, who can read my heart, knows I'm not like that, and that I'm not to blame if my shyness and the way of life I'm used to, which is very different from theirs, make me seem so! But who's going to believe me? Yesterday, as everyone was coming back indoors, because the evening coolness had turned chilly, he came up to me, looking sad and pale, and took my hand. I was trembling so much that I couldn't draw it back. I was in a daze . . . He said in his gentlest voice, 'What have I ever done to you, signorina? Why do keep avoiding me?'

My God! My God! I wanted to throw myself at his feet and ask his forgiveness, and to tell him that he was mistaken, that it wasn't my fault . . . I don't know what I said, or stammered. Annetta came up and I threw myself in her arms and burst into tears.

My dear Marianna, try to be of comfort to me, and help me! Even you're abandoning me! I'm alone, sad and unhappy. Pray God that I may soon return to my tranquil, modest existence, and that the world's stormy blast, which has sown tumult in my dismayed soul, may be stilled in the silence of those corridors.

I've been writing to you with tears clouding my eyes. I don't even know what I've written. Forgive me, and love me, for I desperately need to be loved.

The other evening, when I came into the room where my family and the Valentini were gathered, I was so upset after what he'd said to me that everyone noticed. My stepmother made a scene: she told me off for being ill-mannered, and wilful, and for indulging in irrational fits of joy and bouts of gloom. My father tried to defend me, by saying that I was unwell.

Everyone else remained silent. This torture went on for half an hour. When I was able to retreat to my room, I thanked the Lord and prayed ardently that He would call me to Him.

I had a dreadful night, without so much as closing my eyes. I've searched my heart, and I'm scared.

Marianna, if I weren't afraid of committing a sin and causing grief to my father, Giuditta, my brother, and you . . . to everyone who loves me . . . I'd wish to die of cholera . . .

Goodbye.

Marianna! Marianna! I love him! I love him! For pity's sake, don't regard me with contempt. I'm terribly unhappy. Forgive me!

O God! Why so harsh a punishment? Now I'm blaspheming! O God, how I've cried! Is there any woman more wretched than I am?

I love him! What a horrible thing to say – it's a sin, a crime, but it's no use my pretending otherwise. My sin is stronger than me. I've tried to escape, and it has clung to me, it has pinned me down, and trampled my face in the mire. My whole being is replete with that man – my head, my heart, my blood. I see him before my eyes as I write to you, in my dreams, and in my prayers. I can't think of anything else. I feel as if his name is always on my lips, and that every word I utter turns into the name by which he's called. When I hear him, I feel happy. When he looks at me, I tremble. I wish I could always be with him, and yet I avoid him. I wish I could die for him. Everything I feel for that man is new, unfamiliar and terrifying . . . more fervent than the love I bear my father, and more intense than my love for God. This is what, in the world, is called 'love'. I've experienced it, I've seen it . . . it's horrible! horrible! It's God's punishment, damnation, blasphemy! Marianna, I'm lost! Marianna, pray for me.

Yesterday, he'd gone to Catania on some family business. He was supposed to catch the coach back to Trecastagne and be home before nightfall, but at nine o'clock there was still no sign of him. You can imagine how upset his family and all the rest of us were! The reports we get these days are so bleak, there wasn't a soul among us who didn't imagine the worst. His mother and Annetta were crying. Signor Valentini was extremely restless and kept climbing up the bank that rises above the vineyard, from which you can see a good stretch of the lane leading to the village, for his son was supposed to

have got off the coach at the usual stop and then walked up here. It was very dark, and you couldn't see more than ten yards down the lane. Two messengers had been sent off to try and find out the reason for this delay, and to let us know if he was on his way. Every so often, his poor father called out his name, as if hoping that he would respond from a distance. You can imagine how anxiously we all strained our ears: one minute went by, then ten, and his voice died away, far off down the valley, and was followed by silence. The clock struck nine thirty, then ten! There was general weeping and wailing. Signor Valentini had gone out alone, in the dark, like a madman, to make inquiries of every passer-by, determined not to give up until he had found his son. But there wasn't a soul to be seen. Not even the boldest traveller would have ventured out at that hour of the night, when the roads were under the suspicious watch of peasant-folk on their guard against cholera! Those tears broke my heart. That silence terrified me. That darkness seemed full of horrible visions. I'd shut myself in my bedroom, to kneel at the foot of the cross and weep, and to pray for him. Now and again, I'd interrupt my prayers, dry my tears, and stifle my sobs in order to strain my ears, to devote all my attention to listening. Outside all you could hear in the distance was the sound of a few gunshots that threw us all into crisis, and the lugubrious howling of the dogs. I became superstitious. I thought, 'After I've said one hundred Hail Marys, I'll hear his voice.' I said fifty straight off, then I began to recite the rest more slowly, because I felt that I'd said the first ones in too much of a rush, that it was cheating on the time that I'd set, that God wouldn't answer my prayers because I'd said my Hail Marys too distractedly. When I had recited the last ten, I went back and started all over again, deluding myself that I'd miscounted . . . I said the last two, one after the other, breaking off to listen . . . And I thought I heard distant voices . . . I waited, and waited . . . nothing! silence! Then I said to myself, 'If the first person to speak is Annetta, he'll arrive in a quarter of an hour . . .' Then, 'By the time the wind has made the leaves on the trees rustle ten times, he'll be here.'

The branches tossed and stirred, and no one came! Then I felt as if I were suffocating, and losing my mind, and the blood were flowing so fast through all my veins that it was making me run about aimlessly like a madwoman. The room felt cramped and the roof seemed to be pressing down on me. I went out on to the lawn. It upset me to see his poor relatives weeping, listening anxiously to the slightest sounds of the countryside, and quietly voicing false hopes, to delude themselves more than anyone else. I went and sat on the wall, away from everybody, in the darkness. With burning eyes, I stared into the shadows, almost feeling that I could dispel them by the strength of my desire, listening to the howling of dogs in the distance and trying to tell whether they were barking at his approach.

O God! what agony! All of a sudden my heart seemed to stop beating . . . I heard a distant bark, a bark I recognized. My heart began to pound furiously, making a noise when all I wanted was to listen . . . It was nothing, nothing! I was mistaken . . . Then came another bark, closer and more distinct. This time everyone heard it: it was Ali barking. He's here! He's coming! That's Ali's bark! Ah!

Ali raced closer, barking joyfully, announcing the good news at the top of his voice. He knew that we were worried and frightened, and he came running . . . you could hear the vines suddenly shake as he raced past. He still hadn't come into view, but I could have said exactly where he was. My heart felt as though it would burst from my breast. Everyone had come rushing up to the wall, beside me.

Here he is. He jumps up on the wall. It's Ali! It's him! He leaps on me, barking with joy, although panting, and poor Ali, he also is overwrought.

I hugged him, extremely tightly, because I thought I was going to faint, and I burst into tears.

When poor Nino arrived, he was pale, tired and breathless! He'd walked from Catania, because the coach had left without him, and he hadn't been able to find any other carriage prepared to make the journey at that hour. His father, who'd come back with him, kissed him. His mother and Annetta

held him in their arms. Everyone made a fuss of him; everyone cried with joy. He must have thought me selfish and disagreeable, because I ran off and shut myself in my room, to cry, and laugh, and sob without restraint, to embrace the foot of the Cross, the furniture and the walls!

O God! Is there any creature on earth more wretched than me?

Since this temptation has taken possession of me, I don't recognize myself any more. My eyes see more clearly, my mind learns of mysteries that should have remained unknown to me forever. My heart experiences new sentiments that it should never have experienced, that it ought never to have been allowed to experience. It's happy, it feels closer to God, it cries, it feels small, alone, and weak. This is all frightful! On top of which, insignificant trifles become a torment: a look, a gesture, a tone of voice, a step; whether he sits in one place or another; whether he talks to this person or that. You won't understand, you'll think I'm mad. O God! If only I were, how happy I would be! This is to experience constant doubt, anxiety, dismay, and indescribable delight. Add to all this, the thought of what my status is, remorse for my sin, my powerlessness to fight against a feeling that is stronger than me, that has seized me, consumes me, overwhelms me, and makes me happy by subjugating me . . . the desolation of discovering my lowliness, discovering what I am – I'm less than a woman, I'm a poor nun, with a faint heart for everything that falls outside the confines of the convent, and the immensity of this horizon that is unexpectedly opening up before her, blinds and bewilders her.

I wonder whether this love, this sin, this monstrousness is not an aspect of God! I want to be beautiful, like the feeling I have inside me. I look at myself, surprised by my own unusual curiosity, and I'm saddened by what I find myself to be: a shapeless bundle of black twill, with hair unattractively scraped back, and unrefined manners, a shyness that might seem awkward . . . and I see other young girls around me, who are elegant and gracious, and commit no sin by being in love, like me . . . I blush for myself, I blush for my blushes . . .

And yet . . . that's not all! There's another cross to bear: the fear that this secret, which I jealously keep to myself, will be discovered! It means being afraid of your blushes, your pallor, the trembling of your voice, the beating of your heart! It means having the impression that your entire being is accusing you, that everyone is spying on you . . . and feeling ready to die of shame if this disaster should occur! I blush at what I'm writing to you, at what you will read . . . you who are a part of me!. . . and I impose it on myself as a form of penance . . . I'm so madly in love with him, and I'd die of shame if he knew!

I wish I could throw my arms around his neck, I wish I could die at his feet, but not for all the gold in the world would I dare to give him my hand. And if he looks at me, I lower my eyes. And to think that in any case my father . . . my stepmother . . . he, too . . . might be able to see into my heart! O God! let me sooner die!

And if I were to tell you that this fear of mine is not completely unfounded . . . that this morning my stepmother called me, and fixing me with a gaze that seemed to penetrate right through to my heart, she said, 'You've been much too pale and restless for some time now. What's wrong with you?'

I was quaking, and I've no idea what I stammered out, but I didn't know what to say. She went on, looking at me in that same unnerving way: 'I've noticed a great change in you in recent days. My child, if the country air doesn't agree with you, your father won't insist on keeping you here – he'll let you return to your convent.' And she accompanied these few words with such a look and such a tone of voice that seemed to say, 'I know everything. I know your secret.'

I felt like dying. Fortunately, I was sitting down, otherwise I'd have fallen to the ground, and she didn't notice that my eyes filled with tears, because at that moment Giuditta came in, looking very happy. Oh, my poor mama, lying at rest in Camposanto . . . if only I could have thrown myself in your arms and, bursting into tears, asked your forgiveness!

Giuditta said, 'Listen, mama: the Valentini have invited us to go with them to the Bertoni's house – they live just near by.

There'll be dancing, you know! Come on, now, mama, be a darling! Do let's go . . . What fun a dance in the country will be!' And the dear girl cajoled her mother so sweetly that her stern expression immediately softened. She kissed Giuditta with a smile, and said just one word: 'Flibbertigibbet!'

Oh, how blessed is a mother's holy love, entirely revealed in a single word or caress! How blessed is the happiness which the happiness of our dear ones gives us! They both seemed so beautiful to me just then, in the blessings that Heaven had showered on them, that I prayed to God for all those, like me, who are deprived of them.

Giuditta hurried away to get ready, skipping and singing to herself, and she called for me to do her hair. She has wonderful chestnut braids. And every day, when I loosen her hair to comb it, I think what a great shame it would be if they were condemned to being cut off like mine. However, that day I was in such turmoil that I couldn't do anything right. I braided her hair twenty times, but she was never satisfied, and kept angrily undoing her braids.

'My God!' she exclaimed. 'Anyone would think you were doing it deliberately today!'

'I'm sorry,' I said, 'it's not my fault.'

'No, it's probably that you're tired of combing my hair.'

'Oh, what ever do you mean, Giuditta! No, I swear I'm not. I'm doing my best,' I replied tearfully.

My dear sister is infinitely kind. She looked at me in surprise, shrugged her shoulders, took the comb from my hand, and said, 'Go on, there's no reason to cry. I'll do it myself.'

I wanted to hug her, to kiss her, to ask her forgiveness, to get rid of that knot of bitterness that I felt here, in my heart. How stupid and troublesome I am! It was already late, and she was keeping everyone waiting. She was right to lose patience and say to me, 'Oh, for heaven's sake, leave me to comb my hair by myself at least!'

So I went out, wiping my eyes. Annetta met me at the door, and said, 'What are you doing? Aren't you coming, too?'

'What can you be thinking of?' exclaimed my stepmother. 'A postulant! That would be the limit!'

Nino kept staring at me and didn't say anything. I could see him, even though I wasn't looking at him. Meanwhile, my father came up and asked what all these preparations were for, and the reason for this merriment. 'What about you?' he then asked.

'I'm staying at home, papa.'

'No, you can come with us – we're in the country, after all.'

'Papa, I'd rather stay at home.'

'Then I'll stay behind with you.' (Dear papa! He really does love me!)

'What? Then who'll accompany us?' said his wife.

'You can go with our friends here.'

'But it's not good manners, the first time that we're to visit people we don't know. Maria can perfectly well stay behind with the maid and the steward for company.'

There was some further discussion, but papa eventually conceded to his wife's wishes – because, you know, my poor papa never contradicts her, for the sake of peace.

My friend, I confess that for the first time in my life, I was sorry to be the only one left out, when everyone was so looking forward to having a good time . . . And shall I tell you something else? There was another thing that upset me . . . the idea that he would be seeing so many other pretty young girls, and that he would even dance with them. At the thought of this, my heart filled with tears . . .

Now I'm alone. I watched them go off, in high spirits, singing. Only he looked sad. He gazed at me as if he would like to have asked me a hundred questions. He gave his arm to my sister . . . How beautiful Giuditta was in her lovely pale-blue dress, leaning on his arm, laughing and chatting with him.

I followed them with my eyes until they turned into the lane, and disappeared behind the hawthorn hedge that rises above the vineyard wall. Then for a while I could still hear their voices and their laughter, a merriment that was painful to me . . . O God, what an envious and wicked person I am! I had to think of him to prevent myself from sobbing. I had to remember the way he stared at me, in order not to envy them . . .

I was left on my own. The stars began to shine. It was a beautiful autumn evening, still mild and warm . . .

The steward's wife has lit the fire to cook their soup, and placed her baby in its cradle. Her husband has come home from the vineyard, leaving his gun at the door, and started playing with his little boy, who stands between his knees. All is calm, peaceful and serene. Only I am anxious, sad and unhappy.

I'm writing down everything that's close to my heart, and when my tears prevent me from being able to see what I'm writing any more, I look out of my window at the starry sky and the shadow of the trees. I think of that party, and of all those happy people enjoying themselves, with him! I think of him! And then I can't write any more, I've no other thoughts but for him alone. I have to picture him, in my mind's eye at least, while he's there dancing and laughing with someone else . . .

I'll say goodbye now . . .

Marianna! Marianna! Cry with me! Laugh with me! Hug me! He loves me! Would you believe it! He loves me! Can you imagine! I can't tell you any more. You'll understand totally what these three little words mean: he loves me!

Yesterday evening, do you remember? I had that sad letter in front of me, with my elbows resting on the desk. My tears were very quietly falling on to the paper and, without my noticing, were blotting out what I had written. All of a sudden came a noise from outside . . . the sound of footsteps! Could you explain why the sound of footsteps should be detected by your heart, as though the heart could hear? And why it should shake your nerves, and make your blood run cold?

I looked up . . . the window was open, and outside there was a figure, a voice softly calling me. It was him, do you understand? Him! If a cry didn't escape me, it was because I couldn't breathe.

'Forgive me, signorina,' he said, 'forgive me.' And that was all.

I dared not look at him, but those words were as sweet as honey to my heart.

'Your mother's mean and unfair to you. Everyone over there is having fun, and I thought of you, being here on your own . . . Have I done wrong?' After a brief pause, during which he must have heard my heart beating, he added, 'Will you forgive me?'

Then I looked up at him, and I saw him with his elbows resting on the windowsill and his chin cupped in his hands, as I had seen him before. He had been thinking of me, and his voice was trembling!

'Signor!' I said. 'Signor!' And I couldn't say anything else. Then he began to sigh, in the same way that I did. 'Listen, Maria . . .' he said, but nothing else. He passed his hand over his eyes, and seemed to be stammering – he, a man! I was

shaking all over, as if that name had penetrated every pore of my living flesh. He called me Maria, do you understand? Why did it have that effect on me, to hear him say my name?

'Listen,' he repeated. 'You're a victim.'

'Oh no, signor!'

'Yes, you're a victim of your circumstances, your step-mother's unkindness, your father's weakness, and fate!'

'No, signor, no.'

'Then why are you forced to become a nun?'

'No one's forced me, signor . . . it was my own free will.'

'Ah!' And he sighed again. I think he actually wiped his eyes. I couldn't see him clearly, because he was in the dark, in front of the window, and my eyes were veiled with tears.

'Necessity,' I said.

He didn't say anything. Then after a few moments' silence, he asked me – but his voice was husky – 'And will you return to the convent?'

I hesitated, but replied, 'Yes.'

He fell silent again. He didn't say any more. Then I waited. I waited for a long time for him to say something. I wiped my eyes to see if he'd gone: he was still there, in the same place, in the same position, except that his face was buried in his hands. This gave me courage, and I stepped forward, away from the candlelight that was bothering me. You know how narrow my little room is – one step and you're by the window . . . He heard me and raised his head, and I saw that he was crying. He held out his hand to me, without a word. There was a moment when I couldn't see anything at all any more, either with my own eyes or in my mind's eye, and I found myself with my hands in his.

'Maria,' he said, 'why are you going to return to the convent?'

'Do you think I know? I must. I was born a nun.'

'So you'll leave me then?' And he wept silently, like a child, without the pride that other men have to hide their tears. I think I must have cried too, because I discovered that my cheeks were wet, and my hands as well . . . but my hands might have been wet with his tears, which I felt dripping on

them. In fact, when I was alone again, locked in my room . . . tell me off and shout at me, if you want to . . . I kissed my hands while they were still damp.

We stayed like that, in silence, for a long time. The only thing he said was, 'How happy I am!'

'And I,' I replied, almost without being aware of it.

You see, Marianna, we were crying and saying that we were happy! But we hadn't yet said that we loved each other. Such sweetness flooded my heart that I wasn't thinking of anything any more, and I no longer felt ashamed to be with a man . . . with him . . . alone, at night! We didn't speak, and didn't look at each other. We gazed up at the sky, and it was as though our spirits communed through the surface of our hands, and embraced each other in the meeting of our gazes among the stars.

Marianna, this part of God that has been given to mankind must be very great if everything before it – both sin and crime, duties and the most sacred attachments – pales into insignificance, if it can create a paradise out of a single word!

I'll leave you now. My heart's too full to think of anything else. In writing to you, I've relived the same emotions . . . Now I need to be alone, to dream, think and be happy . . .

How wretched we are, my friend, if we can't be the judges of our own happiness. I wrote you a letter that today is a bitter irony, that I can't read without crying. Listen: there we were, at the window, silent and happy, with our dreams. All of a sudden there was uproar: Vigilante was barking, and my father's voice could be heard, as well as Gigi's. I abruptly drew back and closed the window. I was trembling all over, as if I'd committed a great offence. Papa found me in bed. I was running a fever and it lasted all night. Giuditta didn't come. I could hear her talking in the next room. She sounded annoyed and in a very bad mood. The next day I was so pale when I got up that papa wanted to send for the doctor. Later, mama called me to her room, and just looking at her face, I felt my knees buckle. She spoke at length about her responsibilities and mine, about my vocation, and the need imposed on me by my poverty to be ruled by that vocation. She spoke of the dangers that a young girl destined for the convent might encounter in the most straightforward relationships, and concluded by telling me that in future, when outsiders came to our house, even the Valentini, I was to stay shut in my room.

My God! how did I endure the torment of those reproofs. She seemed to take delight in needling me, in levelling at me veiled accusations of a thousand misdeeds, and she didn't even make clear to me whether or not she'd discovered that Nino had left the dance to come and find me.

More than once, while she was talking, I felt that I was about to faint, but she didn't notice my pallor, or my trembling, she didn't notice that I had to clutch the back of a chair because I couldn't stand upright any more. If she'd realized the state I was in, she would surely have taken pity on me and spared me this torture. Once I could be alone, I went to bed. My fever had returned. I felt ill, and I wished I were dead.

Giuditta didn't even come then. She was cross with me. My God, what have I done to her? I had the sense of being like one of those criminals that everyone avoids and no one dares to go near . . . I felt ashamed before that window, opposite my bed, there, like some adamant accuser. I was hurt by this isolation and neglect. Towards evening I called for my sister – I needed to see her, to be comforted. Even my dear papa looked more serious than usual. Giuditta eventually came, but she seemed very cold. I threw myself into her arms, and I thought the tears that made me feel much better irritated her.

Now I'm alone. Everyone seems to be avoiding me, and I'm hateful to myself. They're right, I'm very much at fault. Only God can pardon me – God whom I've sinned against by loving one of His creatures more than Him.

I sew, I sew, all day long at the window, with the curtains kept scrupulously closed, and I cry when I'm lucky enough not to be seen, and to be able to give vent to my tears. And my eyes sting . . . The sky is cloudy, the fields desolate, the rustling of the trees frightens me, the birds don't sing any more . . . only occasionally I hear a plaintive nightingale somewhere. Yet I spend hours with my hands crossed in my lap, looking through the window-panes at those huge dark clouds racing westwards, at the treetops slowly swaying and shedding their dead leaves. Winter has arrived in the natural world, just as the winter of the soul has arrived. Carino has flown away, poor thing! I neglected him so much! He's taken his chirpiness and his lively twittering somewhere else, because I'm living in such a gloomy atmosphere. Only Vigilante comes now and again to seek me out, hoping for a smile, expecting me to stroke him. He comes in very quietly, almost hesitantly, questioning me with his beautiful eyes, asking whether he's bothering me. Then he stops in uncertainty, and wags his tail and licks his lips – all of which means to say, 'I'm sorry to be so persistent.' And he comes and lays his head on my lap to tell me that he still loves me, and he looks sad when he goes away, but he still wags his tail and stops at the door to say goodbye.

All day long I can hear the voices of the Valentini talking

with my family in another room. Two or three times I've heard a voice that has wrung my heart – his voice.

Him! Him! Always him! Always there's this thorn in my heart, this temptation in my mind, this fever in my blood. Always I see him, before my eyes, there at the window, with his face in his hands. Always in my ears is the sound of his voice, and on my hands the dampness of his tears . . . O God, my God!

Several times I've heard footsteps outside my window, and my heart felt as though it would burst from my breast. I have dizzy spells, faintings fits and bouts of delirium. I can't cry, I can't sleep, I can't pray any more. O Marianna!

What will he think, not seeing me again? Will he know that I've been forbidden to see him? Will he perhaps curse me? Will he be angry? Will he forgive me? You see how far I've fallen? I pray God to make me forget him, and I feel maddened by the mere thought that he might forget me. Sometimes, at dawn, when I'm quite sure that no one might catch me by surprise, I very quietly open the window to look down into the valley, at the house where he lives, where he's probably asleep at that hour, to see his roof, his window, the pot of jasmine, the vine that casts its shade over his door . . . Then I try to guess the spot where he'll rest his elbows on the sill when he opens the window, the clod of earth that he'll first set foot on, his line of vision when he first gazes out, seeking my window . . . for my heart tells me that he will first gaze at my window, and he will know that I was here, watching him sleep, thinking of him, always of him – in my dreams, before I fall asleep, when I first waken, and in my prayers. O Marianna! Pray for this poor sinner who is weaker than her sin. Send me the scapular of Our Lady of Mount Carmel that was blessed in Rome, and send me your little prayer book. I want to think of God. I want to pray to the Virgin, so that she will protect me, and hide me under her mantle of mercy, from the eyes of the world, from myself, my shame and my transgression, and from God's punishment!

I've been ill, my friend, very ill – that's why I haven't written to you. There were days when everyone was crying, and I thanked God for at least granting me the peace of exhaustion. I saw all those pale faces around my bed, all those tears dissimulated with an even more painful smile . . . and seeing as though in a dream, my eyes watched calmly. I saw all those dear to me, all of them . . . excepting only for him! They must have forbidden him to come. Yet with that exquisite sensitivity of the sick, I sensed he was there, outside the window, crying and praying . . . and I kept my eyes that were tired of life fixed on those panes of glasses through which came a ray of winter sunshine that settled on my bed. I couldn't convey to you the feeling I had inside me: I felt calmer, easier, in an atmosphere of peace and serenity; I was still thinking of him, but with such quiet fondness that I felt as if I were among the angels, and one of them, called Nino, had taken me by the hand and called me by name, and as on that night, we'd both looked up at the stars.

It's cloudy, and raining – you know how sad the sound of rain beating against the windowpanes is! Little birds come, shivering, to seek shelter under the eaves, and the wind whistles in the chestnut grove. Apart from this mournful sound, everything is silent. This morning I got out of bed for the first time, tottering and drained of strength. If you could see how I'm writing to you! Supported by a heap of pillows, pausing at every moment to regain energy, to wipe the sweat from my forehead . . . and yet it's cold! My head feels heavy, my hand shakes, my thinking's confused and uncertain. They say you came to see me . . . I don't remember, Marianna! It must have been one of those days when I was unaware of what was going on around me. This tiny room where I have suffered so much, this trestle-bed, this cruficix, these pieces of furniture seem to have become part of me. I've spent such long hours in a

convalescent's state of melancholy inertia, daydreaming about heaven knows what, gazing at all the objects in my small room, that the shape of the furniture, and, as it were, the cast of the walls, are dear to me. The doctors say that I'm better now, praise God! For the good Lord should always be praised in what He does! My father, Giuditta, Gigi, you and Annetta will all be pleased . . . and he, too!

How sweet it is to return to life after having been on the brink of leaving it – if only to see all these smiling faces, to receive all these signs of affection, to feel loved, to look at the sky, to hear the wind, the rain, the cheeping of the little birds suffering from the cold. Everything looks new and beautiful. It's like the awakening of a tired mind, and its thoughts, turning to something once cherished, with grateful surprise find it even more vital than before. Everything is a source of delight, blessed be God! Everyone takes my pale, thin hand, clasps and kisses it . . . he alone doesn't! he alone!

I got up, swaying and leaning on the furniture, and opened the window. My God! How enchanting is everything I see, even though it's cold, and the ground is covered with snow, and the trees are bare, and the sky is black! I saw that house over there, after such a long time! that vine, that window-sill, that door . . . the jasmine's gone, the vine has lost its leaves, the doors are closed, there's an air of sadness about it all, and yet it seemed like paradise to me . . . I thought I saw the window being closed . . . My God! My eyesight's so weak! I saw a figure behind the shutters . . . It's him, it's him! He saw me! He was waiting for me. O God! O God! Marianna, don't you see? It's him!

At last the doctor's given me permission to step outside in the middle of the day when the weather's fine. They say that I need lots of care because my health's delicate. My poor mother's health was delicate, too, and she died young. Yesterday was Christmas, that wonderful festival that at the convent meant a night of carols and joy, and the moving experience of midnight mass . . . do you remember? The Valentini came every night of the Novena before Christmas to play cards with my family. I heard them talking and laughing in the dining room, where a warm fire had been lit, with doors and windows tightly closed, while the wind moaned outside, and sometimes hail-stones thundered down on the roof. How they must have enjoyed being together, all warm and snug, with the cold and rain outside!

To celebrate the festival we had a special lunch, but without the Valentini . . . because of me, I realized, so that I wouldn't meet him. It was a cheerless occasion compared with the meal we had on my father's name-day, do you remember?

In the morning there was brilliant sunshine. I went and stood outside the door for a while. They wrapped me up in shawls and scarves, and papa supported me. How pleasant and agreeable everything was: a bright sky of the purest azure, the sun gilding the snows that covered Mount Etna, the deep-blue sea, the belltowers of the villages that appeared as white smudges among the trees, the fields with their green grass contrasting with the whiteness of the snow, the wood that was silent because there was no wind and it had no leaves to shed, the lawn on which we'd danced and had such fun, the chickens scratching around in the straw, the little shed that steamed as the snow melted in the sunshine, the birds twittering on the roof, Vigilante stretched out across the threshold, sunning himself, the steward's wife who was hanging out the washing to dry on the bare branches of the chestnut tree, and

singing to herself, glancing with ineffable maternal content-
ment at her two children playing on the doorstep.

Blessed be God! Praise be to God, for the joy and delight
He grants to the bird that sings, to the burgeoning leaf, and
the basking snake, and the sun that shines, to the mother who
holds her baby to her breast, and to my poor soul that rejoices
and gives Him thanks.

How early it gets dark in winter! I'd like to have stayed
outside for a long time filling my poor tired lungs with that
invigorating breeze, and, leaning on my father's arm, to have
managed somehow to reach the edge of that lovely chestnut
grove where I've spent so many happy hours! I'd like to have
sat on that little wall that's covered with green moss. It was
cold, the sun was disappearing, down in the valley a thick fog
was gathering, and the birds had stopped singing. How
mournful the silence of sunset is in winter! My father wanted
me to return to the house and go to bed, while the most
beautiful moon in the world was glistening on the window-
panes. I wish that at least they'd left me with that lovely moon-
light, but they even closed the shutters. I'm ill, you see? It's
cold . . . so they had to . . .

They were expecting the Valentini for supper. How won-
derful Christmas evening is! Even here, in this solitude, every-
thing has a festive air: the peasant who comes home from the
plain, singing, to spend Christmas with his family, the fire
crackling beneath a big cauldron, the village girls who dance
to the sound of bagpipes. I saw the preparations going on in
the kitchen for the meal, the wood in the grate, the candles
and playing cards left ready on the table, and a plate of sweets
and a few bottles of liqueur set out on the desk by the window
– all the pleasant trappings of a homely Christmas evening.
I counted the chairs placed around the table – there were
eight . . . mine wasn't there any more . . . I saw the place
where I used to sit and the chair that he took beside me when
he looked at my cards.

I thought about all these things as I lay in bed, all alone, in
that tiny little room which is dark, silent and gloomy-looking.
I would like to have fallen asleep, and not to have heard the

talking, those voices, that festiveness close by . . . I spent an extremely restless night, without a wink of sleep. I think I've still got a fever. I feel so weak! I held my breath all evening trying to hear what he said and to tell from the sound of his voice whether he was sad or happy. I heard him three times: once he said, 'thank you', then 'it's my turn', and the last time, 'signorina'. If you could only imagine all that these words convey! If I could only express it!

They played until midnight. I could hear them from here. Then they sat down to eat . . . Now I'm tired, my head is swimming . . . I wrote to you to keep myself awake . . . to give myself something to do . . .

Let's talk about you instead . . . Did you have a good Christmas? Are you happy and cheerful?

I want to amaze myself; I want to regain my strength in the next few days; I want to overcome this terrible affliction. God who is merciful will help me! Write to me, write to me! Perhaps we'll see each other soon, and we'll have so much to tell each other!

Oh, Marianna! My dear Marianna! How I've cried! How I've suffered! The Valentini are leaving tomorrow, do you realize? There's no cholera any more, there's nothing! They're leaving . . .

I shan't see him again. I found out by accident, a few moments ago. They didn't even have the grace to tell me . . .

I thought I'd die. I regretted that God had ever made me get better. I cried the whole night. My chest hurts a lot. I sometimes sobbed so loudly that Giuditta must have heard.

I'm completely shameless! I've no restraint any more. I've only one thought. I went out like a madwoman to ask the steward's wife for information. It's tomorrow! He came to say goodbye to my family, and they didn't even let me see him for the last time! And I shan't ever see him again . . . and it was after nightfall when I found out, when it was already dark . . . when I couldn't see any more to look at the little house where he'll be spending his last night!

My God! what kind of people are these . . . that are so heartless, without pity or tears?

What a night, what a horrible night! How cramped this little room is, and how miserable it is here! All night long the rain beat against the window-panes, the wind rattled the shutters, the thunder sounded as if it would bring the roof of the house down on us, and the sinister flashes of lightning were discernible even from inside . . . I was afraid and dared not cross myself . . . I'm damned, excommunicated, for even at that moment I thought only of him . . . more than once I prayed to God, hoping that this storm would last, I don't know how long, provided he didn't leave, that he remained always near by me . . . That's all – not to see him, not to speak to him, but to know that he was there, down in the valley, beneath that roof, behind that window, so that I could send him my greetings in the morning, and with my eyes embrace

that threshold, that earth, that air . . . Is that too much to ask? My God! If I can be content with that . . .

But hasn't he realized that I'm pining away for him? That I'm weak and ill? Hasn't he cried? Hasn't he suffered as well? Why hasn't he come, for a moment, one single moment, just for one last sight of him, to say goodbye to me from afar?

Why hasn't he let me hear the sound of his voice? Why hasn't he been through the wood? Why hasn't he fired his gun into the air? Why hasn't he got his dog to bark – the dog that he asked me if I loved, on whose head he placed his hand next to mine . . .

O God! O God!

I'm writing to you in bed, with a big book resting on my knees. Sometimes I shiver with cold, and I'm overcome with dizziness, but if I didn't write to you I couldn't stand being shut up in here – I think I'd go mad. I've no tears left, and anguish devours me like a rabid dog. I feel frenzied, feverish, and delirious. This falling rain and whistling wind, these claps of thunder and flashes of lightning are unbearable. This roof presses down on me, these walls suffocate me. I wish I could open the window, and feel that icy rain beating on my forehead, and drink in that cold wind. I wish I could enjoy the lightning, the storm that howls and writhes and moans like me. If I'd only known that I'd have to suffer so much . . . Why did these merciless people take me away from the convent? Why didn't they leave me there to die, alone, and helpless, of cholera and neglect?

Hush! Listen, Marianna! Didn't you hear? I thought . . . there, at the window, amid the tumult of wind and rain . . . a footstep . . . Yes, yes, it's him . . . it's him!

My heart's bursting, and I'm clutching my head with both hands, because it feels as though I'm also losing my mind . . . It's him! What's he doing? What does he want? He's knocking at the window! O God! Let me die, let me die! He's saying goodbye . . . and I . . . my God, what's happening inside me . . .

I've had a coughing fit . . . that's my farewell . . . He must have heard. I can't see any more . . . I feel terrible . . . My God! What if they were to find me with this shameful letter?

God had mercy on me: I opened my eyes and found this letter still in my hands. No one saw it. The door's still closed. The sunlight's already entering my room through all the vents in the shutters. The birds are twittering on the sill. The sun! How horrible it is! But what about the storm? And what about . . .

I leap out of bed . . . I haven't the strength to stand upright . . . I haven't the courage to open the window . . . And yet . . .

My God, thy will be done!

It's all over! I saw that silent house, the shutters closed, and over the entire surroundings an air of heart-breaking quietness, desolation and abandonment.

I consulted the sky that saw us as neighbours, the trees that rustled over his head, the mountains we still shared a few hours ago, that are now lonely, sad, and forsaken . . .

He's gone, he's gone!

Under my window, in ground made soft by the rain and white with snow, I saw his footprints . . . his last footprints! He stood there, and his hand touched the sill . . . he was here! Here! This air surrounded him, and everything that I see, he saw . . . And now he's gone and there's nothing left! Nothing!

I found a withered rose lying on the window-sill, a poor rose that he'd more or less stolen from me, and that I had let him steal. The rain has ruined it. It's a memento. I have it here on my breast . . . and when I'm shorn, I'll lay this poor dead flower on my hair and send it to my sister . . .

Today is our last day at Monte Ilice. Tomorrow morning we leave for Catania. If we pass through Mascalucia, I shall see you.

If you could only see how miserable everything is here! The cloudy sky, the chilly atmosphere, the valleys shrouded in mist and the mountains covered with snow, the trees that have lost their leaves and the birds that have lost their cheerfulness, the pallid sun, the long black lines of crows wheeling through the air, cawing, and the country folk huddled round their fires.

My family can't stay on here any longer, by themselves, in the cold weather, and now that the fear of cholera's past, papa can't wait to leave. I spend hours thinking, of heaven knows what, leaning on my sill when it's sunny, or gazing sorrowfully at the sky through the window-panes.

My God! This is death . . . the death of nature, and of the heart . . . and of that poor rose . . .

And to think how beautiful this place was! And how happy I was here!

I'm reconciled with God and with my vocation. I've realized that peace, calm and tranquillity are only to be found there, in that cell, at the foot of that Cross. And that all worldly pleasures – every single one of them! – leave you with a sense of bitterness in the end.

Yet I feel that I'm leaving a bit of my heart in this place where I've spent so many hours of sadness and so many days of joy. At the sight of every object, I thought, 'After tomorrow, I shan't ever see that again!' This evening I went for a last walk in the woods. I sat for the last time on the wall. I gazed at the little cottage opposite our front door, and standing at the window I contemplated with an inexplicable sense of sorrow the trees, the mountains with their ravines, and the sky from which daylight was fading . . . and I took final leave of them, and even of the moss-covered stone and of the eaves over my

head. All these things have a special look, the melancholy look of things that seem to say farewell . . . And mine is an eternal farewell. In the coming year, when these mountains that now stand silent and dreary are alive with sounds and smells and brightness, when the village girls sing in the vineyards and the lark up in the skies, my family will return . . . They'll see these lovely places again . . . but not I! I'll be far away, enclosed in the convent . . . for ever.

I gazed at his house again . . . it looks sad and frightened, alone, cold and silent, lost at the bottom of the valley. I closed my window for the last time. I watched as the twilight faded from these window-panes and the stars came out in the firmament, one by one. By the light of the last evening's candle the walls have a special look: this trestle-bed, this crucifix, these pieces of furniture, all these little things have become animate, they're sad, and they've wished me goodbye . . . And I am sad . . . I cried, and my heart felt lighter.

My dear Marianna, if you were expecting to see me, there was no point – we didn't go through Mascalucia; it would have made our journey much longer and the weather was bad. We've been here since yesterday evening, and tomorrow I'm going back to the convent . . .

We left Monte Ilice at about ten, with rain threatening, but that couldn't be helped – everything was ready for our departure and mama wouldn't have wanted to unpack the trunks and cases again, not for all the gold in the world. And so much the better – what was the point of staying there any longer? Even the sky seemed to be driving us away. Nevertheless, I crossed the threshold of that house with a heavy heart.

I wanted to take a last look at those little rooms, the lawn, the steward's cottage, the dry-stone wall, that fine chestnut tree with its branches spread over the roof. I fondly touched the walls and the furniture in my little room. I opened my window for the last time, to hear the hinges creak. I walked round the house to see my window from the outside, as he must have seen it . . . to try to identify the place where he stood . . .

Everyone was happy – Giuditta, Gigi, papa and mama. Vigilante frisked about, poor thing, not realizing that we were deserting him. The steward's wife wished us a safe journey, while her children clung to her skirts. A little bird shivering with cold came and settled on a small leafless branch of the tree, and it, too, began to cheep plaintively.

We set off on foot. The mules were waiting at the bottom of the valley to take us down to Trecastagne, for as you know, you can't come any further up these mountains except on horseback. Every now and again, we'd turn to take a last look at the place we were leaving. At the bend in the lane, further down in the valley, we passed by his house . . . I didn't have the heart to look, and yet the smallest details are engraved on

my mind. His window has green shutters and one of the panes of glass is broken. On the sill there's a patch of damp where the pot of jasmine used to be. The wind has ripped away the vine from above the door, and cast it to the ground. On the lawn in front of the door lie bits of broken glass and scraps of letters and rain-sodden newspapers blown this way and that by the wind, and there's still a broken pipe on the sill. All these things speak, and what they say is, 'He's not here any more! He's gone away! We're alone!'

This was the lane that he took to come to us. He must have walked along it so often! From there, he'd have seen our house peeping through the chestnut trees – countless times he must have seen it! And countless times he must have rested his gaze on these moss-covered stones, and sat here with his splendid dog lying at his feet . . . Marianna, I can't bear all these memories!

The mules took us down to Trecastagne, where the carriage was waiting for us. Poor Vigilante was all over us, urging us to take him along. What could I do? I gave him a hug, and it almost brought tears to my eyes to see him being forcibly dragged away by the steward, who put him on a leash.

I turned to take a last look at my beloved Monte Ilice. I could no longer see the house, the cottage, or the vineyard, only the brown mass of the forest; the rest was lost in the mist, and white with snow. We climbed into the carriage and left.

When we came into town, my heart lightened immensely. I looked out of the window and seemed to recognize him in every person I encountered . . . They must have thought me shameless! When I saw a group of people, I couldn't help sticking my head out of the window – I was all in a turmoil, sure that I was going to see him there . . . The carriage went swiftly past, and it wrang my heart to think that I hadn't time to pick him out among those people. Does anyone know where the Valentini live? This question came to my lips countless times, but I didn't have the courage to voice it. Catania's so vast! It's not like being in our beloved mountains, where you always knew where to find someone you were looking for. These great roads seemed forbidding, all these

people looked sad. We arrived at the house – my stepmother's house . . . I felt like a stranger in the family . . . they were all so delighted to be back . . .

I wonder whether the Valentini will be aware of our arrival, and whether they'll come? I wonder whether I'll see him passing in the street? O God! Our street's so deserted! No one comes here for a walk . . . unless . . . But he might . . . Who knows where he could be walking at this moment? And what if I were seen at the window?

My stepmother's told me that I'm going back to the convent tomorrow. She must have thought this would comfort me – she doesn't realize that I felt chilled with terror . . .

I'd stopped thinking about it . . . But I must resign myself . . . That's my home. God will forgive me and soothe this poor heart that should never have gone away from Him.

I shall see my cell again, my crucifix, my flowers, the church, my fellow postulants . . . all except you! You're not coming back to the convent! The Lord's will be done. At least you'll occasionally come to visit your poor friend who's so unhappy . . . Who knows whether I'll be able to write to you and confide in you any more?

Goodbye! Goodbye!

These few lines are perhaps the last that I shall write to you. The carriage is waiting below. Papa, mama, Gigi and Giuditta are all dressed up to accompany me.

I've cried. I'm now wiping my eyes and taking my last breath of freedom.

The Valentini came to say goodbye. He wasn't with them. They hugged me. How Annetta and I cried!

I shall go downstairs and climb into the carriage, and in twenty minutes it will all be over.

Goodbye to you, too, goodbye. My heart is breaking.

From the convent, 30 January

I didn't want to let the end of the month go by without writing to you. You might have thought that I was sad and unhappy, whereas here, at the foot of the altar, in the austere observance of our rule, I've found, if not peace, at least a quietness of heart.

It's true, that you get a feeling of overwhelming dismay as you enter this place, and hear the door shut behind you, suddenly seeing yourself bereft of air and light, down in these corridors, amid this tomb-like silence and monotonous drone of prayer. Everything saddens the heart and instills it with fear: those black figures to be seen passing beneath the dim light of the lamp burning before the crucifix, figures that meet without speaking to each other, and walk without a sound, as if they were ghosts; the flowers withering in the garden; the sun that tries in vain to penetrate the opaque glass in the windows; the iron railings; and the brown twill curtains. You can hear the world going on outside, its sounds faded to a whisper, deadened by these walls. Everything that comes from outside is weak and muted. I'm alone among one hundred other forsaken souls.

I've also lost the consolation of my family. I can only see them in the presence of lots of other people, in a big gloomy room, through the double grating over the window. We can't hold hands. All homely intimacy is gone, leaving nothing but phantoms speaking to each other through the screens, and I'm always wondering if that really is my father, the father who used to smile at me and hug me; if that's the same Giuditta who used to dance with me; and if that's the Gigi who used to be so bright and cheerful. Now, they're grave, cold and melancholy. They look at me through the grille, as if peering into a tomb, in which they, the living, observe corpses that talk and move.

Yet all these hardships, all these austere practices serve to

detach the heart from earthly frailty, isolating it, making it think of itself, and imparting to it the still calm that comes from God and from the thought that our pilgrimage on earth is thereby shortened. I've confessed. I confessed everything – everything! That kindly priest took pity on my poor sick heart. He comforted and counselled me, and helped me to tear the demon from my breast. I feel freer, easier, more worthy of God's mercy.

Tomorrow I begin my noviciate. They tried to delay it for a few more days because of my delicate health (I've never completely recovered from the illness I suffered up at Monte Ilice: I have a fever every two or three days, and every night I cough), but God will give me the strength to endure the ordeal of this noviciate. From now on, only very rarely will we be able to see each other, and I won't be able to write to you because I shan't so often see Filomena, the kind-hearted lay sister who has been sending you my letters.

I shan't even be seeing my poor papa any more . . . The Lord's will be done!

Marianna, pray for me to God, that I might undergo this trial with resignation.

I've completed my noviciate. I was granted a dispensation because of my health, which is still very poor. I often have a fever, I cough, and I've grown so weak that the least effort exhausts me. Yet my heart is at peace, and that is the greatest blessing God could have granted me. Sometimes frailty rebels, and temptation assails me again. Then I prostrate myself at the foot of the altar, I spend all night kneeling on the cold paving of the chancel, I mortify my body with fasting and penance, and when the flesh is subdued and passions quelled, temptation is overcome and peace returns.

This year of trial has been very difficult, but God has enabled me to triumph. I saw my family depart at the sudden outbreak of cholera last summer, and I felt abandoned even by my loved ones . . . I went out on the terrace and fixed my gaze on that wonderful place where I was with them for a while . . . Ah, what good times they were! I thought of many things . . . yes, admittedly, I cried, and sometimes I felt weak, but in the end I triumphed.

Everything here serves to close the mind in on itself, to circumscribe it, to render it mute, blind and deaf to all that is not God. Yet even at the foot of the cruficix, when those temptations assailed me, and I remembered our little house, those fields, the cottage, the fire on which the steward's wife used to cook her soup, I'd think about that poor peasant-woman, cuddling her babies on her lap, without any of my temptations, doubts and regrets, and I wondered whether she might not be closer to God than I who mortify my rebellious spirit with many penances.

How often have I not envisaged those mountains, woods and bright sky! And how often have I not said, 'At this time of day, they're sitting together beneath the chestnut tree. Now, they're strolling down the paths through the vineyard, and now Vigilante is barking, and the birds are twittering under

the eaves!' And when I've awakened as if from a dream, I've found my face all wet with tears.

And then there's another thought . . . another ghost . . . there . . . always there, fixed before my eyes . . . at the foot of the Cross, in the midst of the crowd attending mass, at my bedside, behind that green twill curtain – the temptation that grabs me by the hair, and drags me from my prayer, that makes me cry and sends me into a frenzy . . .

There have been times when I thought I was going mad – and I thanked God for it, because the mad are blameless. I think I see him down among all those people in the church, on Sundays. I cross myself, and appalled, in tears, I rush to the foot of my confessor. The good old man tries to comfort me, and he prescribes the penances supposed to remove this stain from my heart but that prove ineffectual because I'm a great sinner . . .

Yet he might have come to church at least once . . . to hear mass . . . without even looking up at the choir . . . but only to show himself . . . He must know that I'm here, and he hasn't tried to see me!

O God! Forgive me, Marianna . . . you see how much at fault and how wretched I am! It's the devil assailing me when I least expect it . . . How often, when praying to the Lord to take this cross away from me, have I not looked down into the church to see if he were there, searching for him among the crowd! And my prayer has died on my lips! And my thoughts have lingered on him . . . lost in reverie, dreaming of running through the fields, of listening for his footstep and that knock on the window, gazing up at those stars, touching that hand as it stroked that fine gun-dog's head, and hearing in my ears the name 'Maria', that might have come from heaven . . .

O God! I'm weak and very frail . . . but I fight and struggle with myself . . . My God, I'm not to blame! It's stronger than me, stronger than my will, my remorse and my faith.

You write that you are happy, and glad to be outside the convent. My dear Marianna, thank the good Lord for sparing your mother, and for sparing you from being born poor, for not having driven this thorn into your heart, or having made you weak, hysterical, excitable and sickly.

Only when this flesh is dissolved will I cease to suffer. That's why I would like to detach myself from the world that clings to me stubbornly, and I look up to heaven and raise my arms in entreaty . . .

Now that I've been reunited with my dear Filomena, who takes pity on my sorrows and allows me the comfort of writing to you and receiving your letters, I'll write to you a few more times before taking my solemn vows. You will come to the ceremony, won't you?

I want to say goodbye, through the grille, amid the clouds of incense and the sound of the organ, to all those who are dear to me. I want all those friendly faces to sustain me in this difficult step, because my poor heart is frail. I need to be able to gaze into your eyes, and those of my papa, my sister, Gigi, and Annetta, when I hear the rasp of the scissors in my hair . . .

I'm scared, Marianna, I'm scared! I'm scared of those scissors . . . of that moment . . . I'm scared of him . . . if he were to come to the church that day . . . My God! No, no, I'm weak . . . for pity's sake . . . You'll come with my father, Giuditta, my brother, mama, Annetta and the Valentini . . . My God! Thy will be done!

My dear Marianna, my sister ... I thought I was inured to pain, but this has caught me unawares, rending me, crushing me, annihilating me! Here I am, weaker and more wretched than before! My God! And now this! Now this!

Do you know what I've heard, Marianna? Do you know what I've heard? Could you ever have imagined it! I've been extremely ill for more than two weeks. Now I'm up, writing to share my tears with you.

What is this wretched thing inside me that groans and suffers, that can't tear itself away from all this misery and raise itself to God?

They shouldn't have told me ...They've no mercy! No, it's just that I'm weak. It's my fault, and God is punishing me.

Signor Nino is going to marry my sister ... do you hear? They came to bring me the glad tidings! It's a good marriage ... they're both rich ... Giuditta is pleased and happy ... I didn't have the courage to ask them to spare me the ordeal of the usual visit ... because he will come, too ... I sense that I shan't have the strength for this further sacrifice ... it will kill me ...

And will he have the strength for it?

Yet I'll pray so hard to God ... for me ... and for him ... I'll flagellate myself and weep so much that God will give both of us the strength to get through this cruel ordeal.

I've cried until I've no tears left to shed.

My chest aches, my mind is wandering. I wish I could sleep. Most of all, I wish the Lord would spare me this pain ...

God's will be done!

28 February, midnight

Praise be to God! The ordeal's over. I thought I'd die, but it's in the past now, all over and done with . . .

They'd informed me, as well as all the other nuns in our family, the abbess and the novice mistress. We waited in the big hall outside the parlour. I was sitting between Mother Superior and the novice mistress. They arrived exactly on time. I heard the carriage stop at the door, and the sound of their footsteps as they climbed the stairs and approached the grille. I rose unsteadily to my feet . . . I couldn't see anything . . . I heard the bell summoning me . . . The novice mistress opened the curtain. I clung to the drapes and collapsed on to the wooden bench. I saw a blur of faces crowding the grille, but they couldn't have seen me – it was dark on this side. They talked. After a while I was able to hear them. My stepmother talked, and so did papa . . . Giuditta didn't say anything, and neither did he . . . My sister, wearing a pink dress and matching bonnet, looked happy. He was sitting beside her, holding his hat, and stroking it with his gloves. I didn't cry . . . It seemed as though I was dreaming. I was surprised not to be suffering more . . . Then they stood up. My father said goodbye to me, mama gave me a smile, Giuditta blew me a kiss, Gigi asked for some sweets . . . He bowed. I watched him walk away. He was at Giuditta's side. At the door he gave her his arm. Then the door closed, their footsteps faded away until they couldn't be heard any more. The carriage left . . . and silence remained. Nothing else! Nothing! I'm alone!

In a month's time I shall take the veil. Preparations for the occasion are already under way. Everyone showers me with affection. Not a day goes by that papa and mama don't come to see me. They want to celebrate the event. There'll be music, fireworks, and guests. My dear papa seems happy that I, too, should be gaining status, as he puts it. Giuditta has also come, several times. If you could only see how beautiful her happiness makes her! God bless her!

And you, too, are engaged to be married, my dear Marianna. You write that you're happy. I hope so. But in your happiness don't forget your poor friend who has more need than ever of your affection. Come and see me once in a while, when you have time. If you only knew how happy I am in those few rare moments when I see the people who love me. You know, it's an act of charity to visit poor prisoners!

You who are betrothed, you who are happy, tell me what joy and celebration and jubilation my sister must be feeling. Tell me what must be in her heart at the prospect of remaining for ever at her beloved's side, free of doubt, remorse and fear, blessed and feted and cosseted by everyone. Tell me what happiness it must be to think that she will be his, and that he will belong to her; that she will see him every day, at every hour, and hear him speak; that she will rest on his arm, and whisper in his ear everything that passes through her mind; that she will be called by his name, and see the day when she will cradle his children in her arms and teach them to love him, and to pray for him to the good Lord. To think that everything will be a joy, and there will be no end to that joy. How good the Lord is, to grant such happiness! I've been told that the wedding's on Sunday . . . God bless them!

Sunday, 29 March, midnight
My dear Marianna, I'm writing to you from my cell, by night, afraid that my small light might be seen through the curtain and even this meagre comfort of being completely open-hearted with you will be taken away from me. What a day this has been for me, Marianna! Will my suffering never end?

I'm alone, shivering with cold. All is silence. There's only the sound of the clock's pendulum, like the footsteps of a ghost moving down these long, dark corridors. I spent all day in the chancel, praying and weeping before God. Now I'm weak and tired, I can't take any more, but I'm a little calmer. Today's Sunday! You'll appreciate the full significance of that word – I'll say no more . . . It was today!

You know, they brought me refreshments from the wedding! Don't they remember I'm ill and that such things would be bad for me?

Yet how were they to remember? Everyone's so happy, this is a day of rejoicing . . . It's my fault for being such a poor sickly, tiresome wretch. What a celebration it must have been!

I couldn't sleep at all last night. And they can't have slept either, waiting for this Sunday to dawn . . . dreaming, open-eyed, of those flowers and wedding outfits, of the crowd and those smiling faces . . .

I, too, pictured all those things. I saw Giuditta, looking so beautiful in her bridal gown, with her white veil and crown of orange blossom, and him, holding out his hand, smiling at her . . . They entered the church, surrounded by friends and relatives, by their loved ones . . . The altar was all lit up, and the organ was playing. Then they knelt down and called on God as a witness to their happiness.

God who is merciful must have allowed him to forget that evening when he took my hand, and the words that he said to me, and the starlight, and that stormy night when he came to

say goodbye to me, and his knock at the window, and my coughing fit . . .

I, too, have forgotten . . . I want to forget . . .

It's all over now . . . everything . . .

You see, Marianna, that I'm resigned, that God has taken pity on me! Tomorrow I'll be preparing myself for this great step with spiritual exercises. I shan't write to you; I shan't see anybody ever again, not even my father. This is a torment to me.

Could that happy couple, in the tumult of their happiness, have spared a few moments' thought for this poor woman, dying here, alone and forsaken?

Come to the ceremony. It'll be on Sunday, 6 April – another Sunday, as you see . . . only this will be a sad one! Will you come? I'll expect you. Goodbye (don't you think this is a very gloomy word?).

I'm writing a hurried note to remind you that I'm expecting you, that I have need of you, all of you, that I have need of strength and courage.

They brought me my veil, flowers and new gown – it's a lovely bridal gown. The final preparations are being made. Tomorrow's the day . . .

You should see what unusual activity there is, what excitement and jubilation! It's a festive occasion for all these poor recluses. This vast sepulchre only comes to life when it opens up for another victim.

It's a lovely April day. The weather has been bad until today, but now there's brilliant sunshine. I went out on the terrace for a last breath of life.

I saw so many things from up there, Marianna – the fields, the sea, that huge mass of buildings, and Etna, far away in the distance . . . And all these things seemed to have an air of sadness about them . . .

I'd like to have seen Monte Ilice one last time, and our little house, and that lovely chestnut grove . . . I couldn't, nor shall I ever see them again . . . I feel a pang, here, in my heart!

A hubbub from the road reaches the belvedere – the sound of carts and carriages, of voices, of people working, to-ing and fro-ing . . . All these people going about their business have their joys and sorrows, they work, and live . . . And these birds fly far away from here . . .

Tomorrow, in a few hours' time, between me and all this life around me will rise an insurmountable wall, an abyss, a word, a vow . . .

How shall I get through this coming night? If only I had you here with me, at least . . .

I'm scared!

God, sustain me!

My sister! Have you ever heard the dead speak from the grave?

I'm dead! Your poor Maria is dead. They laid me out on the bier and covered me with a funeral shroud, they recited the requiem, and the bells tolled . . . It's as though something funereal were weighing on my spirit and my limbs were inert. Between me and the world – nature, life – there's something heavier than a tombstone, more silent than the grave.

It's a terrifying spectacle – that of Death amid the exuberance of life and the tumult of the passions, that of the soul seen by the body to expire, of matter surviving spirit.

I open my eyes as though in a trance. I gaze out into infinity, amid this darkness, and silence, this still calm . . . Everything is infinitely distant. I see you as in a dream, beyond the confines of reality. Is it you that has vanished into the void, or I that have strayed into nothingness?

I'm still in a daze. I feel as though I were wandering about in a vast tomb, as though all this were a dream . . . that it couldn't last for ever, and I was bound to wake up. I witnessed a solemn spectacle, but it didn't seem to be for me . . . I felt that I, like everyone else, was attending a funeral, a lugubrious religious ceremony, but that when the music fell silent and all the bells stopped ringing, when the candles were extinguished and the priests filed out to the sacristy, when all those people got up to leave, I, too, would leave and not have to remain alone here . . . where I feel scared . . . I saw all that funereal, heart-wringing ceremonial – and was I at the centre of it all? Was I the one that was dying? Those people in their Sunday best, that music and bell-ringing, those lights – were they all for me? And could I possibly have consented to die? Could I have been willing to die?

They dressed me as a bride, with a veil, a crown, and flowers. They told me I was beautiful. God forgive me, but I was pleased, only because he would have seen me like that!

They led me up to the grille. You saw me. I couldn't see anybody – I saw a cloud of incense, a blurred throng, and many candles burning, and I heard the organ playing. Then they closed the curtain, stripped me of that lovely gown, removed the veil and flowers, and clothed me in a habit, without my having any awareness of what was happening. I couldn't see or hear anything . . . I let them do as they pleased, but I was trembling so much that my teeth were chattering. I thought of my sister's lovely wedding dress, of the ceremony she would have taken part in without experiencing the dismay that then overwhelmed me. The curtain was drawn back again. All the people were still there, watching, listening, with an avid curiosity that chilled me with inexplicable terror. They loosened my hair and I felt it come right down over my hands, which I kept joined together. They gathered it all up in a fistful . . . then came a rasp of steel . . . I thought I'd been seized with a shiver of fever, but it was the touch of coolness on my neck from that cold implement in my hair. Otherwise, I had only a confused idea of what was happening. I saw my father, crying. Why was he crying? I saw my mother, Giuditta, and Gigi . . . At Giuditta's side there was another person looking very pale, and watching me with staring eyes. At that moment the rasp of those cold scissors seemed to drown the priests' chanting, the organ music, and my father's sobs. My hair fell all around me in heaps of curls, in whole tresses . . . and tears fell from my eyes. Then the organ became mournful, and it sounded to me as though the bells were lamenting. They laid me on the bier, and covered me with a funeral pall. All those black figures gathered round me; pale and as impassive as ghosts, they watched me, chanting, with candles in their hands. The curtain closed. From the church came the shuffling of all those people leaving. Everyone was abandoning me, even my father. The ghosts hugged me, and kissed me. They had cold lips and they smiled without making a sound.

All this meant that I was dying! And how was it that it took only this to quieten all the passions seething in my breast? To stifle them? How could that ceremony – the candles, the bier, the scissors – have had the power to leave me devoid of

feeling, and my senses dulled. How had they got me to bury myself alive, and give up all God's blessings – air, light, freedom, and love?

And still I'm sinning! Still! Even after I'm dead! But my sin will die, too. Here, where my heart used to be, there's nothing now. These are the last throes of life, the struggle of a spirit that doesn't want to die. I think, I groan, I'm troubled and distressed, but it won't be for long. I spent the whole night unable to sleep, or dream, or think. What have they done to me? What have they done? That's what I ask myself in terror. All night, that face is always there, above the curtain . . . his face . . . that watched me, pale and silent, with staring eyes, while the scissors rasped incessantly in my hair. I haven't the strength to cry any more: I'm overwhelmed with emptiness.

No, it's not true! The strange mystery that has taken place hasn't brought me any closer to God. It's left me in the dark, in the void; it's annihilated me. I don't know what's inside me any more: there's a silence that terrifies me.

15 May

I'm writing to you from my bed. I'm very ill. My dear Marianna, if you could only see how the fever has devoured my flesh. I look at my poor pale and trembling hands, and they're so thin that I think I can see the blood flowing through my veins. I have a hot, burning sensation here in my chest.

Today I'm feeling a little better, and I'm strong enough to write to you. I wish I could chat to you and think of those happy days that were full of life and joy, but everything around me is so dismal that even if I close my eyes and dream of the past, I don't have the heart to smile. I've been very poorly, but the Lord hasn't forsaken me. They've transferred me to the sick-room, which was a great blow. At least in my little cell I had lots of memories that, although painful, I nevertheless cherished; but here, everything seems so gloomy, as if every sick nun had left behind the spectre of her suffering. Who knows how many nuns have died here? Perhaps in this very bed! And as these thoughts occur to me, during the long, sleepless nights when I'm racked with fever, I'm seized with an uncontrollable shudder, and I see ghosts shrouded in black veils creeping quietly along the walls, causing the dim light of the lamp in the corridor to waver . . . and I feel scared and hide my head under the sheets. I cry from morning until evening, remembering that dear little room at Monte Ilice with its friendly walls that knew me, where I was with my family, with that lovely sunshine and fresh air, and those beloved faces . . . And when my heart has more need of comfort and affection, all I see around me are the faces of the nursing sisters, grown impassive through familiarity with the sight of suffering. And the light that comes through the window is pale, wan, and sickly. Joyful spring has visited the earth without sending a single one of its festive colours to this forsaken corner of pain and misery.

Yesterday a little white butterfly came flitting by and settled on the window-pane. You, who've been blessed by God, and are able to see the sun and fill your lungs with deep breaths of fresh air, can't conceive of the sense of tenderness a butterfly's visit, or the scent of a flower can bring to the heart of a sick nun! It's as though the whole joyful panoply of spring – the perfumed breeze, the greenness of the meadows, the skylark's early-morning song – were gathered round that butterfly and had come to cheer the sad home of all these desolate women. Alas, having rested for a moment on that sorry little flower growing out of a crack in the window-sill, the butterfly flew off, fluttering its wings, and disappeared into the blue. It was free, and happy, and perhaps had seen all these pale faces and all these tears!

In two or three days, I hope to be able to get up for an hour or two. I'll force myself, as long as they let me return to my little cell . . . as long as they let me out of here . . .

Who knows when I'll be able to see you again? I feel so drained of strength that it seems to me that I may never get out of this bed again.

I've come back to this letter two or three times, and yet you couldn't possibly imagine how much effort it's cost me to write it . . . However, it's been a great comfort . . . the only comfort left to me. I wish I could keep on chatting to you, because in the meantime I stop thinking about my suffering, about being here . . . and lots of other horrible things besides. But now I'm exhausted. I've written a long letter, haven't I – a very long letter for a poor sick person like me! You'll have some difficulty in deciphering my writing because my hand's unsteady, but you love me, so you'll be able to tell what I've written . . . and what I haven't written.

I should thank God even for this illness. It's somewhat stupefying. I feel as though I'm dreaming, and I still don't fully understand what's happened to me . . . When I wake up, God will give me strength . . .

Goodbye.

Why have you all abandoned me, Marianna? Even my father! Even you! Here I am, all alone, suffering, in this huge corridor, where there's not a ray of sunshine, and no loving faces. I'm in a state that would wring compassion from a stone. I'm going to die, Marianna. Your poor friend will die here and never see you, or her father, again.

I thought I was getting better; I'd hoped to be leaving this dreadful sick-room. I've got worse, and no one's hiding from me the seriousness of my condition.

If I were to die here, alone!

The nights are terrible, Marianna! Those long hours that never end! That flickering light, that crucifix, those gloomy pictures, those stifled groans, that snoring from the nursing sisters asleep in the armchairs. I have a raging thirst and daren't disturb the sisters, who grumble, poor things, when they keep being wakened. Last night I tried to drag myself over to the little table to quench the burning dryness inside me. I felt as if I were going mad with thirst. But I'd no sooner got out of bed than I fell to the ground in a faint, and cut my head badly. I was found in a pool of blood . . .

Dawn comes, pale, sad, and unsmiling. Night falls, full of fears and shadows. I think of my father, my little family, of all those things that would allay even these present sufferings, and I cry and cry, and my chest feels sore.

My God! If I were to die here? If I were to die . . . without seeing my father?

It must be a terrible moment, Marianna! I'm frightened at the thought of being alone, with no one to comfort me . . . If I could only see my father, at least! Don't you think it's barbarous not to let us see those dearest to us at least one last time at that solemn moment? The only comfort I have is that of writing to them, as I write to you. But when I can't write any

more – what then? If my papa had any knowledge of even a fraction of what I'm suffering!

It costs me so much effort to write to you. In those rare moments when I feel a little revived, I force myself to write two or three lines: it makes me feel that I have a hold on life again – and I assure you that I cling to it desperately. But my hand shakes so much that I can't even read what I've written, and I'm so feeble-headed I don't know what my mind is telling me. I have to come back to the letter ten times to write ten lines.

That charitable soul Filomena comes to see me every day and brings me your news. God bless her for the comfort she gives to this poor sick woman! I can't tell you how precious to my desolate heart is the smallest favour, or the least sign of sympathy . . . I've such great need of being loved . . . and loving intensely, since life is slipping away from me!

O Marianna! Tomorrow they're going to give me the Last Rites! Is my condition so serious, then?

Yet I don't feel as if I'm about to die . . .

O God, thy will be done!

Outside the window the sun's still shining, and you can hear the sound of all those people moving about, living . . . a sunbeam coming through the window has settled on my bed . . .

What a world there is in a ray of sunshine! Everything it sees and casts its light on at any moment . . . countless joys, and sorrows, and people who love each other . . . and him!

Under the eaves there's a swallow's nest – the sun shines for them, too . . .

O God!

Yet how can I die without seeing my father? May I never see him again? O God! I'm resigned to dying, but I wish I could see my father one last time . . . Poor papa, who doesn't know that I'm dying . . . Why haven't they told him? Why haven't they sent for him? There's no telling how much he'll grieve for me!

To think of dying – of dying so young . . . I'm not yet twenty!

O God!

When will I die? If I could at least die quickly! This spiritual torment is so painful!

I've made my confession. How terrifying, Marianna, how terrifying!

While everything going on around me was speaking to me of the next life, I was still thinking of him! And with all the nuns kneeling around me, reciting litanies, his name was on my lips!

What a gloomy ceremony, with those candles, that bell, that canopy, that chanting!

Goodbye to all those I love, to my father, Marianna, my sister, Gigi . . . and to you . . . goodbye.

O Marianna, tell him that I was thinking of him even at this moment!

O Marianna! Marianna! Thank the Lord! I'm not dead . . . I may well live . . . God will show me His mercy, and let me see my dear ones again . . .

They've told me that even this hope is a sin, and that we must resign ourselves to the will of God . . . Lord, forgive me for this desire, but my heart is weak and feeble . . .

O God is merciful! I shan't die! The doctor says that I'm getting better . . .

I'm going to live, Marianna, I'm going to live! God's letting me live! I'm so weak . . . I pray . . . I bless the Lord . . . and when I see that sunbeam glistening on the window-pane I cry with tenderness, and my crying does me good.

O my dear Marianna!

13 June

What a joy it will be to see that good old man again, and all my nearest and dearest! What tears! What consolation!

They won't let me tire myself, so I shan't write a long letter – and anyway, I wouldn't have the strength. If you only saw how wasted away your poor Maria is!

They tell me to keep calm, but they can't prevent my mind from racing away, and thinking of all those things make me cry with joy . . . of the day when I'll go down to the parlour and see you all . . . and my poor heart is filled with gladness.

But then you'll go away and leave me again – here, alone!

Praise be to God! At last I've seen my papa! You know how much I had to beg the doctor and the abbess to grant me this favour. Yesterday the doctor finally allowed me to leave the sick-room.

The weather was fine, and I could feel my poor, very unhealthy chest swell to breathe in the invigorating, morning air. Filomena lent me her arm to cross the garden. The sun was shining brightly and there were flowers . . . I'd been so cold in those dismal big rooms that were practically dark! The leaves barely rustled because the breeze can't get into this enclosure, with such high walls all around. The gravel on the paths crunched under our feet, and two or three butterflies flitted from flower to flower . . . It didn't amount to a great deal, admittedly, but you don't know how much this very little means to a poor recluse! Up above, at one of the dormitory windows, a canary sang sweetly . . . it's true that it was in a cage, poor thing, and that had we been able to understand it we might have realized that it was grieving . . . Yet all these insignificant things that cannot be put into words, that for most people pass unnoticed, constitute a wealth of joys for anyone who has nothing but the memory of fields, woods, life . . . and they gladden the heart, if not the mind.

If you closed your eyes in that walled enclosure, you might forget that you were in the convent and imagine yourself to be surrounded by cheerful countryside, full of light and fresh air . . . and to be free. Then the sight of such high walls and windows all covered with grilles sends an involuntary shudder through your heart.

You see what I'm like! To think that this corner of land, a patch of sky, a vase of flowers could have sufficed to give me all the happiness on earth, if I hadn't experienced freedom and felt in my heart the gnawing fever of all the joys that lie outside these walls. And to think that if I fall ill again, if they

put me back in that sick-room, I'll be deprived even of this garden, these little flowers, and this sun that doesn't come to visit the poor nuns who are ill because even its rays would be saddened . . .

O Marianna! What a thrill it gave me to see my beloved papa waiting for me in the parlour! And to put my trembling hands to the grille! I couldn't tell you whether it was a thrill of pleasure or pain. The good old man couldn't hold back his tears, to see how pale and wasted I am. Gigi cried as well, and so did Giuditta, and I with my weak heart, who am so feeble and give way to tears over nothing, burst into sobs that brought relief to me. I wanted to throw myself into his arms, but there was that hard, cold grille between us, between father and daughter who were seeing each other after being on the point of never doing so again . . . I'd never fully understood until then, all that's hateful about life in an enclosed order.

When we had given vent to our tears, my father questioned me in great detail about my illness. He tried to smile, and comfort me, and every so often sobs would choke his voice, while tears fell on his grey beard and he didn't notice . . . It broke my heart! Yet it was supposed to be a joyful occasion, wasn't it? Giuditta was there, looking so pale! She was also crying. I gazed at her closely, as though I could see in her something new, and indefinable. I wanted to sob or cry out aloud in her arms, and her affection made my heart ache. I gazed at her and my eyes filled with tears, and through my tears I could see another very pale face, beside hers, that temptation conjured up before me . . .

O Marianna! This weakness comes from my long illness. These hallucinations are the work of the devil. O God, help me!

And in those moments that should have been sacred, coming between me and those dearest to me was the nun who accompanied me, an outsider indifferent to this joy, this sorrow, these tears . . . Don't you think even tears have their own modesty? There was also my stepmother who wouldn't allow us the blessed relief of tears, on the grounds that crying was

bad for me. Among all these cold, hard, unforgiving things, the iron grating was the least hostile.

How quickly those two hours that I was allowed to stay in the parlour flashed past! Eventually all those people that I cherish, who are a part of me, had to leave. My eyes followed them to the door, but when they were about to cross the threshold my heart failed me, I felt as though I were going out of my mind. I called out loud to my father, almost beside myself, as if I were never going to see him again. I wanted an excuse to keep him for a few minutes longer, but I didn't know what to say, and I burst into tears. We all cried and no one could find a single word to say. My papa promised to return the next day. Then he really did leave, and I felt the sound of the door closing reverberate in my heart. I gripped the iron grille convulsively, and kept my eyes fixed on that closed door . . . My God, those were the worst moments! The nuns helped me back to my cell, and only when I was alone, with no one to see me, could I go down on my knees and give way to sobs.

Now I'm calmer. I've thanked the Lord for allowing me to see my papa again. I've asked His forgiveness for this grief, which is an offence, because I'd already accepted this life of privation and sorrow, I'd vowed to dedicate myself entirely to Him . . . and the world still binds me with its most tenacious ties.

Merciful God, am I to blame if I haven't the strength to break these ties?

My dear Marianna, won't you come to visit this poor invalid one of these days? Come, please, do. I so badly need to see you!

I wonder what you'll think of me – a nun who moans and complains, and writes to you in secret? When I stoop to examining myself, I find myself so culpable, so abject, that I don't understand how you can still favour me with your friendship . . . My sin is monstrous, admittedly; yet I feel there's something more culpable than I am for my misfortune . . . and for this reason, God will forgive me. There are times when, if I didn't write to you, all the pain inside me would scream out of every pore . . .

Do you know, Marianna, the same temptation still possesses me? I have the same serpent still lurking here, in my heart! When I talk to you about anything else and try to hide it from you, from myself, then it bites me even more sharply, piercing me with its poisonous fangs. I'm afraid of being damned. I struggle against the Devil and he tightens his grip on me . . . I'm in his possession, do you understand? He possesses me! Now that I'm weakened by my illness, I haven't the strength to fight any more. I don't want to die, because I'm afraid of hell . . . because I love my sin!

Forgive me, my dearest sister! Even I'm appalled by what I write, by what I think . . . I can't pray to God any more because I daren't raise my eyes to Him . . .

My God, what have I done? What ever have I done?

I still love him! More than ever! Insanely! And I'm a nun, and he's married – to my sister! It's horrible, monstrous! I'm damned to perdition! But what fault is it of mine? How can I have earned such harsh punishment? Now that I'm buried alive, this love has grown into a fury, a raging frenzy! I no longer recall those moments of bliss, I no longer feel those timorous joys . . . Here, in my mind, in my heart, before my eyes, there's always a fearsome figure that makes me burn with anguish and passion . . . I hear a voice calling me from the world of the living . . . Listen . . . Maria! Maria! The name I

had when I was alive . . . Now Maria is dead . . . and quaking all over, in a cold sweat from the terror in her limbs, because she feels the hand of the devil dragging her by the hair into the abyss . . .

Seeing all these virgins, so pure and innocent, as they kneel and pray, and feeling that I'm the only guilty one among them, having to hide my remorse, when it increasingly torments me, and with the most comforting religious practices turned into yet another sin for a poor fallen woman! And being forced to deceive God . . . Oh!

Every Sunday I go and kneel in the confessional-box, but alas, I haven't the strength to admit to this terrible transgression . . . I even invent sins I haven't committed, as though to compensate for what I never dare say, what I jealously hide in my heart, as a she-wolf hides her young in a cave.

I think I must be mad, Marianna . . . I'd like to tear my hair out, and rip open my chest with my fingernails. I'd like to howl like a wild beast, and shake these grilles that imprison my body, torture my spirit, and provoke my nervousness . . .

What if I really were to go mad? I'm scared . . . so scared . . . A shudder runs through every fibre of my being, and the blood turns to ice in my veins.

I'm scared of that poor Sister Agata who's been locked up in the lunatics' cell for fifteen years. Do you remember that ghastly, thin, pale face, those wild, dull-witted eyes, those bony hands with long fingernails, those bare arms and that white hair? She's never stops prowling round, in the confined space of her tiny room. She clutches the iron bars and appears at the grille like some wild beast, half-naked, howling and snarling! And do you remember, there's a frightful convent tradition by which that cell is never left empty, and when one poor lunatic dies there's always some other miserable wretch to be locked inside? Marianna, I'm scared that I'm to succeed Sister Agata when God takes pity on her and calls her to Him.

I'm feverish. I shall die young. O God, don't punish me so harshly! I'm scared, I'm scared of that white hair, those eyes, that pallor, that grimace, those hands that clutch at the bars of the grille . . . What if I were to become like that! Oh, no! no!

It's night, and all is silence. The window's open. I heard a shopkeeper arguing with his wife, and in the end he beat her! Lucky, lucky woman! Then came the footsteps of someone out late: someone with a home, a family, and cherished possessions . . . Why do I think of these things that make me cry? Why am I sickly and weak-minded? Why am I at fault? Oh, I'd forgotten about my fault!

Now, let me tell you how terrible my transgression is: how it recurs in every guise. On Sunday I was in the chancel, attending mass. I felt such peace, calmness and serenity in my heart. It seemed to me that at last God had taken pity on me and forgiven me. I prayed, with my eyes fixed on a man standing below, in the church, leaning against a pillar. He was of the same build, with the same black hair and a certain similarity of bearing. I'd have sacrificed what little hope of life was left to me, if he had only looked up at the chancel. I watched, and at times I thought it was definitely him . . . and then the blood would start rushing round my head. When mass was over, he turned to go, and I prayed to the Virgin that he would look up at her statue, which is by the chancel, so that I could see his face, but he left, and I couldn't be sure it was him. I remained there, for I don't know how long, as if turned to stone, staring at the pillar that a man who might have been a complete stranger had been leaning against.

I want to see him! I want to see him! Just once! Just for one moment! O God, would it be such a great sin to see him? Only to see him . . . from afar . . . through the grille! He won't see me. He won't know that behind the grille there's a woman here dying, damned to everlasting punishment for his sake . . .

Why did they take him away from me? Why did they steal my Nino from me? My heart, my love, my share of paradise . . . Murderers, who killed my body, and are still torturing my soul!

Oh, how I love him! How I love him! I'm a nun . . . I know! Who cares! I love him! He's my sister's husband, and I love him! It's a sin, a monstrous crime . . . I love him, I love him!

I want to see him! I want to see him! If only for the last time! I'll wait for him at the window of the bell-tower over-looking the street. I'll wait there every day . . . he's bound to pass by . . . once, just once . . . God will send him this way . . .

God – O Marianna, how that word terrifies me! I'm raving, you can tell . . . I'm beside myself . . . I don't know what's wrong with me . . . it must be fever . . . or nerves . . . I must be mad . . .

I saw him, Marianna! I saw him! I suffered this additional agony! Praise be to God!

He went by with some of his friends, but he didn't even look up. Perhaps he didn't remember that his poor Maria from Monte Ilice was in this convent . . . a pale, dying Maria, who cries, and shivers with fever, and keeps him always in her heart . . . The sparkle in my eyes didn't dazzle him! He talked and laughed, with a cigar in his mouth, and the smoke rose to my window . . . I saw him, yes, yes, him, his face, clothes, movements, and I was scared of that smiling man, smoking and talking to his friends . . . Isn't that horrible, and monstrous?

Then he disappeared. He turned the corner into another street and I lost sight of him.

All those people continued to stroll and chat and enjoy themselves, and didn't notice that he wasn't there any more. Where was he? Where did he go? Home? To my sister . . . to his wife!

If only I were a tiger, or a demon! I'd tear my flesh to pieces, poison the air with my desperation, blot out the sun with my sorrow.

Damn! Damn me, him, everybody!

O God, God, what do you want of me?

Marianna, I ask your forgiveness, and the forgiveness of everyone I might have scandalized with my sins, just as I've asked forgiveness of merciful God . . . What must you have thought of me – of this abject sinner who spends her life weeping and praying at the foot of the Cross in order to purge her transgressions?

We had a special series of spiritual exercises. A very renowned preacher was called in, and speaking through him, God's voice thundered in the semi-darkness of the church with its black-curtained windows. How dreadful the word of the Lord is! No, it was my sins, my guilty conscience, and my remorse that made it frightening. For my heart tells me that the word of God cannot but resonate with infinite love and mercy.

How upset I was by those sermons! They instilled me with fear and terror. God seemed cruel. I saw the blast of His divine anger strike from above the altar, I heard a snarling of demons that was lost in the dome, and I saw the black wings of bats etched against the shadows of the vaulting. God spoke of hell, and of the damned . . . and all night long I thought I heard the lamentations of the souls in torment, weeping and wailing in the next world . . . And I was filled with dread, of myself and my sin.

Now I feel completely deranged . . . my heart tries in vain to take refuge in the thought of divine mercy . . . My sin is monstrous. Can I ever be forgiven? The preacher wasn't clear about that – he listed every transgression, threatening divine retribution against all the most wicked sins, but he dared not even include mine among them. His mind must have shunned the enormity of it!

Good God, what's become of me? Perhaps I've even forfeited the right to invoke you! A depraved sinner, condemned to suffer your anger, can I still listen to your word? Can I still

prostrate myself at your feet among these virgins that are your chosen?

Marianna, it's dreadful to be abandoned even by the Lord! Yet there are times when temptation tells me that I'm innocent, that I'm blameless of my sin, that God might forgive me . . . Why am I lost? What have I done?

It's the devil that suggests these doubts to me, and it's the devil that possesses me!

I consider myself damned. I'm filled with fear and loathing of myself, with remorse and terror. Yet I still love my God, and I wish I could unburden my soul of its immense anguish at the foot of the crucifix. But I can't, I can't . . . I'm damned!

The nights! If you only knew what the nights were like – when the light burns out, and the shadows waver, and the furniture creaks, and the silence is full of whisperings and indistinct sounds. They're nights of deep terror, of sepulchral mysteries, the snarling of demons, the howls of the damned, an unholy rustling of wings. Everything's so gloomy – that long, dark and silent corridor, the dead lying beneath our feet, that church, those lamps and pictures – grotesque figures appear on the walls, and above my bed, at the foot of the crucifix, there's a shapeless skull . . . there's the fear of the air you breathe, of a silence that conceals sinister noises, of the space around you, of the weight of the blankets on your body . . . I daren't cry out because I'm afraid of awakening terrible echoes, of feeling a thousand horrible shapes settling on my flesh. Sleep is troubled, fraught with nightmares. I often wake with a cry, bathed in a cold sweat and tears.

Why was that sermon so frightening? Why is the word of God so terrible?

O Lord, have mercy even on this wretched sinner, have mercy even on this lost soul!

Thank you, Lord, thank you! I feel reborn. I feel purified by your forgiveness. I cried and prayed so hard that my wretchedness aroused your compassion. Now I'm calm and resigned. I don't want to think any more, I don't want to be alone. Thinking is our downfall, our temptation. I shan't write to you again, Marianna, because writing to you means remembering, and I don't want to remember you, or my father, or anybody! Forgive me, my loved ones . . . The heart is a great danger: if we could rip out our hearts, we'd be nearer to God!

O, the Lord will give me strength . . .

If I were to die right now, I think the angels would smile on me . . . but, no, Marianna, even this desire is a sin: we must remain here in this world for as long as God wills. My soul, which is craven and weak, has so little desire to remain here that it sees with a wrongful sense of joy how rapidly my illness progresses from day to day.

My poor Marianna, you should see me now! I've become a skeleton. You should see my hands, face and eyes! My poor chest is entirely consumed with a burning fever. You should hear me cough. If only you could be with me when the pain of my illness exceeds my courage.

It's better that you don't see me again, Marianna, that no one should ever see me again! I have what I might call the shame of the sick. In his providential blindness, my papa always finds countless reasons for deluding himself and not noticing the state that I'm in.

O God, I belong to you, just as I am, with my failings and weaknesses, with my faults and my guilt, and with my immense love for you. Have pity on me, God, have pity on me! Let me not think! That's my only prayer, that I might live and die in acceptance of no other thought but of You.

O my God, why have you forsaken me?

There's no word for what I feel! To have such a sense of guilt, to be so fearful of your own sin, and unable to break away from it . . .

That sermon! Still, that terrible voice is in my ears! The horror of it! I see hell gaping before me. I feel lost, like Satan, in the abyss of God's abandonment . . . and I love Nino just the same! I'm afraid of demons, and I think of him! I dare to raise my supplicant eyes to the altar, and I think of him! My mind is full of spectres and flames and dreadful faces . . . and I smile and yearn for him – the embodiment of sin, temptation and the devil!

Let me tell you what happened, Marianna! I was on the terrace, sitting by that little chapel that we used to decorate with garlands of flowers. It was just after sunrise. You could hear the many sounds of the streets, and the birds singing. The sky was blue, and the sea sparkling bright, and a fragrant breeze filled my poor ailing lungs . . . And I mused and mused . . .

You see how the tempting devil, called thought, treacherously sneaks inside us through every pore and mercilessly penetrates our minds! I contemplated the little flower with its trembling dew-drops, the smoke rising from the chimneys, the sails of a ship disappearing into the brightness of the sea, the singing that floated up from the street. Was I dreaming? I don't know. Two butterflies followed each other from flower to flower – one had wings of gold, the other's were all white. With a touch of mischievousness, the one with snow-white wings hid inside a pretty flower, even whiter than itself, and its poor companion searched for it, fluttering its little golden wings in distress. How timidly those butterflies approached the petals of that lovely bloom! Then the other one peered into the heart of the flower, and may have smiled, and then hid

in there as well. What did they say to each other? What were they fighting over? What was going on inside their tiny minds? How much happiness was enclosed within that little flowerhead? A small bird cheeped on the ridge of the chapel roof, and beat its wings so rapidly that in the dawn sunlight its feathers looked as if they were made of golden straw. 'Come, come!' it said, and it seemed to be crying. Who can tell? Perhaps it really was crying. Who was it waiting for? Who was it calling? Then it took off, swift and straight and sure in its flight. Where was it hurrying? It was free, and away it flew! By a large crack in the wall, a lizard basked in the sun. You should have seen how happy that little creature was! How its little sides panted, and its tiny head moved, and its eyelets shone! Perhaps it was blessing that ray of sunshine, which it, too, was enjoying, and that dew-drop which the petal let fall. Who has ever considered all the joys around us? The happiness that exists in the worm that crawls on the ground, and within the invisible atom? Then came the sound of a carriage: the horses had harness-bells – you know how cheerful harness-bells sound, how reminiscent they are of the countryside, of green meadows and dusty roads, of flowering hedgerows and larks that dart in front of the horses . . . Then the screech of a pulley could be heard, and the bright, fresh voice of a woman singing one of those nonsensical, popular songs that are deeply moving – it was a serving-girl, drawing water from a well. Why was she so happy? What was she thinking of? Her native village? Sunday mass? The small square in front of the church, crowded with young people dressed in their best clothes? The familiar voice that used to come and sing that old song outside her door?

All these things spoke, and what they said was, 'Nino! Nino!' I looked round in search of him, and I saw him! I saw him at the window of a nearby house. It was him, it really was – with a pipe in his mouth and his elbows resting on the window-sill. He was taking in all the joyfulness of a beautiful morning. Oh, my poor heart! I seemed to remember once being told that my sister had moved to a house near the convent, but God had spared me from thinking about it . . . Now

there he was before me . . . Why? O God, why? What was he doing? What was he thinking? Could he see me? No, no! His eyes were distracted . . . yet he should have been able to see me, in my black habit and white veil, with my arms outstretched . . . What was in that man's heart? Oh, the tears I shed! O Lord, let me see him on his own, and I shall be for ever grateful! O my God, let me not see my sister, let me not see her!

Nino! It's me, over here! Can't you see me? Don't you remember? What's the matter? What have I done wrong? Oh, my head! Nino! Look at me! See how pale I am! Hear how laboured my breathing is! O Nino, please, look at me!

He turned round. I saw a figure behind him . . . a dress . . . I fled because I was losing my mind! God, what agony! I went and retired to my cell, like some wounded beast going to earth . . . Oh, what burning pain! My head! My poor head!

It was such a dreadful day, with that figure continually before me, and my heart pierced with anguish the whole time.

I'm almost insane. I feel something clutching my flesh and dragging me back up to the terrace . . . to see that man, the mere thought of whom breaks my heart . . . I wish I could spend all my days there, and die of sorrow with my eyes fixed on that window. I tried to think of God, and God seemed cruel. I tried to think of that sermon, and it seemed to me unjust. All the furies of hell are tormenting my heart . . . Listen, Marianna, listen to this lost soul – because I want to be lost, I want to be damned! At night when everyone was asleep, I went up on to the terrace, in bare feet, squeezing my chest so that the nuns wouldn't hear the beating of my scared and cowardly heart, and stealing through the shadows like a ghost. It took me half an hour to get there – half an hour of terror, and anxiety, and inward strife, taking fright at the slightest sound, holding my breath at every door, collapsing in exhaustion on every stair . . . If he could have seen me! Then when I got up there, and I saw the stars above my head, and that lighted window, not even I could tell you what happened inside me . . . Listen! I'll tell you what I saw, and you'll suffer as I did . . . I wish for all those I love to suffer . . . Eleven

o'clock was striking. The chimes had a sharpness of vibration that stabbed like a knife. The streets were still crowded . . . there were people strolling and laughing – you could even hear what those that were closest were saying. You could see that lighted window in the darkness, staring at me with its wide-open eye. I had often spent the evening lost in reverie, gazing at some distant light shining in some far-off room, trying to imagine all the care and affection, all the little troubles that to my poor mind seem another joy of family life, and the conversation, and the talk probably going on round that solitary light. But this window had a fiery reflection. I couldn't look at it without feeling a heat rushing through all my veins. It was him! It was him! It was his house, occupying his life and his affections, in all peaceful serenity, with all the blessings of the family. The room was wall-papered in a pattern of big, blue flowers; by the window was an armchair, and further back, on a little table, were numerous objects that I couldn't distinguish, but some of which gleamed in the candlelight. Imagine the tabernacle – I can think of no other way to describe it . . . Each of those objects had the imprint of his hand on it, and he had sat in that armchair a hundred times. Why was the room empty? It seemed to be afraid, and it also frightened me . . . Then a door opened and a woman came in. My sister! How beautiful she looked! She was able to touch every one of those objects and to sit in that chair. She came to the window, blocking out the light – cruel, cruel woman! – and she leaned on the window-sill. She seemed to be looking at me. I was scared of that face turned towards me that remained in shadow. I hid behind the chapel. How I trembled! How my heart pounded! After a while she suddenly drew back and went to open the door by which she'd entered. It was him! He took her hand and kissed it. God! O God, let me die! Even if I'm damned!

You can have no idea what frenzy, what furious delight there is in inflicting atrocious torture on yourself . . . punishing yourself because you can't punish others. I watched that man kiss that woman . . . the man, Nino, and she, my sister! I watched them sitting together, talking and holding hands,

exchanging smiles and taking turns to steal kisses from each other. I knew all the sweet things they were saying to each other, and by a miracle of intuition I saw the smallest movement of his face, and the expression in his eyes. No one could have seen what I saw. My dry eyes opened wide; my heart stopped beating; and there was a whiff of the devil inside me . . . And this spectacle lasted nearly an hour! An hour out there, with bare feet, burning with fever, shuddering with horror, filling my lungs with anguish and fury. In order to see him, I inflicted that terrible joy on myself, a joy with the fiery edge of anguish . . . and I returned there every evening, despite the risk, the fever and delirium . . . I saw him! What does it matter how? I saw him! I spent days out on the terrace, with a blazing sun beating down on my bare head, my mind dazed, befuddled, and dizzy, my eyes smarting, and my body on fire with fever, for nothing more than to see him, just for a moment, passing from one room to another!

Ah, if sorrow could kill!

God, let me die! Let me die!

For pity's sake! Have mercy! I can't take any more.

I'm ill, Marianna. The fever's in my brain, and my head's burning. From my little cell I can hear the screams of poor Sister Agata. I feel like screaming, too, and scratching the plaster off the walls with my fingernails, as she does.

Why have they shut me up in here? What have I done? Why these grilles, veils, and bolts? Why these lugubrious prayers, dim lights, and pale, frightening faces? Why this darkness and silence? What have I done? My God, what have I done?

I want to leave, I want to get out of here! I don't want to stay any more! I want to escape . . . Help me, Marianna, help me! I'm scared. I'm frantic. I want light. I want to run free!

Marianna, why are you abandoning me as well? Tell my father to come and fetch me out of this tomb. Tell him that I'm dying, that I'm being murdered. Tell him I shall smash my head against these walls. Tell him I'll be good, that I'll love everybody; I'll be the servant of the house, I'll be content with a kennel, as long as I get out of here. Tell him I haven't done anything wrong. Why is he, too, being so ruthless? Will no one take pity on me? Will no one help? Will it not occur to any of the passers-by in the street, with the grace of happiness in their hearts, that there might be some miserable wretch locked up inside here, dying in despair? Shout! Yell with me! Cry for help! Tell all who can hear you that I'm kept in here by force, that I've done no wrong. I'm innocent . . . Tell them this is a place of death . . . there's a smell of dead bodies here . . . and you can hear the screams of a madwoman . . .

The madwoman wants to escape, too, poor thing! They keep her locked up behind iron bars . . . She can't sleep, she can't die . . . She prowls that small space allowed to her, from morning to night, raging and howling . . . the poor wretch! It's frightful!

What if they were to lock me up with Sister Agata? How ghastly! How horrible! What if I were to go mad?

O Marianna, I wish I could jump out of the highest window, but they're all barred!

What torture! What agony! Even death, suicide and hell are denied to me! What have I done? What ever have I done? I swear, I'm innocent!

Listen, I shan't love him any more! I'll pluck him out of my heart . . . I'll rock his children's cradle . . . I'll go far away . . . Let them do what they will with me – anything – as long as they take me away from here.

Tell them I didn't know what they wanted of me when they made me a nun, that I didn't know I'd have to be imprisoned for ever, that I was mad, that I'll lose my soul here, that I haven't long to live, not long at all . . . So why don't they let me die in peace?

Yesterday the doctor came to see me. Why did they send for him? He kept looking at me in a strange way . . . He took my pulse. I'm all right, I feel nothing at all . . . He asked me lots of questions I didn't understand. What does this mean? What do they want of me? They're watching me. They're keeping me at a distance . . . What's happened? Are they trying to frighten me?

I told the doctor that I want to get out of here. I promised to be good, to work and do whatever was wanted of me, as long as they let me out. The kindly old man smiled and was unnervingly quick to promise me everything I asked of him.

What does this mean, Marianna, what does this mean? I'm alone. I look at myself, and I think I'm dreaming. I don't know what's happened, but it must be something dreadful . . . something really horrible!

It's because I'm frightened by Sister Agata's screams that are audible even from here, whenever the poor creature has one of her fits.

Today I spent the whole day staring at the door by which I came into this place . . . a solid black door with huge bolts, that only opens to let in victims, that you can never return through . . .

And I came in by that door! I was free outside, and I crossed that threshold on my own two feet! No one dragged me across, no one pushed me! My God, how did it happen? Was I mad? I must have been in a trance. What on earth lies on the other side of that door? What goes through the mind of any passer-by? How bright the sky must be! Nino's on the other side! Isn't he?

They wouldn't let me stay there looking at it any longer. Why not? Is that wrong as well? They took me away. I do whatever they want . . . I'm meek . . . I'm scared . . . I'm scared they'll lock me up with the madwoman . . .

Nino! Nino! Where's Nino? I want to see him! Why won't they let me see him? He's the only one I want to see. I don't want to see my father, my brother, or my sister . . .

My sister! She stole him from me! Why did she steal him? Didn't she know he was mine? Why can't I see him? Tell him to come . . . Tell him to come and free me. We'll go to Monte Ilice together . . . we'll go and hide in the chestnut grove . . . alone . . . like the creatures of the wild. Tell him to come, to come armed with his gun . . . that way, he'll frighten my goalers . . . they're women . . . they'll be scared . . . he'll kill them if necessary . . . he'll save me . . . he'll find me here in my cell . . . and I'll throw my arms round his neck! Yes, the nun!

The nun will escape . . . she'll run away with him . . . with her sister's husband . . . she'll steal him back . . . They'll go far away . . . they'll walk and walk . . . they'll go to the mountains, to the woods . . . they'll be together and they won't be afraid . . . they won't hear Sister Agata screaming . . . There'll be the stars, and the rain, and the sound of thunder, and he'll knock on the window . . . She'll cough . . . He'll say, 'Maria! Maria!'

Who's Maria? I think I knew her . . . Maria's dead, she's run away . . . Where is she?

Oh, my poor head! Listen, Marianna . . . it's night-time now . . . everyone's asleep . . . no one will see me . . . I'll creep downstairs . . . across the garden . . . it's dark . . . the gravel on the paths won't make any noise out of compassion for me . . . I'll go up to the door . . . that nasty door will say no! And I'll cry, and beg, and go down on my knees . . . I'll say that Nino's waiting for me, that I have to go to him . . . and not being a nun, the door will then take pity on me . . . and let me slip through the keyhole . . . then I'll be outside . . . where there are sunshine and fresh air, streets, and people, and him! Where you can shout, and run, and cry, and hug the people you love . . . I'll run away, I'll run away . . . because Sister

Agata clings to me if she sees me . . . and I'll go and knock at his door and say, 'Here I am!' And he'll hold out his arms to me . . . No, that's wicked, that's a sin! I'll say to Giuditta, 'I'm your sister . . . your poor sister who's suffered so much . . . they wanted to kill your poor sister, they wanted to bury her alive . . . they wanted to lock her up with Sister Agata . . . let me stay here, I'll be your servant, I shan't love him any more . . . I'll just look at him, through the keyhole, when you're asleep and don't need to look at him.' O God! I'm so happy, Marianna, I'm so happy! Thank you, God, thank you!

Help, Marianna, help! My father, help! Nino! Nino! Kill them! Kill them! Gigi! Giuditta! Help! They're laying hands on me, they're dragging me by the hair! Help! They're hitting me! Ouch, ouch, my hair . . . my arms . . . they're all bruised! There's blood! They say I'm mad! Mad! Ah, Sister Agata! Sister Agata!

What do they want? What do these people want? Why are they laying hands on me? I'm innocent . . . I haven't done anything wrong . . . I want to get away from here, I want to escape . . . there are corpses . . . and demons . . . I'm scared! God has abandoned me! Don't abandon me as well! Nino! Nino! You're brave – help me!

I've no strength left in me . . . they're dragging me off . . . they're dragging me off . . . Where to? Where to? My God!

Ah! The lunatics' cell! Sister Agata's cell! No! No! For pity's sake, I'm not mad! I'm scared! I shan't do it again . . . Here I am . . . I'll stay here, I'll be good, I'll pray . . . What do you want? What do you want? Send for my father, send for Marianna . . . they'll tell you I'm not mad! Ah, Nino! Nino! Why can't you hear me? Nino? Such yells and screams and tears! Such foaming at the mouth and bleeding! Nino! Help! Here! Help! I'll bite, I'm a wild animal! No! Please! No! Not in there! Nino!

Dear Signora Marianna,

I was asked by poor Sister Maria – God rest her soul! – to see that you received the little silver crucifix and handwritten pages that I'm sending you via our gate-keeper.

I hesitated for a long time before reaching a decision in such a delicate matter of conscience. The deceased's last wishes were certainly sacred to me, but our rule forbids us from disposing of anything whatsoever, even in the case of death, without the permission of Mother Superior. I hope that I've been enlightened by the grace of the Holy Spirit, for this is what seemed to me the best solution, to the greater benefit of God and a fellow-human being.

I resorted to an equivocation to obtain this permission, which might have been difficult to obtain otherwise. I told Mother Superior of Sister Maria's last wish, and I showed her the crucifix that the poor young girl had bequeathed on her death-bed, together with the handwritten pages, as if these were of no significance and served only as a wrapping for the small gift.

I don't know what these pages contain. However, had they been read, I doubt that permission would ever have been granted to send them to any outsider. On the other hand, if they'd ever been found inside the convent, I fear they might have given rise to scandal, very detrimental to the memory of the departed and of great harm to her soul.

Under the impression that it was a matter of little significance, Mother Superior readily granted permission, without feeling obliged to seek the chaplain's advice, and I have the satisfaction today of fulfilling my duty without incurring any blame. You, my dear lady, will receive the small package in the same state it was left in by the dear departed. There are nine pages in all, four of blue paper, two sheets of writing paper, and the last three written on the envelopes of other letters, all carefully numbered. The package is tied with a black ribbon and contains:

1. A small silver crucifix
2. A lock of hair.
3. Some rose petals.

If my poor friend had not in her dying moments shown such attachment to these two or three dried petals, I would not have taken the liberty of sending them as well, in the fear it might have seemed to you an unseemly jest on my part. But the dying girl tried to kiss them when the pains that consumed her became more agonizing, and she expired with these dead petals on her lips.

May God ease her suffering in purgatory for what the poor martyr has suffered here on earth! She died like a saint, God bless her!

On that fateful day when she was mistakenly thought to be mad, her ruined health was dealt a final blow. Jesus and Mary! What a day that was! How the poor girl suffered! She was so frail, so weak, she could hardly stand, and yet it took more than four lay sisters to drag her to the lunatics' cell! I think I can still hear those desperate, totally inhuman screams ringing in my ears, and still see her face, crazed with terror, and bathed in tears that would break your heart . . . She was unconscious when they opened the cell. They left her there, on the bare floor . . . God forgive me! I think that poor mad Sister Agata was the only one to show the poor girl any pity, because she did not venture to do her any harm. She gazed at her with those dull eyes, and lay on the floor beside her, touching and shaking her as though trying to revive her. When the doctor came, he found her still in that state. He then gave orders for her to be taken to the sick-room. When Mother Superior, in the interests of the community, expressed fears that Sister Maria might have another fit, the doctor reassured her, saying that it would only be for a little while . . . And indeed she did not long survive . . .

The poor sick girl regained consciousness in the infirmary. You can't imagine how heart-breaking it was just to see the terrified look that she gave us . . . for she couldn't move, poor soul! She had no strength left in her. She lingered on like this for three days – three days of agony. She couldn't move or

speak any more. She lay there, just as they'd placed her, with her eyes wide open, trembling the whole time, with a breathless wheeze in her throat. Not until dawn of the third day did she manage to convey to me with her eyes that she wanted her head turned towards the window, and when she saw the sky her eyes filled with tears.

Poor Sister Maria! She was no more than a skeleton. Only her eyes – those beautiful eyes! – were still alive. She told me so many things with her eyes, and the last dregs of her wretched life were fraught with pain. When I raised her head, she looked at me in such a way that I could not hold back the tears. She tried to lift her arm to throw it round my neck, but she hadn't the strength, and sighed. So I took her hand and she squeezed it – she squeezed it as though she were speaking to me.

At about ten o'clock they administered the last rites to her. She took communion with such serenity and faith that it seemed that all the saints and angels in heaven were gathered round her bed. God bless her! She remained like that all day, while litanies were recited round her. When the sun went down she seemed distressed again. She wept so freely that one of the lay sisters was moved to pity and wiped the poor girl's face – it was bathed with tears, and she couldn't see us any more. Then she moved her lips as though to call. I bent down over her. She strained to put her face close to mine, and whispered in my ear this last wish, breathing with such difficulty it was heart-breaking . . . Her wheeze was suffocating her. I guessed rather than heard what she said. I ran to fetch the package that she wanted, and seeing it in my hands, she gave an angelic smile . . . When her wheeze wasn't suffocating her, she kept saying, 'For him! For him!' She must have been delirious. She wanted me to show her everything: the pages, the hair, the crucifix, the dry petals. She kissed them, she kissed them so much that I removed one of those petals from her lips after she had died.

Then she turned her head away with a gentle sigh. She seemed to have fallen asleep . . . and it was an everlasting sleep.

Poor Sister Maria!

Yet now she's among the blessed, praying to the Lord for us wretched sinners who in our weakness mourn her death. I must add, to the credit of Mother Superior and the whole community, and to the comfort of all those who loved her in her lifetime, that her funeral was extremely moving. More than thirty masses were celebrated at every altar in the church, and there were more than a hundred candles burning at the De Profundis. Please remember me in your prayers.

I remain, respectfully, your most devoted servant,

Sister Filomena

TEMPTATION
AND OTHER STORIES

translated by
Christine Donougher

TEMPTATION

It was like this. Honest to God! There were three of them: Ambrogio, Carlo and Pigna the saddler. It was Pigna who dragged them all off to have a good time. 'Let's go to Valprio by tram.' And with no wretched women in tow! After all, they just wanted to enjoy their day off in peace.

They played bowls, strolled down to the river, treated themselves to a drink, and finally had lunch at the White Blackbird, under the vine-trellis. It was very crowded, and there was a fellow playing the accordion, and another with a guitar, and there were girls shrieking on the swing, and lovers in search of a shady nook: a real holiday. Until Pigna started fooling about with a pretty girl at the next table, with her hand in her hair and her elbow on the tablecloth. And Ambrogio, who was the peace-loving type, tugged at his jacket and whispered in his ear, 'Let's go, otherwise there'll be an argument.'

Later, in prison, when he remembered how they had met their downfall, he thought he was going out of his mind.

In order to catch the tram, towards the end of the day, they walked quite a long way. Carlo, who had been in the army, claimed to know the shortcuts and led them along a path that zigzagged across the meadows. That was their undoing!

It must have been about seven, a lovely autumn evening, with the fields still green, and not a living soul in sight. They were singing, cheerfully enjoying their country outing, young men, all of them, without a care in the world.

It might have been better if they had been penniless, or out of work, or had other problems. And Pigna kept saying they had made good use of their money that Sunday.

The conversation turned to women, and each of them spoke about his girlfriend. And even Ambrogio, suggesting there was more to him than met the eye, told them in elaborate detail what went on with Filippina when they met every evening behind the factory wall.

131

'You'll see,' he finally muttered, for his shoes were hurting, 'you'll see, Carlino's lost the way!'

Not according to Carlino. The tramway was surely over there, beyond that row of pollarded elms, it just wasn't in sight yet because of the evening mist.

'Under the bridge, under the bridge gathering fire-woooood . . .' Ambrogio sang bass, hobbling along behind.

After a while they caught up with a peasant girl with a basket over her arm, following the same path. 'What a stroke of luck!' exclaimed Pigna. 'Now we can ask for directions.'

Indeed! She was a fine figure of a girl, of the kind that awaken temptation when encountered on their own. 'Young lady, is this the right way to where we're going?' asked Pigna, laughing.

A respectable girl, she lowered her head and quickened her pace without paying any attention to him.

'What a brisk walker, eh?' mumbled Carlino. 'If she's hurrying like that to meet her lover, he's a lucky guy!'

Seeing that they were following at her heels, the girl suddenly stopped, with her basket in her hand, and began to shout, 'Leave me alone and let me go my own way.'

'Hey, we're not going to eat you, damn it!' replied Pigna.

She set off again, with her head down, like the stubborn peasant that she was.

To break the ice, Carlo asked, 'O where are you going, pretty maiden . . . what is your name?'

'Never you mind what my name is, or where I'm going.'

Ambrogio tried to intervene. 'Don't be afraid, we don't mean you any harm. We're honest lads, we're just heading for the tram.'

Because he looked a decent sort, the young woman finally relented, after all it was getting dark and he was in danger of missing the tram. Ambrogio wanted to know if this was the right way to the tramstop.

'So I've been told,' she replied, 'but I don't know this area.' And she said she was going to town to find herself a job. Pigna, always one for a laugh, made out that he thought she wanted a job as a wet-nurse, and if she didn't know where to

go, he'd find her a good position, all nice and cosy, that very same evening. And since he couldn't keep his hands to himself, she gave him a dig with her elbow that almost broke his ribs.

'Christ!' he muttered. 'Christ, what a powerful punch!' And the others hooted.

'I'm not afraid of you or anyone else!' she said.

'Or me?'

'What about me?'

'And all three of us?'

'What if we were to take you by force?'

Then they looked around, in the open countryside, and there was not a living soul to be seen

'Now, what about your sweetheart,' said Pigna to change the subject, 'now, how come your sweetheart let you go?'

'I don't have one,' she replied.

'Really? A pretty girl like you?'

'No, I'm not pretty.'

'Oh, come on now!' And Pigna started paying her compliments, with his thumbs tucked into the armholes of his waistcoat. My God, was she pretty! With those eyes, and that mouth, and so on and so forth!

'Let me pass,' she said, laughing surreptitiously, with lowered gaze.

'A kiss at least. What's a kiss?' She could at least give them a kiss as a token of friendship. After all; it was getting dark and there was no one to see.

She warded them off, lifting her elbows.

'God, what a sight for sore eyes!' Pigna avidly feasted his eyes on her from beneath her raised arm. Then she squared up to him, threatening to bash his face with her basket.

'Go ahead! Hit me as much as you like. It'll be a pleasure, coming from you.

'Let me go or I'll call for help.'

'You can shout your head off,' he stammered out, his face flushed, 'no one will hear you.' The other two wet themselves laughing.

Finally, as they were closing in on her, the girl, half serious,

half laughing, began to strike out at random, hitting whichever of them she could. Then, hitching up her skirt, she took to her heels.

'Ah! you're asking for it!' shouted Pigna, running after her, panting. 'You're really asking for it!'

And breathing heavily, he caught up with her, clamping a big heavy paw over her mouth. Then they tore at each other's hair, both of them lashing out in all directions, the girl frantically biting and scratching and kicking.

Carlo found himself trapped in the middle when he tried to separate them. Ambrogio grabbed her by the legs so that she didn't cripple anyone. Eventually, Pigna, pale and panting, got her down on the ground, with his knee on her chest. Then, all three of them, at the touch of that warm flesh, seemed suddenly to be overcome with raving madness, crazed with lust . . . God save and preserve us!

She got to her feet like a wild animal, without a word, pulling together her torn dress and picking up her basket. The others exchanged glances, with a strange snigger. As she was about to walk off, Carlo stood in her way with a scowl on his face.

'You won't say anything?'

'No, I won't say anything,' the girl promised in an expressionless voice.

Whereupon Pigna caught hold of her skirt. She began to scream.

'Help!'

'Shut up!'

'Help! Murder!'

'Stop it, I tell you.'

Carlo grabbed her by the throat. 'You want to ruin us all, damn you!' She was no longer able to scream, held in that tight grip, but she still threatened them with those staring eyes in which they saw the police and the gallows. She turned blue, with her tongue hanging out, a huge, black tongue that could not fit in her mouth any more; and all three of them were frightened out of their wits by the sight of it. Carlo squeezed her throat tighter and tighter as the woman's arms slackened,

and she went limp, her head falling back on the stones, with the whites of her eyes showing. One by one, they let go of her, terrified.

She lay still, stretched out on her back, on the edge of the path, face up with white staring eyes. Grimly, without a word, Pigna gripped Ambrogio, who had not stirred, by the shoulder, and Carlino stammered, 'All three of us, mind! All three of us did it! O Mother of God!'

Darkness had fallen. How much time had passed? There was still the sight of that black, motionless thing lying on the ground, across the pale path. Fortunately, no one came this way. Beyond the patch of corn was a long row of mulberry trees. A dog began to bark in the distance. And the three friends thought they were dreaming when they heard the whistle of the tram they had been on their way to catch half an hour earlier – it seemed like a hundred years ago.

Pigna said they should dig a deep hole to conceal what had happened, and he forced Ambrogio to drag the dead girl into the field, since the three of them were in this together. The body was as heavy as lead. Then it would not fit into the hole. Carlino cut off the head with a hunting knife that Pigna happened to have with him. After they had filled in the hole and stamped down the earth, they felt calmer, and set off down the lane. Ambrogio kept a mistrustful eye on Pigna, who had the knife in his pocket. They were dying of thirst, but made a big detour to avoid a country inn that came into view as dawn broke. A cock crowing in the coolness of the early morning made them jump. They proceeded warily, and without uttering a word, but they were loathe to part, almost as if they were chained together.

The police arrested them a few days later, picking them up one by one: Ambrogio, in a brothel, where he was holed up from morning till night; Carlo, near Bergamo, for the way he was wandering about had attracted their attention; and Pigna at the factory, right there in the midst of the workers coming and going, and the machine roaring away. But at the sight of the police he turned pale and all of a sudden his tongue felt knotted. At the trial, in the dock, they looked daggers at each

other, regarding one another as traitors. But later in prison when they remembered how they had got into this mess, they felt as if they were going out of their minds, seeing how one thing leads to another, and how you could start out just having a bit of fun and end up with blood on your hands.

THE SCHOOLMASTER

Every morning, before seven, the schoolmaster would be seen passing, as he went from house to house, collecting his pupils: with a walking stick in one hand and a fractious child attached to the other, and a bevy of youngsters trailing behind, who at every stop would throw themselves on the pavement like tired sheep. Donna Mena, the haberdasher, would have her Aloardo waiting, all nice and clean again, by dint of repeated walloping, and the schoolmaster, ever kind and patient, would drag the little brat away with him, screaming and kicking. He would come back later, before lunch, with Aloardino in tow, now completely covered in mud, leave him outside the shop, and take by the hand again the child with whom he had arrived that morning.

So he would pass by, four times a day, before and after lunch, always holding a laggardly child by the hand, with the rest straggling behind, of every background, of all sorts, dressed in smart fashionable clothes or dragging their feet in worn-down old shoes; but invariably keeping by him the pupil closest to home, so that every mother might think that her child was his favourite.

He knew all the mothers. Ever since they had come into this world, they had seen him pass by, morning and evening, with his faded old hat over one ear, his shoes always shiny, and whiskers likewise, an unfailingly patient smile on a face like a battered old book; with no sign of tiredness except in the sun-faded and brush-worn jacket on his slightly stooped shoulders.

They knew too that he had a great weakness for the ladies. For almost forty years he had been traipsing backwards and forwards, morning and evening, like a mother hen with her chicks, always with his head in the clouds, waving his cane like a decoy, as if he were a real bird-catcher, in search of a sweet-heart – without meaning the slightless harm. Someone who would look out for him every time he passed, and produce a

handkerchief when he blew his nose, nothing more. He would have been satisfied just to know that somewhere, near or faraway, he had a soulmate. So, along that daily Via Crucis of year after year, he had imaginary stations of consolation, windows on which he used to cast sidelong glances as he turned the corner; which meant something, spoke, only to him; at which he had seen beloved faces grow old, or from which they had disappeared to go off and get married. Only he remained ever the same, bearing within himself an inexaustible youthfulness, dedicating to the children the sentiment he had felt for their mothers, dreaming of playing Don Giovanni while living the life of a hermit.

It was almost the inevitable result of his profession: the projection of the poetic fancies that filled his hours of leisure, in the evening, before the oil lamp, with his aching feet in his felt slippers, well wrapped up in his overcoat, while his sister Carolina darned his socks, on the other side of the small table, she too with a book open in front of her. He was a school-teacher because he had to make a living, but his real passion in life was literature, sonnets, odes, Anacreontic poems, acrostics especially, with the names of all the saints in the calendar spelled out in the first letters of the lines. As he went from one side of town to the other, trailing the schoolchildren behind him, he bore beneath his threadbare coat the sacred flame of poetry, that which makes young girls sing on their balconies in the moonlight, and must have made them think of him. He knew, as well as if someone actually had told him, of all the curiosity his appearance was bound to arouse, the quickening heartbeats one of his glances excited, the daydreams left in his wake. Though he was too scrupulous to take advantage.

One day, as he remembered ever after with sweet inward embarrassment, a young girl to whom he used to go and give lessons in handwriting, tried to present him on his nameday with a beautiful flower that was in a vase on the desk, a rose or a carnation, he could not remember which because of the confusion that had clouded his vision. She offered it to him with kindness and, seeing how shy and embarrassed he was, she said, 'I kept it here for you, sir.'

'No, I beg you . . . Spare me . . .'

'What do you mean? You don't want it?'

'Let's continue the lesson, please! These are not things that . . .'

'But why ever not? What harm is there in it?'

'To betray the trust of your parents . . . in my capacity as your teacher . . .'

Then the girl burst into such uncontrolled, impudent laughter that it still rang in his ears at the recollection, and still, after so long, a misgiving would enter his mind, one of those flashes of illumination that make you hide your head under the pillow at night, in order to escape their radiance. Ah, those blessed young girls, who would ever understand them, no matter how many years went by! They laughed at him behind his back. Then, long afterwards, when he came by to pick up their children, twirling his persistently black whiskers, they would soften, feeling a certain emotion in recalling the past, the rosy daydreams of their early youth, evoked by the melancholy figure of that eternal seeker of love.

'Come in, Don Peppino, the boy's getting dressed.'

'No, thank you, there's no need.'

'You want to wait in the sun, sir?'

'I have some children with me. I can't leave them alone.'

'Heavens above, you have so many! You must need the patience of a saint, from morning till night, all these years you've been doing this job!'

'Yes, we've known each other for some time now, by sight at least. When you lived in Via del Carmine, the terrace with the basil plants. Do you remember?'

'We're all growing old, Don Peppino! Now our hair's turning white. I speak for myself, with a daughter old enough to be married.'

'Indeed, I've a little something for Donna Lucietta. It's her nameday today, if I'm not mistaken.'

'What is it, a picture of St Lucy? No, a poem! Lucia, Lucia, come here, look what the schoolmaster has brought you.'

'Just a trifle, Donna Lucietta, forgive my boldness.'

'It's lovely, lovely, thank you so much. Look, mother, what a beautiful sheet of paper. It looks like lace.'

'It's really nothing. Just a little piece of embroidery in verse, befitting a lovely girl like you. A trifle, truly!'

'Thank you, thank you. Here's Bardolino. The schoolmaster's been waiting half an hour for you, you bad-mannered child!'

'Look, mama, if you cut the edge of the paper off all the way round, it would make a pretty surround for a posy, were anyone to send me flowers today.'

The school was in a big whitewashed room, with a partition wall at the end of it, half the height of the room, and a mysterious big semicircular fanlight above, to let the light into a cubicle on the other side. Beside the door stood the schoolmaster's desk, covered with a hand-embroidered table-mat, and a lot of other objects on top of it, made of odd bits and pieces: a pen-wiper, a lampshade, and an orange-wool tangerine with little green leaves, a source of infinite distraction to the pupils. The other ornament in the school, on the large expanse of bare wall behind the desk, was a small picture frame made of perforated card, a painstaking work by the same hand, which contained two small yellowing photographs, portraits of the schoolteacher and his sister, as alike as two peas in a pod, despite his waxed whiskers and her grotesque hair style: the same prominent cheekbones that seemed to jut out of the frame, the same thin line of bloodless lips, the same cloudy eyes, as though weary of gazing perpetually, from the depths of sunken eye sockets, at the mismatched chairs scattered across the schoolroom; and all around the dreariness of those white walls, tinged in one corner by the wan light from the dusty window that looked out on the little courtyard.

Early in the morning, as soon as the carpenter next door began to hammer, two sleepy voices could be heard whispering in the dark cubicle, and then the fanlight above the partition would light up. Shuffling in his slippers, and all bundled up in a threadbare overcoat, the schoolmaster would go and fetch a handful of wood shavings, and light the fire

to make coffee. Then, outside the misted window, a flame could be seen rising from the fireplace sheltered beneath four tiles projecting from the wall, and thick smoke gathered in the enclosed yard. Meanwhile, at the far end of the tiny cubicle, the schoolmaster's sister would start coughing, from dawn.

He would fetch his shoes that were leaning up against the door jamb, side by side, heels uppermost, and begin to polish them lovingly, while waiting for the coffee to boil, a fireside ritual, with the collar of his overcoat turned up to his ears. Then he would remove the coffee pot from the flame, always with his left hand, and with his right hand take the cup without a handle from the shelf nailed up beside the cooking hearth, rinse it in the cracked bowl wedged between two stones by the well, and finally fetch the lamp from the cubicle, which was divided in two by an old curtain suspended on a piece of string. His sister would sit up in bed at the back of the room, with difficulty, coughing, blowing her nose; moaning constantly, with her dishevelled braids, her consumptive face, and already weary eyes, greeting her brother with the sad smile of the incurably sick.

'How do you feel today, Carolina?' her brother would ask.

'Better,' she invariably replied.

Meanwhile sunlight spilled over the roof opposite the window, like gold dust, in which chattering sparrows darted. Outside the door came the sound of goat bells passing.

'I'm just going for the milk,' Don Peppino would say.

'All right,' she replied, with the usual weary nod.

And she would begin to dress slowly, while the schoolmaster, squatting down with a glass in his hand, would argue with the goatherd who measured out the milk for him as if it were liquid gold.

Carolina would get up and make her brother's bed, on the other side of the curtain, which she would lift up, over the string, to air the room, as she would say; and she would start slowly sweeping the schoolroom, moving the chairs, one by one, resting on the broomstick to cough, amid the dust.

Her brother would return with two cents' worth of milk in the bottom of the glass, and two breadrolls in the pockets of his overcoat. He would fold back the edge of the tablemat, so as not to dirty it, and they would sit and breakfast in silence, on either side of the table, cutting thin slices of bread, one by one, chewing slowly, as though lost in thought. Yet, every time she coughed, her brother would raise his head and gaze at her anxiously, then look down at his plate again.

Eventually he would go off with his cane under his arm, his hat over his ear, his whiskers waxed, turning up the collar of his jacket, carefully pulling on his gloves that smelt strongly of ink, with his sister, who insisted on wearily passing a clothes brush over him, trailing after, cherishing him with an almost maternal gaze, accompanying him to the doorway with the resigned smile of an old maid who thought all women were in love with her brother.

She too had been young once, though for a girl without a dowry, and no beauty, it was a forlorn spring, when, for every major festival, she would make adjustments to the same simple wool and silk dress, and create fantastic hair-styles in front of the small cracked mirror. Oh, what bright hopes were invested in that poor garment, as she sewed all night long. And what bitter dejection afflicted her in front of that mirror, which would inevitably reflect those bony cheeks and a nose that was too long. Among the exuberantly frivolous group of other girls she had a constant and painful vision of her own grotesque appearance, and she would keep at a distance – out of shame, some said, out of pride, said others. For she also was known to be bookish. Amid the bleakness of their respectable poverty literature had brought comfort, illusion, as it were a touch of luxury that made up for her neighbours' ill-disguised pity. She jealously treasured her brother's verses, in beautiful handwritten copies, all flourishes and embellished capital letters; and when he had finally yielded to general indifference, to weariness of the humble and taxing use he had to make of his learning to earn his living, she alone continued to be a great reader of novels and verse: epic cloak-and-dagger

142

adventures, complicated and extraordinary tales, heroic love stories, crime mysteries, four hundred pages of letters, all harping on one word, lamentations bayed at the moon, the sorrows of souls grieving before birth, bewailing future disappointment. Her entire dismal youth was consumed in those ardent fantasies, which peopled her sleepless nights with plumed horsemen, fair-haired consumptive poets, bizarre and fabulous events, among which she dreamed of living, even while she swept the schoolroom or cooked their meagre dinner in the enclosed yard that served as a kitchen. And under the influence of all this medievalism, her painful anxiety about her plainness and poverty manifested itself in a grotesque manner, in contrived ringlets on her forehead, flowing locks down her to shoulders, medieval-style puff sleeves and starched frilly collars.

'Is that the latest fashion?' the most elegant and cruellest of her companions asked her one day.

But for him alone – so long ago! these days he worked at the local magistrate's court – what tremors of the heart, what joys, what dreams! And now, nothing, whenever she happened to run into him, with his wife and children in tow. In those days he was a gaunt young man, with big pensive eyes, watching the 'whirl of the dance' from a doorway, as though from on high, miles and miles away. The girls used to tease him, partly because he never danced; they called him 'the poet'. From a distance, he pinned a fateful glance on that young girl, standing alone and forgotten in a corner, like himself. Finally one Sunday he arranged an introduction; he told her in a long garbled sentence that he had sought the honour of making her acquaintance because 'at the party' she was the only person with whom one might exchange a few words: he could tell, he had been told so; he also knew that she was a great book-lover . . .

The dances whirled round and round, raising a great cloud of dust, beneath the light of the oil lamps, and they could have been a hundred miles away, exactly as described in novels, half-hidden behind the crocheted curtain, he with his hat on

his hip, concentrating his mind on every word that fell from her lips; she made radiant by this first flattering attention she had ever received from a man, with a new softness in her eyes, peering through her curls.

'Is it a poem?'

'No, a novel.'

'Historical?'

'Shame on you, young lady! What do you take me for? You know the saying: "Who will free us from the Greeks and Romans?"'

'Like Manzoni, then?'

'No, more modern. I was about to say more subtle, certainly more restless . . . with all the restlessness of the century in which we live . . .'

'And the title? May one ask what that is, at least?'

'You may, of course! Love and Death!'

'Wonderful, wonderful wonderful! Have you spent a long time working on it?'

'About four years.'

'Why don't you have it printed?'

The young man shrugged his shoulders with a disdainful smile.

'What a pity!'

There was a gleam in his eyes, to accompany the reply that flashed into his mind, prompt and sure; a gleam that misled the poor girl.

'I needed only to hear you say so!'

Carolina blushed with joy, and bowed her head, her heart bursting.

'What do you mean? I? What ever do you mean?'

And he, swelling in his frockcoat at this first experience, for him too, of being flattered by a woman, imparted to her bowed head, from the lofty height of his starched collar, the confidence that for a writer the most coveted success was a word . . . a single word . . . of praise . . . of encouragement . . . from someone . . .

'Excuse me!' He broke off abruptly, suddenly stepping backwards.

'Did you get wet?' the lady of the house, who was going round with a watering can, asked apologetically. 'Forgive me . . . It's just that we're being choked by the dust. Don't you think so?'

The poet continued, saying that it was truly a stroke of good fortune to have met each other . . . amid such intrusive vulgarity . . .

'Do you not dance?' he finally asked her.

'I?'

'Don't worry. I don't dance either. You know the saying: "I don't understand why they don't get servants to do the work!" And that's the truth of it. Try blocking your ears, and see how grotesque they look . . .'

'You're right, you're right.'

'And then listen to the topics of conversation! The heat, the crush of people, the lights. When the talk turns to hair-styles, that's already great progress. By the way, you look divine . . . No, no, let me have my say, you're different from the others; you have good taste, originality . . .'

He arched his eyebrow and let fly the final arrow.

'And after all, appearances can be deceptive, but good taste reveals the soul.'

How lovely the waltz playing at that moment sounded! How it remained in her heart all night long! And how she would then hum it under her breath, her eyes swollen with delicious tears, as she sewed in the dark courtyard. On the step of the well the carnations that reached out their stunted stems from a cracked flowerpot stirred gently in the sun, and seemed to revive. How much at peace with herself, when she looked in the mirror! What sweetness in certain tones of her voice! What softness in the moonbeam that kissed the top of the wall opposite! And in the golden sunset that peeped out from behind the chimney pot on the rooftop, and glinted on the windowpane in which you could sometimes see a little fair-haired infant, sitting motionless for hours in a high-backed armchair. To feel so alive, even in that dreary courtyard, within those four walls with their familiar almost cherished gloom, in the humble tasks grown dear to her, with that other fantastic

world that books opened up to her, in the caress of her brother's loving and protective voice; and now deep in her heart, what might be described as a spot of brightness, a delicate string that quivered at the slightest touch, a great joy that needed to conceal itself and leapt to her throat at every moment, a feeling of trust, a new tenderness for everything and everyone she knew – looking forward to the next Sunday, the next country dance amid the dust and the stench of oil, when she knew she would see him again, someone who for the last week had occupied such a great part of her heart and her life!

This time he came over to her as soon as he saw her, with a handshake that immediately reestablished their spiritual intimacy, and he stood by her side, behind the crocheted curtain, with his right hand in the front opening of his waistcoat, talking to her constantly about himself, his tastes, his preferences, the few things he warmly admired, his ambitions, which reached the sky.

Every now and again, whenever he thought the girl was bowing her weary head beneath all this relentless egoism, he would drop her a compliment, as a coachman cracks the whip going uphill. However, the young girl bowed her head in emotional turmoil, her heart wide open to the confidences that avidly sought her sympathy. While, swept along by his own enthusiasm, stirred by his own rhetoric, he let himself get carried away, began to unburden himself, going so far as to mention his little problems: a father who opposed him in his aspirations, in the natural bent of his genius . . . In two years at university he had learned nothing. All he had done was to write verses on the desks in the Faculty of Civil Law.

'A real parricide!' Carolina remarked with a smile.

For the first time he blessed her with a look of ineffable tenderness.

'Carolina! Carolina!' her brother called. And he said quietly in her ear, 'Can't you see, everyone's looking at you; you're with him all the time. Who is he?'

And indeed, glimpses of ill-dissembled smiles were to be

seen here and there, behind fans and among the groups of young girls. But Carolina proudly introduced him to her brother.

'Signor Angelo Monaco, distinguished poet, and author of Love and Death.'

'I know that you too are a distinguished man of letters!' said Monaco, regally proffering his hand.

The novelist 'requested the honour' of reading the manuscript of his novel in the schoolmaster's house, 'in order to get an informed and honest opinion'. One evening after school, they sat him at the little table with the embroidered tablecloth, with two lighted candles in front of him, like a conjuror; Don Peppino with his head in his hands, completely intent on the prospect of organizing a reading of his own verses, which he felt flourishing once more inside him, envious of this occasion; his sister already emotionally affected by the solemnity of their preparations, the closed door, the children's seats all lined up in a row, as though for a large invisible audience.

The manuscript was substantial, about half a ream of handmade paper, enclosed in a moroccan leather folder with the title in gold on the cover, and tied with ribbons of the Italian Nationalists' colours. The author read with conviction, reinforcing every word with gestures, with the expression of his voice, and with occasional glances that sought admiration on the face of an extremely pallid Carolina, and the impenetrable face, behind the palms of his hands, of her brother. He was enlivened by his own words, like a Barbary horse by the rattle of clappers attached to its tail; without a moment's weariness, almost without needing to turn the page. The pages swiftly succeeded one another, with a rustling like that of dry autumn leaves, in the deep silence of the night. All noises from the street had ceased, one by one. The moon appeared in the window, high in the sky.

There was a point at which the despairing hero of the novel forced his way through a bevy of liveried servants keeping him at bay in an antechamber, in order to die by his own hand in the boudoir of his beloved, just returned from the ball, still

147

swathed in lace and ribbons. He assailed her with fiery words, wanting to offer this implacable goddess the sacrifice of his blood, his senses, his infinite love, there at the foot of that very altar, on the Persian rug before that unsullied bed. And in the triumphant glance which punctuated this, the author saw with cruel joy that she who listened was softly weeping, with her hand before her eyes.

He took that hand, and held it to his lips for a long time, making the most of his triumph.

'Forgive me,' he then murmured.

She gently shook her head, and replied in a faint voice, 'No! I'm so happy!'

The moon at the window quietly kissed the wall opposite. At the sudden silence, the schoolmaster roused himself.

Angelo Monaco took to frequenting the schoolmaster's house, attracted by the sympathy he found there, flattered by that fervid admiration, that deep and timid love for which his vanity expressed gratitude by sometimes feigning a reciprocation of that same sentiment. Carolina waited, happy, full of new vitality amid her usual modest pursuits; overtaken by sudden quickenings of her heartbeat, by inexplicable emotion, over nothing, on account of a few ordinary things that had previously not meant anything special to her; rejoicing in a look, a smile, a word, a handshake, from him; all atremble at the time of day when he usually appeared; overwhelmed with inexplicable tenderness at the sight of moonlight on the window, when the moon was full, and at the sound of the bell ringing for the angelus, of the barrel organ passing, of her brother's voice uttering his name; perturbed by an unaccustomed sense of embarrassment and by a new warmth towards him. He too seemed different to her. For some time he had been treating her with affectionate and almost sorrowful gentleness, with discreet and compassionate reticence. Finally, one day, just as he was about to leave with the children, with his hat on his head and a nosegay in his hand, he drew her aside, behind the red curtain.

'You know, Carolina . . . He's going to be married . . . No!

listen! Be brave! Be brave! Look, I've got the children with me . . . Forgive me for upsetting you . . . I had to tell you . . . I'm your brother, your Peppino . . . '

She staggered out into the big room, as if she were suffocating, and after a moment stammered, 'How do you know? Who told you?'

'Masino, that little boy, the bar-keeper's son. Today, we happened to run into him. The boy saw me greet him and told me that he was going to marry his sister.'

'Go, go,' said the poor girl, pushing him away with trembling hands, 'the children are waiting.'

That was all. She never said another word, no complaint ever passed her lips. The last time he saw her, Angelo found her so afflicted, so wrapped up in her sorrow, that he guessed the reason. Moved by the tone of his own voice, he said goodbye to her at the courtyard door, gazing up that patch of sky with a genuine tear in his eyes. The next day he wrote her an impassioned letter, full of love and despair in every line, the first letter in which he ever spoke to her of love, to tell her that his was doomed and must be sacrificed on the altar of filial obedience. 'Be happy! Be happy! Near or far, in life and death!' It was the only love letter she ever received, and she kept it jealously among the dried flowers he had given her, and the faded ribbons she was wearing the day they first met.

Then, wearied, she focused her youthful hopes on her brother; rebuilding for him the castles in the air that had been the setting for the ardent dreams of her cloistered life; reliving, in a different guise, the same fervid fantasies she had retained from all that fanciful reading that had consumed her youth behind the school partition wall, like the geranium, which had died, after ten years' languishing in the sunless courtyard. Once it was a rose that she came upon in the penholder on the desk, which shed its petals without her daring to touch it, and left her feeling miserable as the petals fell into the dust. Another time a perfumed note, glimpsed on the tablemat on the desk, and which mysteriously vanished almost at once, kept her puzzled, and vexed, for a month, while it remained,

with its faint scent, locked in the drawer, until her eyes happened to light on it among the waste paper thrown out in the courtyard – the same gilt crown at the top of the scented page, the same elegant hand in which a mother apologized for some shortcoming or other of her son.

One day at last the fairytale seemed about to come true, when a splendid blonde woman turned up in an elegant carriage to collect her pale little boy, filling the whole school with the rustle of her gown, the scent of her handkerchief, the melodious sound of her bright and cheerful voice, like a ray of sunshine that dazzled both master and pupils. For many days afterwards, the poor old maid, hidden behind the partition curtain, awaited the beautiful seductress, with pounding heart, agitated to the core, and as though ravished by a delicious secret, a strange disquiet, in which a new tenderness for her brother mingled with a vague sense of jealousy, contentment, and a secret pride.

There were bashful silences, circumspect reticence, mutual feelings of embarrassment, over a hint, a word, a distant allusion dropped in the course of conversation, while they sat at the table, on either side of the folded-back tablemat, as they daily rehearsed the same empty and meaningless exchanges as on the previous day, repeating in low voices, with a certain shamefaced timidity, the same boring phrases that epitomized their colourless and monotonous existence.

He bowed his head, flushing, as though taken by surprise; and with a shrug of his shoulders he would swear she was mistaken, while inwardly rejoicing, with a little smile of vanity quivering on his lips. Sometimes, in a sudden burst of grateful affection, he would place his right hand on her head, with that same discreet little smile that seemed to say, 'Don't worry, silly!'

However, in her instinctive moral rectitude, the old maid felt, with growing aversion, a distressing anxiety about whatever was surely dubious or perilous in this clandestine romance. Then she went rushing off to throw herself at the feet of her confessor, in the new religious fervour in which

she had found refuge after experiencing the greatest sorrow of her youth, a broken heart and the abandonment of every worldly illusion. And she asked forgiveness for the sweet offence she had not committed, and did penance for the imaginary sin that had entered her home. And still inspired with that same fervour, she found the courage to exhort her brother, with veiled allusions, discreet insinuations, an effusion of timid and almost maternal tenderness, to return to the straight and narrow.

'Peppino!' she said at last. 'You must do something for my sake. You must make up your mind to take a wife.'

He raised his head, surprised at first, and then flattered by this suggestion that made him feel twenty years younger, protesting with the ingenuous enthusiasm of his earliest youth that 'matrimony was the tomb of love', only seeking further persuasion.

'Mark my words, Peppino! If you leave it too late, you'll be sorry!'

He continued to shake his head, inwardly flattered to be able for the first time to refuse, without noticing the sorrowful expression in the poor old maid's voice.

'No, why should I tie myself down? Don't worry. I'm too fond of my freedom!'

She felt a strange sense of sympathy, commiseration, and enmity towards the pale and thin little boy that the blonde lady came to fetch, and whom she supposed to be an innocent accomplice to their affair. Hidden behind the curtain, she kept a close watch on him from afar, as if, in his clear childish features, he brought to school a reflection of his mother's alluring charms, worrying if the youngster was sometimes absent, spinning an entire family saga out of the least of the unwitting boy's actions. She would call him over, when she could do so privately, caress him, question him, offer him some trifling little gift, at once attracted and repelled by his childish winsomeness.

One day the little boy, looking very happy, said to her, 'After the holidays, I'm not coming back to school any more.'

Stammering, she asked him why.

'Mama says that I'm a big boy now. I'm going to college.'

So that romance too came to an end. She felt almost a great relief, but at the same time a misgiving, a bitter disappointment, sensing that even her last hopes, which she had invested in her brother, were now dashed.

The illness that had been lurking within her for years finally confined her to bed. Thereafter, the poor schoolmaster never had any time to himself; always busy, even in those brief moments of freedom the school allowed him, sweeping, lighting the fire, making the beds, running to the doctor and the chemist, with his whiskers undyed, his shoes muddy, his face ever more wrinkled. His neighbours, feeling sorry for him, would take it in turns to come and lend a hand: Donna Mena, the haberdasher's widow, in all her gold jewellery, as if she were going to a wedding; and Agatina, the carpenter's daughter, with her quick hands, and invariable good humour, who filled the poor cheerless house with her youthful gaiety. And the old bachelor was thrown into complete turmoil by having these women about the house; as if restored to youth, tempted, even in the midst of his troubles, by subtle twinges in his heart and blood, which then tormented him in the hours of darkness, like pricks of remorse.

'Better, better. She's been sleeping.'

The poor fellow, overjoyed on receiving this good news at the threshold, seized her hand, and kissed it.

'Oh, Donna Mena! Thank goodness!'

She signalled to him to keep quiet, and led him on tiptoe to see the patient, who lay asleep with a sweet expression on her face, on which the shadows of death were already encroaching. And as if the sweetness of that moment of reprieve had transmitted itself to him, exhausted by the anxiety he had been dragging round, along with children, from one side of town to the other, he collapsed into the chair behind the curtain, without letting go of Donna Mena's hand, who gently withdrew it. The room was already dark, with a mysterious, sad sense of intimacy.

Suddenly his sister, waking up, called out to him, almost as if

she sensed he was there; and for the first time, as he lit the lamp, he felt embarrassed in front of her, standing beside another woman.

It was a terrible bout; her first battle with death, which had its prey already in its clutches. The invalid, having regained consciousness, gazed at the light, the walls, her brother's face with astonished eyes, in which it seemed the vision of arcane terrors still lingered, and she caressed him with her smile, the murmur of her voice, her trembling hand, in a resurgence of unutterable affection, which clung to him as though to life itself.

And when they were alone, she said to him with that peculiar tone of voice and expression in her eyes, 'Not her! Not her, Peppino!'

Round about August, she seemed to be getting better. The sunshine reached her bed, from the door on to the courtyard, and in the evening all the sounds of the neighbourhood entered the room to keep them company, the chattering of women, the squeaking of pulleys in the wells nearby, someone singing the latest song, the tuning of the guitar with which the barber opposite killed time while waiting for a customer. The carpenter's daughter called by, with a flower in her hair, and a cheerful smile imbued with youth, health and a taste of spring.

'No, no, don't leave yet! Look how happy my poor sister is, when you're here!'

'It's getting late, sir. I've been here an hour.'

'No, it's not late. Your family know that you're here. Why not say you have friends waiting outside?'

'No, no.'

'Or your lover, eh? This must be the time he usually goes by, with a cigar in his mouth . . . '

'Oh . . . what on earth are you talking about, sir?'

'Yes, yes, a pretty young girl like you . . . it's only natural. Who wouldn't fall in love at the sight of those eyes . . . and that smile . . . and that mischievous little face.'

'What idea's got into your head now?'

And one day, in the moonlit doorway, he even ventured to say to her, 'Ah, if only I were the one!'

'You, sir! What ever do you mean?'

He felt choked with emotion, while the girl, out of respect, dared not withdraw the hand that he had grasped. And a flood of disconnected phrases spilled out of him: 'Love that levels all . . . poetry which is the perfume of the soul . . . the wealth of affection stored in timid hearts . . . the divine pleasure of seeking out the thoughts and face of one's beloved by the light of the moon, at a prearranged time.'

With big wide-open eyes, the girl stared at him almost in fear, completely pale in the moonlight.

'I shall never forget these moments you've granted me, Agata. Or that name! Never! Separated, far apart . . . but we shall remember . . . both of us . . .'

'Let me go, let me go. Good night.'

The invalid, propped up on a pile of pillows, chatted quietly with her brother, who sat at her bedside, with his hat still on his head and his cane between his legs. She seemed to have something important to say to him, judging by the sudden silences that choked the words in her mouth, by the lingering glances she rested on him, the flushes that briefly reddened the pallor of her drawn face. Finally, with her head bowed, she said to him,'Why don't you think of settling down?'

'No, no!' he replied, shaking his head.

'Yes, before it's too late. You should think about it while you're still young . . . Otherwise, how will you manage when you're old . . . and on your own?'

Feeling himself on the verge of tears, her brother brought this discussion to an abrupt conclusion, by saying, 'Now is not the time to talk about this!'

Nevertheless, she often returned to the same subject. 'If you were to find yourself a pretty, well-educated young girl, from a good family, she'd be just right for you.'

And one evening when she was feeling worse, she started talking about it again, in an anxious prattle symptomatic of her condition.

'No, let me have my say, now that I have a bit of strength. I can't let you sacrifice yourself to keep me company . . . your entire youth . . . You could do with a good dowry. And if you were to leave the school, so much the better. We'll all live together, under one roof. I only need a small room, as long as it's very airy. I'd like one overlooking the garden. I've no use for the street any more. I've always wanted to see the sky from my bed . . . and the greenness of trees . . . if we had a window where the curtain is now, for example, a window that looked out on the countryside . . .'

Pouring rain could be heard in the courtyard, the kind of rain that heralds autumn, and the resonating sound of the milk pan, left outside, under the gutter. A cat, out in the storm, howled incessantly, in a voice that sounded human.

The schoolmaster, who had listened to his sister's hankerings for sunshine and greenery, with his perpetual capacity for self-deception asked her affectionately, 'Now that autumn's coming, wouldn't you like a trip to the countryside?'

'What about the school?' she replied with a melancholy smile. 'However, if you were to get a good dowry . . . with some land . . .'

'These blessed women! When they get an idea into their heads . . .' he replied with a roguish little smile.

And he seemed to be wavering. But after having given the matter some thought, he eventually said, 'No, I won't sell myself!'

And he buttoned up his coat with dignity.

'If I have to make a choice . . . If ever . . . It's no use!' he finally concluded. 'I'm too fond of my freedom.'

She persisted in saying that it was all very well as long as a man was young, that otherwise he would end up in the clutches of a serving girl, or some scheming woman.

Then, since her brother refused to be persuaded, the old maid, giving way to a fit of jealousy, remarked about their women neighbours, 'Don't you see, they're already insinuating their way into the house, and beginning to have designs on you.'

And the poor thing died, broken-hearted at the thought of leaving her brother exposed to the snares of those scheming women.

Because she left a great void in that cubicle, though she had taken up so little space when she was alive, and her brother felt almost lost in there, with his intense loneliness and grief, during the hours that he was free of the children, he took to visiting the carpenter every evening, drawn by a sweet and melancholy gratitude to the young girl who had been so charitable to his poor dead sister. But the carpenter, who had no understanding of certain things, made it clear that there was nothing the schoolmaster could teach in his workshop; and would he please call only in the morning, for wood shavings, if he needed them.

And some time later, when Donna Mena saw that the schoolmaster's visits were becoming too frequent, Aloardino being the excuse for them, and that he never stopped thanking her for the help she had given his poor sister, clasping her hand and making sheep's eyes at her, she came right out and told him, 'Now, sir, let's speak frankly, the neighbours are beginning to talk about us.'

The poor fellow, caught by surprise, grew flustered. But finally he took his courage in both hands: 'Well, now, Donna Mena! That poor sister of mine foresaw it. I would never make up my mind to take this step, because I was too fond of my freedom . . . But now that I've got to know you better . . . if you're willing . . .'

'Well, my dear man, you're not far wrong in your assessment, if you're tired of going round with the children! But what I own, I and my late lamented husband worked for . . . And not for someone else's benefit!'

Once again, the schoolmaster would pass by, every day, morning and evening, holding one reluctant schoolboy by the hand, the rest trailing behind, with his faded hat over one ear, his shoes always polished, his coffee-coloured whiskers, and the foolish face of one grown old teaching the alphabet, and always seeking his beloved, with his head in the clouds.

The only difference being that, on returning home, he would lock the door, and sweep the school, make his bed, and all the other little chores for which he no longer had anyone to help him. In the morning, before daylight, he would light the fire, polish his shoes, brush his coat, never failing to do that, and go and drink his coffee in the courtyard, seated on the edge of the well, all sad and lonely, with the collar of his overcoat turned up over his ears. And now that his poor dead sister had no need of it, he even saved the two cents' worth of milk.

THE DEVIL'S HAND

This is a tale for people who go round with their hands clasped behind their back, and studying their shoecaps; for those who take nothing for granted and try to understand why all things human favour reason on the one hand and absurdity on the other. For those whose cotton pompom on their night cap would stand on end if they had a bad dream, and who would let the Ides of March go by without defiance. For spiritualists, players of the lottery, lovers, and storytellers; for all those who examine under a microscope the links by which one thing leads to another, once you dip into the great hamper of life. For chemists and alchemists, who for five thousand years have spent their time seeking the exact point where dream ends and reality begins, and breaking down the simplest units of truth in your ideas, principles, and feelings, investigating how much of your night-time self there is in your waking self, and the reciprocal action and reaction between the two. For those sophisticated people capable of confidently telling you that you are still asleep when the sun looks bright or the rain looks dreary – or, worse still, when you believe yourself to be taking a stroll with your wife on your arm. Finally, for people who would not let you open your mouth, even to talk nonsense, without trying to prove something or other, this story could prove and explain many things, which have deliberately not been spelt out so that every reader can find in it what he will.

I am telling this tale, now that all the characters in it are safe from the indiscreet investigations of the curious. For, of the three characters – like all perfect stories, it is a story with three characters, and you will have already guessed the relationship between them, however little experienced you might be in these matters – *he* is in Cairo, or thereabouts, running some kind of railway building project, *she* is dead, poor thing, and *the other man* is also dead in a manner of speaking. He has become a different person: he is married, has no regrets, and

would not even recognize himself in his reflection in a mirror ten years ago, were it not for the insolent hangers-on that pester his wife, who keep putting that mirror right in front of his face, and so resemble him, when he himself was insolently pestering, they drive him to distraction. In short, three ideally suitable characters of no account any more, who practically do not exist – you can imagine they never existed.

He and *the other man* were two fine decent fellows, soul mates, friends from childhood, the Orestes and Pylades of Railway Administration. *He* was an engineer, *the other* a designer. They lived in the same house, and went everywhere together, which earned them the nickname of the Siamese Twins. They saw each other every day at the office, from nine in the morning until five in the evening. No one could explain how *he* managed to meet Lina, to court her, and marry her. It was the only wrong this Damon ever did to his Pythias in thirty years.

But in the end not even in this was there any wrong done. It is true that Pythias-Donati was cross with Damon-Corsi at first, but his crossness did not last a week. Lina was the kind of girl who would have made a bear fall in love with her, and Donati was no bear. She was aware of the jealousy she would have to disarm, and with her sweet smile and her kind and affectionate manner she quietly rooted herself in the two men's friendship like a slip of ivy, instead of driving herself between them like a wedge. Within the space of a few months there were three friends instead of two, that was all that had changed. Donati felt he now had a sister as well as a brother, and Corsi was even more convinced of it. Of what you are imagining, and what was actually to happen, there was not even the faintest suspicion in the mind of any of the three, otherwise there would be nothing unusual about this story.

Even more unusual is that this state of affairs went on for eight years, and might have gone on indefinitely. At first, in the demonstations of friendship, of the great affection Donati and Lina felt for each other, there was a slight embarrassment,

perhaps caused by the fear they could be misinterpreted. Then habit, the trueness of their hearts, the very purity of those sentiments, made them more expansive, more uninhibited, and more trusting. Donati was at Lina's side through a long and dangerous illness just as a real brother might have been, and she treated this man who was almost a brother to her husband with all the kindness and consideration of a sister. The closeness between the two small families became so warm, so sincere, so open and unequivocal, that their friends and acquaintances, the rest of the world in other words, did not regard it as excessive or suspect. A rare thing, I admit, just as the honesty of those souls was rare. But if there was any shortcoming in any one of them, I would not need to drag in here that Fate of which the ancients speak, or what the moderns refer to as the devil's hand.

In the evening, after dinner, they would all go out for a walk. Donati would give his arm to Lina, and throw his chest out when he read in the eyes of passers-by, 'What a beautiful woman!' On Sundays they would lunch together, and take a box at the Municipal Theatre or the Alfieri. Donati loved surprises, surprises that could be anticipated with the calendar to hand, at Christmas, Easter, and on Lina's name day. He would turn up with an air of nonchalance that betrayed him even more than his pockets, bulging like saddlepacks, and he would rub his hands together when he saw Lina smiling. On winter evenings they would gather round the table in the sitting room, chatting, leafing through magazines and new novels, playing charades, or Lina would play the piano. Donati displayed admirable patience in absorbing the detailed account of every novel that Lina read: this was her sole vice. He was able tactfully to master the art of listening, expressing surprise or query, shuffling in his seat, converting a yawn into an exclamation, when he was actually falling asleep, poor devil, or did not really understand, or, being the straightforward and easy-going chap that he was, when he had not the least interest in all the expressions of surprise he felt the situation demanded. Often, on going to his rooms upstairs, he would find fresh flowers on his desk, a new rug in front of the

sofa, a few elegant trifles prominently displayed on his modest pieces of furniture. A discreet glimpse of a joyful smile, originating from the bottom of his heart, would appear on that gentleman's untroubled face, and was reflected on all those silent knick-knacks. Then by way of expressing his thanks, he would stamp on the floor two or three times. Lina became greatly preoccupied with finding him a wife. He invariably responded by saying, 'Oh, we're very happy the way we are. Let's not open the door to mischief.' The poor fellow was so convinced of being a part of this little family, was so contented with this tranquil existence, that he felt he would have been setting fire to his home if he had strayed even one step off the beaten track he habitually followed, and by which, in the manner of a perfect employee, his every move was governed. To those friends of his who advised him to start a family, he replied, 'I already have one, and that's enough for me.' Nor did his friends laugh at this. However, Lina said it was not enough. She was thinking of her friend in his later years, in sickness and old age, just as a mother might have. Sometimes, before closing the window, she would hear him walking about, all alone, in the room upstairs, and looking up to the ceiling, she would murmur, 'Poor young fellow!' The loneliness of that melancholy, uneventful, monotonous existence at a time of life meant for passion and pleasure lent a certain distinction to that calm and modest character, magnified the austere figure of that solitary individual, exaggerated the idea of what he sacrificed, made the man endearing, caused her a twinge of discomfort in the midst of her happiness, such abounding, complete happiness. It made her think, with a feeling of fondness, of how much support, fraternal affection and comfort she could bring to this existence.

You who seek to establish how one thing leads to another, make of this what you will!

In Catania there is no carnival to usher in Lent, but on the other hand there are the festivities on St Agatha's Day – a huge masked ball whose setting is the whole city – at which both ladies and ordinary townswomen are entitled to wear

masks, so that they can mystify their friends and acquaint-ances, and wander about wherever they like, however they like, with whomever they like, and their husbands have no right to interfere. This is called the right of the masker, a right that no matter what the chroniclers may say, must be a legacy of the Saracens, judging by its great value for women of the harem. The costume consists of an elegant and sober, if possible black, gown, almost completely shrouded in a mantle, that actually covers the entire person, leaving only one eyehole to see through, to drive a man crazy, or send him to the devil. The only coquettishness the costume allows is a glimpse of glove, ankle-boot, petticoat, or embroidered handkerchief, leaving the rest to the imagination. From four in the afternoon until eight or nine in the evening, the masker is her own mistress (which is saying something in our society), she is mistress of the streets, of all places of enter-tainment, of you, if you have the good fortune to know her, of your wallet and your head, such as you may possess. She will detach you from the arm of a friend, make you leave your wife or lover in the lurch, descend from a carriage, interrupt your business dealings, she will haul you away from the café, call you if you are standing at a window, lead you by the nose from one end of the city to the other, feeling half-dismayed and half-foolish, but with the eloquent expression of a man who has a terrible fear of appearing ridiculous. She will have you getting trampled in the crowd, or, for love of that one eye you can see, buying everything you would rather let the tradesman keep, because that is what she fancies. She will drive you mad and wear you out – the most delicate, most fragile of maskers is indefatigable – she will make a jealous, lovesick fool of you, and when you are exhausted, befuddled and dazed, she will just abandon you there on the pavement, or at the door of a café, with a pitiful, fixed smile of a happy man, and a puzzled look in your eyes, a mixture of curiosity and vexation. To tell the truth, there is always some-one who is not deserted like that, or left with that expression on his face; but the lucky ones are very few, while nine times out of ten, you remain consumed with curiosity, even if

you're the husband of the woman who has been dragging you around for four or five hours – the secret of the mask-wearer's identity is sacred. A strange custom for a place with a reputation for having the most jealous husbands in Christendom! Admittedly, it is a custom that is dying out.

Now it so happened that on one occasion, three or four days before the Festival, Lina, playful as she was, talking about the maskers, said to Donati, 'I'm telling you, this time I advise you not to be seen on the streets.'

Donati knew that Lina had never disguised herself as a masker before, and since she was his only female friend from whom he might expect any surprises, he replied with a shrug of his shoulders:

'Well, I've escaped unscathed for the last eight years!'

'Unscathed or not, that's up to you. A wise man takes no chances!'

But Donati did not want to act wisely, on the contrary, this particular danger attracted him, without making him mindful of what is said in the Gospel. It would be fun, a superb opportunity for giving Lina a real treat by pretending not to recognize her, for gaining the upper hand and beguiling her rather than allowing himself to be beguiled, for enjoying her confusion, playing the innocent, and having a good laugh with her about it all afterwards. He spent the whole day at the office, at his drawing board, dwelling on the idea, learning his lesson by heart, rehearsing quips and ripostes, preparing witty remarks at leisure. There was something illicit about the idea of taking the arm of that lovely young lady while pretending not to know her, of being alone with her in the middle of the crowd, of being her sole protector for an hour, a stranger to her, a new man, and this illicitness, like a stroke of good luck, gave him a sense of elation.

Now this is where the devil takes a hand, revelling in overturning all the good intentions with which hell is paved, penetrating any chinks in them, throwing into relief what lies behind the best sentiments, exposing the reverse side of the most honourable actions, deeds that seem to have the least ambiguous of motives.

The night before the feast day, Donati had a bad dream. But so vivid, strange and surprising was it, the elements that accompanied it so true to life, that even after he woke, he remained uncertain for some time whether it had been a dream or not, and he could not sleep for the rest of the night. He dreamt he was alone with Lina, a Lina who seemed never to have known him, dressed as a masker, with her dark shining eyes, her voice and hands trembling with emotion. They were at a table in Café Sicily, which he never frequented, where they sat motionless, silent, gazing at each other. All of a sudden she let her mantle drop to her shoulders, staring at him all the while with frenzied eyes, flushed as he had never seen her before, and seizing his head, with her hands on his temples, she planted a hot feverish kiss on his mouth.

Poor Donati, lying in his bed, leapt six inches into the air, woke with a pounding heart, and spent five minutes rubbing his eyes, still feeling stunned. Gradually he calmed down, ended up laughing at himself, and gave the matter no further thought.

The next day he played the innocent, pretending not to notice Lina's mischievous smiles, her bustling manner, the unusual comings and goings in the house. He said he would have to spend the evening at the office, because of some extra work, and went to stand guard outside the library.

He waited and waited, and finally, around five o'clock, Lina came hurrying from Quattro Cantoni, a little hampered by her mantle, but gracefully hampered. She made directly for where he was standing, as if she had known he would be there, plunged into the crowd and without further ado tucked her arm under his. By this alone, Donati would have recognized her anywhere. Animated and loquacious, she was determined to bewilder him with her constant stream of chatter, to invent a thousand stories to confuse him, to embarrass him with the little English and French she retained from school, pretending now to be some foreign lady, now a young girl entitled to be the focus of his attention, now a friend who had disguised herself to save him from great danger, now a distant relative, who had been reminded of his existence and come to solicit

the gift of a gold necklace. Donati pretended to be taken in, chuckled up his sleeve, enjoyed himself enormously, took delight in confusing her instead, leading her to suppose that she had divined some great secrets, letting her construct countless stories of no substance on the fanciful foundations she herself had suggested to him. Finally, when he saw she was more intrigued, when he caught in her eyes the first gleam of a fresh emotion, something between surprise and shyness at finding herself with a completely different man, he burst out laughing and, with that waggish good humour of his, said to her, 'My dear Lina, if you want to discover my secret and pass as some unknown woman entitled to be the focus of my attention, you shouldn't wear that bracelet, which I really can't take my eyes off, I know it so well!' Lina too began to laugh, threw back her mantle a little, and said, 'Well done! Now that you've won, you can treat me to a sorbet, since we're right outside the Café Sicily.' And they went in.

By a strange coincidence they sat at exactly the same table as Donati had seen in his dream, facing each other, as in the dream. Feeling warm, Lina fanned herself with her hand-kerchief. She let her mantle fall on to her shoulders and rested her elbow on the table. Donati watched her, without saying a word.

For several minutes past, Donati had appeared strangely ill at ease. He gave disjointed, irrelevant replies, and eventually the words died on his lips. Lina, a little rosy from the heat, and bright-eyed behind her mask, as in the dream, talked enough for two. She finally noticed the discomposure Donati was incapable of mastering, and after an even more incoherent response than before from him, she said, 'Oh . . . what's wrong with you?'

He reddened. After all, really . . . what was wrong with him? It was ridiculous! Incredibly, his dream last night seemed to have rendered him foolish for an entire day! And he shrugged his shoulders, openly laughing at himself. 'Bah!' he said. 'What's wrong is that I'm an ass. It's the silliest thing! And if I were to conceal it from you, I'd be doubly silly. Let

me tell you!' And he recounted the dream that had come true in every respect, except for one detail which he did not mention, of course, or rather he adjusted to spare her embarrassment, telling her that in the dream she had confessed to being in love with him, no less!

Donati laughed again, wholeheartedly, as he gave a blow by blow account of his weird dream, which became even more absurd in the retelling. He laughed at how strangely affected he had been by the recurrence of some of the details of his dream. At first she blushed. She listened to him in silence, with her chin in her hand, not looking at him any more, nor laughing. When he had finished, she gave a faint smile, by way of some kind of response – it was the best she could manage – and she stood up. They left hurriedly, conversing sporadically, sometimes at a loss for words.

Donati was not quite sure whether he had said something foolish, but he had the vague feeling that he would have given a month's salary not to have told that story, indeed not to have had any story to tell. The feast day ended very quietly, and cheerlessly.

Every year, the day after the holiday, the three friends used to go for lunch in the country. This time Lina was unwell, and there was no outing. Donati desperately wished that day could have been spent the same way as every other year, because he was still bothered by the dream and by his blathering on about it, and he wished the whole thing was dead and buried, so they could continue to do what they had always done, and not give it any more thought. However, they spent that evening at home together, as usual. Lina appeared a little late, looking like a woman with a migraine, but calm and serene. Donati asked her how she was. She stared at him so hard, he felt riveted by those two eyes as if by two nails, and she replied very brusquely, 'Fine.'

That was the first evening of coolness between them. From then onwards there were several such evenings. Lina sewed, Donati played the piano or read, and Corsi did his best to strike up a conversation, to which his wife would respond in monosyllables, keeping her eyes fixed on her needlework, and

Donati with a kind of grunt, without abandoning his book or his cigar. Even Corsi, expansive and good-humoured by nature, also became taciturn and dispirited. There was an atmosphere of sullenness in his house that cast a pall over everything. They would part early, Lina hardly holding out her hand: sometimes she appeared only for a moment to say goodnight.

Poor Donati could not forgive himself. He felt at fault, but the greater fault was to exaggerate the harm he had done, by his guilty demeanour. And he called on all the saints to give him the courage to take Lina aside, once and for all, and say to her, 'Come on, tell me, what's the matter? What's happened? What have I done wrong?' But this simplest of questions became the most difficult thing in the world. This new behaviour, this reserve, this unaccustomed coldness changed her into a completely different woman, a woman who caused the most eloquent pleas to die on his lips, leaving him tongue-tied and shackled in his movements. On one of these evenings, turning round suddenly, he caught Lina staring at him, with an expression in her eyes that made his blood curdle from head to toe. It was a look such as he had never seen in those eyes before, an intense look, with a gleam of bitterness, an unwonted curiosity that was fierce and fervent. Lina's face flamed, and she bowed her head. He dared not turn round again for fear of meeting those wild eyes once more.

Finally, on one occasion when Corsi was not there, he suddenly felt inspired with the courage for which he had so often prayed. Lina was deeply immersed in what she was reading, and had not breathed a word for a long while. He stood up, took a step towards her and stammered out, 'Lina!'

She sat bolt upright, panicked by that single word, as white as a sheet and trembling all over. Donati was left open-mouthed and could not go on. She was the first to recover. She picked up the embroidery lying beside her, but her hands were still trembling so much that her needle kept stabbing the cloth. He became annoyed with himself for being so foolish. 'What's wrong?' he said at last. 'Are you angry with me? Will you never forgive me?'

The woman looked up in dismay and stared at him as

though astounded. She bowed her head again, and in a faint and unsteady voice muttered a few unintelligible words

Donati's visits gradually became less frequent. Corsi behaved ever more coldly towards him. Whenever the two former friends found themselves in each other's company, they felt, without knowing why, an inexplicable awkwardness. Their coldness transmitted itself from one to the other, and thereby increased. Had Corsi deduced everything from the altered behaviour of his wife and his friend, or had Lina told him the whole story? The last time Donati went to see her, on her nameday, he found her alone at home. Lina flushed deep red, and barely suppressed a flinch of surprise. Donati was left fiddling helplessly with his hat, floundering for the right words.

She was seated on the sofa, with such formality the poor visitor felt like jumping out of the window. The visit lasted ten minutes. As he went down the stairs, the former Pollux murmured in a choked voice, 'It's all over! It's all over!'

After that, he did not have the courage to knock at that door again. He would go home dragging his feet, as late as possible, glancing furtively up at that lighted window which reminded him of those happy evenings beside the fire, with a warm heart and warm feet, and he would hurry across the staircase landing. His modest rooms had never seemed more silent, more cold and melancholy. Now the poor lonely fellow spent as little time as possible there. Being out and about, he did what Corsi had done, and met another Lina.

Come September, Corsi moved house without even saying goodbye to him, and they had not seen each other since. Lina had been ill, seriously ill. Donati found out much later. He was told her illness had greatly affected her. He often thought of her, often pictured that delicate, pale profile and those feverish eyes, with almost a pang, almost remorse. But he could never have imagined the effect that face and those furtive glance would have on him the first time he ran into Lina, with his wife-to-be. She had turned to take a sneaking look at him, the way people look at a monster or a criminal.

★

Now a year had gone by, and the feast of St Agatha had come round again. Donati was soon to get married. He was waiting in the crowd for a masker who had more or less promised she would appear for a moment, when he suddenly felt someone grab him by the arm. He took a rapid glance at the masked woman, but his fiancée was of smaller stature and did not have such glittering black eyes. His heart missed a beat. He did not know what to say, and he let himself be led into a café.

His companion chose an isolated table and sat down opposite him. She seemed tired and extremely emotional. He studied her anxiously. 'Lina!' he finally exclaimed.

'Ah!' she said, with a laugh expressive of so many things, and rested her mantled forehead on her hand.

Donati stammered out a few meaningless words.

'Are you surprised to see me here?' Lina asked after a long silence.

'You?'

'Are you surprised?'

Donati bowed his head. She let her mantle fall onto her shoulders, and murmured, 'Look!'

'My God!' exclaimed Donati.

'Do you feel sorry for me? Oh, if only that at least! But it's not your fault, no! I've always been of delicate health. . . . So don't worry . . . I wouldn't like to spoil your honeymoon.'

'Oh, what are you saying! If you knew . . . if only you knew how much I've suffered!'

'You?'

'Yes! And how sorry I am . . .'

'Ah, you're sorry!'

'I can't forgive myself! I can't understand . . . what happened . . .'

'You don't know?'

'No, on my life!'

'What happened was . . . I fell in love with you.'

'You! You!'

She turned even paler, leapt to her feet, and said to him in a strangled voice, 'Why then did you tell me that dream?'

THE GOLD KEY

They were reciting the rosary after dinner at the canonry in Santa Margherita, when suddenly a gunshot rang out in the dark.

The canon turned pale, with the beads still in his hand, and the women crossed themselves, straining their ears, while the dogs in the yard barked furiously. Almost immediately an answering shot resounded in the gorge beneath the Fortress.

'Jesus and Mary, what on earth could that be?' exclaimed the maid from the kitchen doorway.

'Quiet everyone!' cried the canon, as white as a sheet. 'I'm trying to listen.'

And he went and stood at the window, behind the shutter. The dogs had calmed down, and outside the wind could be heard in the valley. All at once the barking resumed even louder than before, and in the midst of it, at intervals, came the sound of someone banging at the gate with a stone.

'Don't let anyone in!' shouted the canon, running to fetch the rifle at his bedside, beneath the crucifix. His hands were shaking. Then, amid the uproar, someone was heard shouting on the other side of the gate. 'Open up, your reverence, it's me, Surfareddu!' And when the bailiff down on the ground floor finally went out to quieten the dogs and unbolt the gate, in came Surfareddu, with a grim look on his face, and the shotgun he was holding still warm in his hand.

'What's going on, Grippino? What happened?' asked the canon.

'What's going on, your reverence is that while you're asleep and resting, I'm risking my life to protect what's yours,' replied Surfareddu.

And, standing on the threshold, rocking on his feet in that particular way of his, he described what had happened. He had not been able to sleep because it was so hot, and had gone to stand at the door of his hut, over there on the mound, when

he heard a noise in the gorge, where the orchard was, a noise of a kind distinguishable only to his ears, and to Bellina, a thin mangy bitch that followed at his heels. Someone was beating down oranges and other fruit in the orchard. No wind ever made a rustling like that – and then intervals of silence while they filled their sacks. So he had taken his gun from beside the door of his hut, the old long-barrelled flintlock with brass fittings that he held his hand. Talk about fate! Because this was the last night he was to spend at Santa Margherita. He had given notice to the priest at Easter, with no hard feelings on either side, and on the first of September he was supposed to move to his new boss's place, over in Vizzini. Only the day before, everything had been settled up with the priest. And this was the thirty-first of August: a dark and starless night. Bellina went ahead of him, with her nose to wind, keeping quiet, just as he had taught her. He walked very slowly, picking his feet up so that no rustling of the hay would be heard. And the dog looked back every ten paces to see if he was behind. When they reached the gorge, he said quietly to Bellina, 'Get back!' And he took cover behind a big walnut tree. Then he gave a call: 'Ayee!'

'A call, God forbid!' the priest used to say, 'that would make your flesh creep, coming from Surfareddu, a man who in his capacity as watchman was responsible for more than one murder.'

'Then,' Surfareddu went on, 'then they shot at me at close range – bang! Fortunately I responded to the flash of their guns. There were three of them, and I heard screams. Go and look in the orchard, my man must be still there.'

'Oh, what have you done, you villain!' exclaimed the priest, while the women wailed among themselves. 'Now the magistrate and the police will be turning up, and you're leaving me in a mess.'

'Is that all the thanks I get from your reverence?' Surfareddu replied curtly. 'If they'd waited to rob you until I'd left your service, it would have better for me too, as I wouldn't have had this run-in with the law again.'

'Now get on your way to the Grilli, and tell the steward

that I sent you. You'll be needed there tomorrow. But for the love of God, don't let anyone see you, now that it's the prickly pear season and there are people all over these hillsides. Who knows what this incident is going to cost me? It would have been better if you'd turned a blind eye.'

'Oh no, your reverence! As long as I'm in your service, Surfareddu is not going to tolerate any infringement of this kind! They knew I was the watchman on your farm until August the thirty-first. So much the worse for them! I'm certainly not throwing my gunpowder away!'

And off he went, while it was still dark, with his shotgun over his shoulder and Bellina at his heels. No one in the house at Santa Margherita slept another wink that night, for fear of thieves and the thought of that man lying on the ground in the orchard. At daybreak, when passersby began to appear on the path opposite, up on the Fortress, the canon ventured out, armed to the teeth and with all the farmworkers behind him, to see what had happened. The women wailed, 'Don't go, your reverence!'

But just outside the yard they found that Luigino had sneaked out with the rest of them.

'Take that child away,' shouted his uncle, the canon.

'No! I want to come and see, too!' screamed the boy. And the sight that met his eyes at such a young age remained imprinted on his mind ever afterwards, for as long as he lived.

A few steps into the orchard, he lay on the ground, under an old diseased olive tree, his face the ashen colour of dying men. He had dragged himself on his hands and knees to a pile of empty sacks and there he had remained all night long. His companions had run off carrying all the full sacks with them. Nearby was a patch of earth raked by his fingernails and all blackened with blood.

'Ah! Your reverence,' mumbled the dying man. 'I've been killed for the sake of few olives!'

The canon gave him absolution. Then, around midday, the magistrate arrived with the police, ready to blame the canon and tie him up like a criminal. Fortunately there were all the

farmworkers and the bailiff and his family as witnesses. Nevertheless, the magistrate railed against this servant of God who was like some ancient baron in his arrogant behaviour, and employed the likes of Surfareddu as watchmen and had people killed for the sake of a few olives. He wanted the murderer handed over dead or alive, and the canon perjured himself, swearing that it was all a complete mystery to him. Until after a while the magistrate accused him of being an accessory, and instigator, and threatened to have him tied up by the police anyway. And so the shouting went on, and the to-ing and fro-ing under the orange trees in the orchard, while the doctor and the registrar did their duty regarding the dead man lying on the empty sacks.

Then the table was moved into the shade in the orchard because of the heat, and the women persuaded the magistrate to take some refreshment because it was starting to get late. The cook excelled herself: marcaroni, sauces of every kind, and even the ladies went to great lengths so that the table should not disgrace anyone on that occasion. The magistrate ended up licking his fingers.

Afterwards, the registrar turned back a bit of the tablecloth from one corner, and hurriedly wrote out a ten-line report, with the signature of the witnesses and everything else, while the magistrate drank the coffee that had been specially made with the coffee machine, and the farm workers looked on from a distance, half hidden among the orange trees. Finally the canon himself went to fetch a bottle of an aged muscatel that would have raised the dead.

Meanwhile, the body had been perfunctorily buried beneath the old diseased olive tree. When the time came to leave, the magistrate accepted a bunch of flowers from the ladies, who had two large baskets of the finest fruit loaded into the saddlepacks of the registrar's mule; and the canon accompanied the visitors to the edge of his estate.

The next day a messenger arrived from the district administration office to say that the magistrate had lost his watchkey in the orchard, and could they have a good search for it, as it was sure to be there.

'Give me two days, and we'll find it,' the canon had conveyed to him. And he wrote at once to a friend in Caltagirone, asking him to buy a watchkey. A fine gold key that cost him two *onze*, and he sent it to the magistrate, saying, 'Is this the key you lost, magistrate?'

'Yes indeed it is,' the latter replied. And the legal proceedings followed their course in a straightforward manner, up to the events of 1860, and Surfareddu returned to work as a watchman after Garibaldi's pardon, till he was stoned to death in a dispute with some watchmen over certain pasturing rights. And whenever the canon spoke about what had happened that night that caused him such trouble, he would say of the magistrate of that time, 'He was a gentleman! Because instead of just losing the key, he might have had me looking for the watch and chain as well!'

In the orchard, under the old tree where the olive thief is buried, grow cabbages as big as the heads of children.

COMRADES

'Malerba?'

'Yes, sir!'

'There's a button missing here, where is it?'

'I don't know, corporal.'

'Confined to barracks!'

The same as ever: coat like a sack, gloves that he felt uncomfortable wearing, not knowing what to do with his hands when he had them on, bone-headed in training and on the parade ground. And unsociable! No matter in which beautiful town he was garrisoned, he never went to see the main streets, or palaces, or fairs, not even the amusement stalls or merry-go-rounds. He spent the time they were allowed out wandering the streets outside the city walls, swinging his arms, or he would watch the women hunkered down weeding the ground in Piazza Castello; or else plant himself in front of the chestnut stall, without ever spending any money. The lads made fun of him behind his back. Gallorini drew a charcoal sketch of him on the wall, with his name below. He didn't let it bother him. But when as a joke they stole the cigarette butts he kept hidden in his gun-barrel, he flew into a rage, and once he went to prison for a punch that half-blinded Il Lucchese – the bruise was still visible – and stubborn as a mule, he kept saying, 'I didn't do it.' 'Well then, who was it that did thump Il Lucchese?' 'I don't know.' And he would sit on his bunk with his chin in his hands. 'When I get back home!' It was his constant refrain.

'Well, tell us about it. Have you got a lover at home?' asked Gallorini.

He stared at Gallorini, with suspicion, and jerked his head. Neither a yes nor a no. Then he took to staring off into the distance. Every day, he would use a pencil stub to tick off a little calendar he carried in his pocket.

Gallorini, though, had a lover right there. A big fat woman with a moustache whom they had seen him with at a café one

175

Sunday, sitting together with a glass of beer in front of them, which she insisted on paying for. Il Lucchese found out, while hanging about there with Gegia, who never cost him anything. With his sweet talk, Il Lucchese would find himself Gegias everywhere, and so that they should not take offence at all being lumped together even to sharing a name, he said that where he came from it was a customary term of endearment for your beloved, whether she was called Teresa, Assunta or Bersabea.

That was when it began to be rumoured that there was going to be war with the Germans. Soldiers coming and going, crowds in the street, and people turning up to watch the military drill in Piazza d'Armi. When the regiment paraded, with bands playing and onlookers applauding, Il Lucchese marched with a swagger, as though he were the star of the show, and Gallorini was constantly saluting friends and acquaintances, with his arm up in the air the whole time, saying that he intended to come back either a dead man or an officer.

'Aren't you happy to be going to war?' he asked Malerba when they piled up their weapons at the station.

Malerba shrugged his shoulders and continued to observe the people shouting and cheering, 'Hurrah!'

Il Lucchese even saw Gegia in the crowd, watching with curiosity from a distance, clinging to some young lout in workman's clothes who was smoking a pipe. 'That's called hedging your bets!' muttered Il Lucchese, who could not break ranks, and he asked Gallorini if his girlfriend had joined the grenadiers so as not to be parted from him.

It was like a carnival, wherever they arrived. Flags, lanterns, and peasants who would run up the embankment, to watch the train cram-full of forage-caps and guns go by. But then sometimes in the evenings, when the trumpets sounded lights-out, they felt seized with longing, for Gegia, their friends, everything left behind. The minute the post arrived at the camp, they would go running en masse to reach out their hands for it. Malerba would be left by himself, bemused, evidently not expecting anything. He still marked off his calendar

every day. Then he would listen to the band, from a distance, thinking of who knows what.

One evening at last there was great activity in the camp. Officers hurrying to and fro, baggage waggons heading towards the river. Reveille was sounded two hours after midnight; but even so, there was a distribution of rations and camp was struck. After that, the regiment set off.

It was going to be a hot day. Malerba, who knew about such things, could smell it in the gusts of wind that raised thick clouds of dust. Then the rain came down in big sparse drops. Whenever the showers stopped, at sporadic intervals, and the corn ceased rustling, the crickets began to sing loudly, in the fields, on either side of the road. Il Lucchese, who was marching behind Malerba, amused himself behind his back. 'Move it, comrade! What's keeping you so quiet? Thinking of your last will and testament, maybe?'

With a shrug of his shoulders, Malerba adjusted the pack on his back, and muttered, 'Get lost!'

'Leave him alone,' said Gallorini. 'He's thinking of his girl-friend, how, if the Germans get him, she'll find herself some other guy.'

'You take a walk, too!' replied Malerba.

Suddenly out of the darkness came the clink of a sabre and the sound of a horse trotting by, passing between the two columns of the regiment marching on either side of the road.

'Good luck on your journey!' said Il Lucchese, who was the comedian of the group. 'And regards to the Germans, if you happen to run into them.'

A group of houses showed up pale against a large patch of darkness on the right. And a guard dog barked furiously, running alongside the hedge.

'That's a German dog,' said Gallorini, trying to crack jokes like Il Lucchese. 'Can't you tell from the way it barks?'

It was still very dark. On the left, above what looked like a big black cloud, which must have been a hill, shone a bright star.

'I wonder what time it is?' said Gallorini.

177

Malerba sniffed the air and said at once, 'It'll be at least an hour before the sun rises!'

'What a joke!' grumbled Il Lucchese. 'Getting us up at an ungodly hour for nothing!'

'Halt!' ordered a curt voice.

The regiment continue to shuffle about, like a flock of sheep herding together.

'Oh, what are we waiting for?' mumbled Il Lucchese after a while. Another group of horsemen passed by. This time, as day broke they could see the lancers' pennants flying, and a general ahead, with braiding all the way up to the top of his cap, his hands stuffed in the pockets of his jacket. The road was beginning to grow paler, running in a straight line through the still-dark countryside. The hills seemed to emerge one by one into the uncertain half-light; and a burning fire was visible in the distance, perhaps belonging to some woodcutter, or peasants who had fled before the oncoming tide of soldiers. The birds wakened by the disturbance twittered on the branches of the mulberry trees that materialized in the dawn.

Shortly afterwards, as it grew lighter, a deep rumble, like thunder, was heard from the left, where the horizon broadened in a glimmering of pink and gold, an unnerving sound in that cloudless sky. It might have been the burbling of the river, or the rumbling of the artillery on the march. Suddenly the word went round: 'A cannon!' And they all turned to look towards the golden horizon.

'I'm tired,' Gallorini grumbled.

'They should call a halt,' Il Lucchese agreed.

The talking died out as the soldiers advanced in the heat of the day, amid strips of brown earth and green sown land, vines flowering on the hillsides, rows of mulberry trees as far as the eye could reach. Lonely cottages and abandoned farmhouses were to be seen, here and there. Approaching a well to drink some water, they saw tools lying on the ground at the entrance to a hut, and a cat peering out from the broken doors, miauling.

'Look!' said Malerba. 'Their corn's ripe, poor folk!'

'Want to bet that you don't get to eat that bread?' said Il Lucchese.

'Shut up!' replied Malerba. 'I'm wearing the Madonna's scapular.' And he made a gesture with his fingers to ward off the evil eye.

At that moment a booming came again from the left, towards the plain. At first, isolated bursts that echoed from the hills. Then what sounded like the crackle of rockets, almost as if the village were celebrating. Above the green-capped summit they could see the tranquil belltower in the azure sky.

'No, it's not the river,' said Gallorini.

'Nor the waggons passing.'

'Do you hear that!' shouted Gallorini. 'The party's begun, over there.'

'Halt!' came the order once again. Il Lucchese listened, with raised eyebrows, and said no more. Malerba was standing beside a milestone, and he sat down on it, with his gun between his legs

The bombardment must have been taking place on the plain. Smoke appeared at every explosion, like small dense clouds, that barely rose above the rows of mulberry trees and slowly disintegrated. Peaceful meadows descended to the plain, with the song of quail rising from the turf.

The colonel, on horseback, was talking to a group of officers standing by the side of the road, looking down on the plain every now and again with his spy-glass. He no sooner began to trot than the regiment trumpets all blared together: 'Forward!'

To left and right were bare fields. Then the occasional patch of maize again. Then vines, and water courses, and finally some dwarf saplings. The first houses of a village came into view; the road was choked with waggons and horses. A bewildering din, such chaos.

A cavalryman came galloping up, white with dust. His mount, a stocky long-haired black horse, had red steaming nostrils. Then a staff officer went by, yelling like a maniac to clear the road, striking out with his sabre to left and right at those poor noncombatant mules. Through the elm trees

lining the road the infantry could be seen running forward, their black plumes streaming in the wind.

Now they were following a track that bore right. The soldiers trampled over the seeded ground, which made Malerba feel like weeping. On the top of a rise they saw a group of mounted officers wearing the tricorne hats of carabinieri, with a rear escort of lancers. Three or four paces ahead of them, on horseback, with his hand on his hip, was some bigwig, to whom the generals responded with their hands to their peaked caps, and as the officers passed by, they saluted him with their sabres.

'Who's that?' asked Malerba.

'Vittorio,' replied Il Lucchese. 'Haven't you ever seen him on coins, stupid.'

The soldiers looked back, for as long as they could. Then Malerba said to himself, 'That's the King!'

Further on, there was a dried-up riverbed. The opposite bank, covered with scrub, rose into the mountainside, dotted with pollarded elms. There was no sound of bombardment. In that quietness, a blackbird began to whistle in the bright morning.

Suddenly it was like a storm breaking. The summit, the belltower, everything was wreathed in smoke. With every cannonball, branches of trees cracked, here and there dust rose from the ground. A shell wiped out a group of soldiers. From the top of the hill they heard great cries every now and again, like cheering. 'Holy Mother!' stammered Il Lucchese. The sergeants ordered them repeatedly to drop their packs. Malerba obeyed reluctantly, because he had two new shirts in his, and all his belongings.

'Hurry! Hurry!' the sergeants kept saying. With the rumbling of an earthquake, a few pieces of artillery came thundering up a stony path at a gallop; officers to the fore, soldiers bowed over the bristling manes of steaming horses, whipping them on for all they were worth, and gunners with their hands to the hubs and wheels, pushing them up the slope.

In the midst of the furious roar of cannonfire a wounded horse could be seen bolting across the hillside, with its traces

hanging loose, whinnying, breaking off the tops of the vines, kicking out desperately. Further below, stood swarms of ragged and bloodied soldiers, without their caps, waving their arms about. Finally, entire squads of soldiers, were slowly retreating, stopping to release scattered fire from among the trees. Trumpets and drums sounded the charge. The regiment rushed up the slope like a torrent of men.

Il Lucchese's heart quaked – why this frantic hurry for whatever was awaiting them up there! Gallorini shouted, 'Savoy!' And to Malerba who was dragging his feet, he said, 'Move it, comrade!'

'Get lost!' Malerba replied.

As soon as they got to the top, in a small area of rock-strewn meadow, they came face to face with the Germans, advancing in close formation. A flash of light streaked across those thronging masses; gunfire rang out from one side to the other. A young officer, just out of college, fell at that moment, with his sabre in his hand. Il Lucchese reeled about a little, with his arms outstretched, as if he were stumbling, then he too fell. But after that, it was impossible to see anything. The men fought hand to hand, with blood in their eyes.

'Savoy! Savoy!'

At last the Germans had had enough, and began to fall back slowly. The grey coats went storming after them. In the headlong rush, Malerba felt as if he had been hit by a stone, which made him limp. Then he realized there was blood seeping through his trousers. Like a maddened bull, he charged, head down, with thrusts of his bayonet. He saw a big blond devil coming towards him with his sabre above his head and Gallorini pointing the muzzle of his rifle at his back.

The trumpets sounded the rally. Now all that was left of the regiment, banding together, in groups, ran towards the village, lying resplendent in the sunshine, immersed in greenery. However, at the very first houses there was evidence of the carnage which had taken place. Cannons, horses, wounded infantry, in great disorder. Smashed doors, shutters hanging from windows like rags in the sun. Inside a courtyard there

was a heap of wounded men lying on the ground, and a waggon with its shafts up in the air, still loaded with wood.

'What about Il Lucchese?' asked Gallorini, breathlessly.

Malerba had seen him fall. Nevertheless he instinctively looked back at the hill that was swarming with men and horses. Weapons glistened in the sun. In the middle of the open ground, officers on foot could be seen looking into the distance with a spy-glass. Companies of men came down the hill, one by one, with flashes of light along their lines.

It must have been about ten – ten o'clock, in June, with the sun overhead. Falling on it as though completely parched, an officer drank the water in which they were washing the brushes for cleaning the cannon-barrels. Gallorini lay prone on the ground, by the cemetery wall, his face in the grass; there at least, in the thick grass, a little coolness came from the graves. Malerba, sitting on the ground, bound his leg with a handkerchief, as best he could. He was thinking of Il Lucchese, poor fellow, who had fallen by the wayside, belly up.

'They're back, they're back!' a voice shouted. The trumpet gave the call to arms. Ah! This was too much for Gallorini! Not even a moment's rest! He got up like a wild beast, in complete tatters, and grabbed his gun. The company hurriedly took up positions, among the first houses of the village, behind the walls, at the windows. Two cannons stood in the middle of the road, with their black necks outstretched. They could see the Germans coming in serried ranks, one battalion after another, endless numbers of them.

That was when Gallorini was hit. A bullet got him in the arm. Malerba tried to help him.

'What is it?'

'Nothing, leave me alone.'

Even the lieutenant was firing like an ordinary soldier, so he had to rush off to lend a hand. At every shot Malerba kept saying, 'Let me do it, it's my job!' The Germans disappeared again. Then the order to retreat was given. The regiment was exhausted. Gallorini and Il Lucchese were lucky to be getting some rest. Gallorini had sat on the ground, against the wall, and would not budge. It was about four – over eight hours

they had been in that heat, their mouths dry with dust. However, Malerba had got a taste for it, and he asked, 'What shall we do now?' But no one paid any attention to him. They were descending towards the river, accompanied all the time by the music of the bombardment on the hill. Then from a distance they saw the village swarming with uniforms. Nothing made sense any more, they did not know where they were going, or what was happening. At a curve in the embankment they came across the hedge behind which Il Lucchese had fallen. Nor was Gallorini with them any more. They were returning in disarray, new faces unfamiliar to each other, grenadiers and regular infantry, following ragged officers who limped along, dragging their feet, with their rifles loaded on their shoulders.

Calming darkness fell, in great silence, everywhere.

They kept passing waggons, cannons and soldiers, making their way in the dark, without trumpets and without drums. When they got to the other side of the river, they discovered they had lost the battle.

'What?' said Malerba. 'What?' And he could not believe it.

Then when his term of service was over, he went back to his village, and found Marta already married, having got tired of waiting for him. He did not have time to waste either, and he married a widow of substance. Some time afterwards, Gallorini turned up, with a wife and children too, working on the nearby railway.

'Hey, Malerba! What are you doing here? I'm a jobber. I learned my trade abroad, in Hungary, when I was taken prisoner, do you remember? My wife brought me a bit of capital . . . Hard world, eh? You thought I'd got rich? However we did our duty. But we're not the ones that ride in a carriage. What's required is a good turning over of the soil, so we can start again from scratch.' He would repeat the same sermon to his workers, on Sundays at the tavern. They would listen, poor souls, and nod their heads, sipping their sour wine, enjoying the sun on their backs, like animals, just the same as Malerba, who was capable of nothing else but sowing, harvesting and producing offspring. He would nod

his head diplomatically, whenever his comrade was talking, but he never opened his mouth. Gallorini on the other hand had seen the world, he had an opinion about the rights and the wrongs of everything; especially the wrong that was being done to him, having to go all over the place to find work, with a bevy of kids and a wife to support, while so many others went riding about in a carriage.

'You know nothing about what goes on in the world! If there's a demonstration, and people are shouting long live so and so, or down with so and so, you don't know what to say. You've no idea what's needed!'

And Malerba's response was always to nod his head. What was needed now was water for sowing. And next winter the barn would be needing a new roof.

CAVALLERIA RUSTICANA

AND OTHER STORIES

translated by
D. H. Lawrence

CAVALLERIA RUSTICANA

Turiddu Macca, son of old Mother Nunzia, when he came home from being a soldier, went swaggering about the village square every Sunday, showing himself off in his *bersagliere's* uniform with the red fez cap, till you'd have thought it was the fortune-teller himself come to set up his stall with the cage of canaries. The girls going to Mass with their noses meekly inside their kerchiefs stole such looks at him, and the youngsters buzzed round him like flies. And he'd brought home a pipe with the king on horseback on the bowl, simply life-like, and when he struck a match on his trousers behind, he lifted his leg up as if he was going to give you a kick.

But for all that, Lola, Farmer Angelo's daughter, never showed a sign of herself, neither at Mass nor on her balcony; for the simple reason that she'd gone and got herself engaged to a fellow from Licodia, a carter who took contracts, and had four handsome Sortino mules of his own in his stable.

When Turiddu first got to hear of it, oh, the devil! he raved and swore! – he'd rip his guts out for him, he'd rip'em out for him, that Licodia fellow! But he never did a thing, except go and sing every slighting song he could think of under the beauty's window.

'Has Mother Nunzia's Turiddu got nothing else to do but sing songs like a forlorn sparrow, every mortal night?' said the neighbours.

However, he ran into Lola at last, as she was coming back from her little pilgrimage to Our Lady of Peril; and she, when she saw him, never turned a hair, as if it was nothing to do with *her*.

'It's rare to set eyes on you!' he said to her.

'Hello, Turiddu! They told me you'd come back on the first of this month.'

'They told me more than that!' he replied. Is it right as you're marrying Alfio, as contracts for carting?'

'God willing, I am,' replied Lola, twisting the corners of her kerchief at her chin.

'There's a lot o' God willing about it! You suit your own fancy! And it was God willing as I should come home from as far as I did, to hear this nice bit of news, was it, Lola?'

The poor man tried to keep a good face, but his voice had gone husky; and he walked on at the heels of the girl, the tassel of his fez cap swinging melancholy to and fro, on his shoulders. And to tell the truth, she was sorry to see him with such a long face; but she hadn't the heart to cheer him up with false promises.

'Look here, Turiddu,' she said at last to him, 'let me go on and join the others. What do you think folks'll say if they see me with you?'

'You're right!' replied Turiddu. 'Now you're going to marry that chap Alfio, as has got four mules of his own in his stable, it'd never do to set folks talking! Not like my poor old mother, as had to sell our bay mule and the bit of a vineyard, while I was away soldiering. Ah well, the time's gone by when Bertha sat a-spinning! And you've forgotten how we used to talk together at the window in the yard, and how you gave me that handkerchief before I went away – God knows how many tears I cried in it, going that far off, I'd almost forgotten even the name of where I came from. Well, good-bye, then, Lola. *It showered a while, and then left off, and all was over between us!*'

And so Miss Lola married the carter; and the Sunday after, there she sat on her balcony, with her hands spread on her stomach to show all the great gold rings her husband had given her. Turiddu kept going back and forth, back and forth up the narrow street, his pipe in his mouth and his hands in his pockets, to show he didn't care, and ogling all the girls. But it gnawed him inside himself to think that Lola's husband should have all that gold, and that she pretended not to notice him, when he passed.

'I'll show that bitch summat, afore I've done!' he muttered to himself.

Across from Alfio's house lived Farmer Cola, the wine-grower, who was as rich as a pig, so they said, and who had a

daughter on his hands. Turiddu so managed it that he got Farmer Cola to take him on, helping in the vines, and then he started hanging round the house, saying nice things to the girl.

'Why don't you go and say all those sweet nothings to Mrs. Lola, over the road?' Santa replied to him.

'Mrs. Lola thinks she's somebody. Mrs. Lola's married My Lord Tom-noddy, she has!'

'And I'm not good enough for a Lord Tomnoddy, am I?'

'You're worth twenty Lolas. And I know somebody as wouldn't look at Mrs. Lola, nor at the saint she's named after, if you was by. Mrs. Lola's not fit to bring you your shoes, she's not.'

'Ah là! it's sour grapes, as the fox said when he couldn't reach.'

'No, he didn't! He said: "Ah, but *you're* sweet, my little gooseberry!"'

'Eh! Keep your hands to yourself, Turiddu!'

'Are you afraid I shall eat you?'

'I'm neither afraid of you nor your Maker.'

'Eh! your mother was a Licodia woman, we know it! You've got a temper right enough. Oh! I could eat you with my eyes!'

'Eat me with your eyes, then; we shall make no crumbs! But while you're at it, lift me that bundle of kindling.'

'I'd lift the whole house up for you, that I would.'

She, to hide her blushes, threw a stick at him which she'd got in her hand, and for a wonder missed him.

'Let's look sharp! We shall bind no kindling with nothing but talk.'

'If I was rich, I should look for a wife like you, Miss Santa.'

'Eh well! I shan't marry my Lord Tomnoddy, like Mrs. Lola, but I shan't come empty-handed neither, when the Lord sends me the right man.'

'Oh ay! we know you're rich enough, we know that.'

'If you know it, then hurry up; my Dad'll be here directly, and I don't want him to catch me in the yard.'

Her father began by making a wry face, but the girl pretended not to notice. The tassel of the *bersagliere*'s cap had

189

touched her heart, swinging in front of her eyes all the time. When her father put Turiddu out of the door, she opened the window to him, and stood there chattering to him all the evening, till the whole neighbourhood was talking about nothing else.

'I'm crazy about you,' Turiddu said. 'I can neither eat nor sleep.'

'You say so –'

'I wish I was Victor Emmanuel's son, so I could marry you.'

'You say so –'

'Oh, Madonna, I could eat you like bread!'

'You say so –'

'Ah, I tell you it's true!'

'Eh, mother, mother!'

Night after night Lola listened, hidden behind a pot of sweet basil at her window, and going hot and cold by turns. One day she called to him:

'So that's how it is, Turiddu? Old friends don't speak to one another any more!'

'Why!' sighed the youth. 'It's a lucky chap as can get a word with you.'

'If you want to speak to me, you know where I live,' replied Lola.

Turiddu went so often to speak to her, that Santa was bound to notice it, and she slammed the window in his face. The neighbours nodded to one another, with a smile, when the *bersagliere* went by. Lola's husband was away, going round from fair to fair, with his mules.

'I mean to go to confession on Sunday. I dreamed of black grapes last night,' said Lola.

'Oh, not yet, not yet!' Turiddu pleaded.

'Yes. Now it's getting near Easter, my husband will want to know why I've not been to confession.'

'Ah!' murmured Farmer Cola's Santa, waiting on her knees for her turn in front of the confessional, where Lola was having a great washing of her sins: 'It's not Rome I'd send you to for a penance, it isn't, my word it isn't!'

Master Alfio came home with his mules, and a good load of cash, and brought a fine new dress as a present to his wife, for the festival.

'You do well to bring her presents,' his neighbour Santa said to him. 'She's been adorning your house for you, while you've been away.'

Master Alfio was one of those carters who go swaggering beside their horse with their cap over their ear; so when he heard his wife spoken of in that way, he went white as if he'd been stabbed.

'By God, though!' he exclaimed. 'If you've seen more than there was to see, I won't leave you your eyes to cry with, neither you nor the rest of your folks.'

'I'm not the crying sort,' replied Santa. 'I didn't cry even when I saw with my own eyes Mother Nunzia's Turiddu creeping into your wife's house at night.'

'All right!' replied Alfio. 'I'm much obliged!'

Now that the cat had come back, Turiddu no longer hung round the little street in the daytime, but whiled away his chagrin at the inn, with his friends; and on the Saturday evening before Easter they had a dish of sausages on the table. When Master Alfio came in, Turiddu knew in an instant, from the way he fixed his eyes on him, what he'd come for, and he put his fork down on his plate.

'Did you want me for anything, Alfio?' he said.

'Nothing particular, Turiddu. It's quite a while since I've seen you, and I thought I'd have a word with you – you know what about.'

At first Turiddu had offered him his glass, but he put it aside with his hand. Then Turiddu rose, and said:

'Right you are, Alfio!'

The carter threw his arms round his neck.

'Shall you come to the cactus grove at Canziria to-morrow morning, and we can talk about that bit of business of ours, boy?'

'Wait for me on the high road at sunrise, and we'll go together.'

With these words, they exchanged the kiss of challenge;

and Turiddu nipped the carter's ear between his teeth, thus promising solemnly not to fail him.

His friends had all quietly abandoned the sausages, and they walked home with Turiddu. Mother Nunzia, poor thing, sat up waiting for him till late every evening.

'Mother,' Turiddu said to her, 'you remember when I went for a soldier, you thought I should never come back? Now kiss me like you did then, because I'm going off in the morning, a long way.'

Before daybreak he took his clasp-knife, which he had hidden under the hay when he was taken off as a conscript to the army, and then he set out for the cactus grove at Canziria.

'Oh Jesu-Maria! where are you going in such a fury?' whimpered Lola in dismay, as her husband was getting ready to go out.

'I'm not going far,' replied Master Alfio. 'And better for you if I never came back.'

Lola, in her night-dress, kneeled praying at the foot of the bed, pressing to her lips the rosary which Fra Bernardino had brought from the Holy Land, and repeating all the *Ave Marias* there were to repeat.

'You see, Alfio,' Turiddu began, after he had walked for some distance along the road beside his silent companion, who had his cap pulled down over his eyes, 'as true as God's above, I know I'm in the wrong, and I would let myself be killed. But my old mother got up before I started out, pretending she had to see to the fowls, and I could tell she knew. So as sure as God's above, I'm going to kill you like a dog, so the poor old woman shan't have to cry her eyes out.'

'All right, then,' replied Alfio, pulling off his sleeved waistcoat. 'Now we shall strike hard, both of us.'

They were both good fighters with the knife. Alfio struck the first thrust, and Turiddu was quick enough to catch it on his arm. When he gave it back, he gave a good one, aiming at the groin.

'Ah! Turiddu. Do you really mean to kill me?'

'Yes, I told you! Since I saw my old woman with the fowls, I can't get her out of my eyes.'

'Then open your eyes, then!' Alfio shouted at him; 'I'll give you more than you asked for.'

And as the carter stood on guard, doubled up so as to keep his left hand over his wound, which hurt him, his elbow almost brushing the ground, suddenly he seized a handful of dust and threw it full in his enemy's eyes.

'Ah!' screamed Turiddu, blinded. 'I'm done!'

He tried to save himself by jumping desperately backwards, but Alfio caught him up with another stab in the stomach, and a third in the throat.

'– and three! That's for the house which you adorned for me! And now your mother can mind her fowls –'

Turiddu reeled about for a moment or two here and there among the cactuses, then fell like a stone. The blood gurgled frothing from his throat, he couldn't even gasp: Oh, Mother!

LA LUPA

She was tall, and thin; but she had the firm, vigorous bosom of a brown woman, though she was no longer young. Her face was pale, as though she had the malaria always on her, and in her pallor two great dark eyes, and fresh, red lips, that seemed to eat you.

In the village they called her *la Lupa*, because she had never had enough — of anything. The women crossed themselves when they saw her go by, alone like a roving she-dog, with that ranging, suspicious motion of a hungry wolf. She bled their sons and their husbands dry in a twinkling, with those red lips of hers, and she had merely to look at them with her great evil eyes, to have them running after her skirts, even if they'd been kneeling at the altar of Saint Agrippina. Fortunately, *la Lupa* never entered the church, neither at Easter nor at Christmas, nor to hear Mass, nor to confess. Fra Angiolino, of Santa Maria di Jesu, who had been a true servant of God, had lost his soul because of her.

Maricchia, poor thing, was a good girl and a nice girl, and she wept in secret because she was *la Lupa's* daughter, and nobody would take her in marriage, although she had her marriage-chest full of linen, and her piece of fertile land in the sun, as good as any other girl in the village.

Then one day *la Lupa* fell in love with a handsome lad who'd just come back from serving as a soldier, and was cutting the hay alongside her in the closes belonging to the lawyer: but really what you'd call falling in love, feeling your body burn under your stuff bodice, and suffering, when you stared into his eyes, the thirst that you suffer in the hot hours of June, away in the burning plains. But he went on mowing quietly, with his nose bent over his swathe, and he said to her: 'Why; what's wrong with you, Mrs. Pina?' In the immense fields, where only the grasshoppers crackled into flight, when the sun beat down like lead, *la Lupa* gathered armful after armful together, tied sheaf after sheaf,

without ever wearying, without straightening her back for a moment, without putting her lips to the flask, so that she could keep at Nanni's heels, as he mowed and mowed, and asked her from time to time: 'Why, what do you want, Mrs. Pina?'

One evening she told him, while the men were dozing in the stackyard, tired from the long day, and the dogs were howling away in the vast, dark, open country: 'You! I want you! Thou'rt handsome as the day, and sweet as honey to me. I want thee, lad!'

'Ah! I'd rather have your daughter, who's a filly,' replied Nanni, laughing.

La Lupa clutched her hands in her hair, and tore her temples, without saying a word, and went away, and was seen no more in the yard. But in October she saw Nanni again, when they were getting the oil out of the olives, because he worked next to her house, and the screeching of the oil-press didn't let her sleep at night.

'Take the sack of olives,' she said to her daughter, 'and come with me.'

Nanni was throwing the olives under the millstone with the shovel, in the dark chamber like a cave, where the olives were ground and pressed, and he kept shouting *Ohee!* to the mule, so it shouldn't stop.

'Do you want my daughter Maricchia?' Mrs. Pina asked him.

'What are you giving your daughter Maricchia?' replied Nanni.

'She has what her father left, and I'll give her my house into the bargain; it's enough for me if you'll leave me a corner in the kitchen, where I can spread myself a bit of a straw mattress to sleep on.'

'All right! If it's like that, we can talk about it at Christmas,' said Nanni.

Nanni was all greasy and grimy with the oil and the olives set to ferment, and Maricchia didn't want him at any price; but her mother seized her by the hair, at home in front of the fireplace, and said to her between her teeth:

'If thou doesn't take him, I'll lay thee out!'

La Lupa was almost ill, and the folks were saying that the devil turns hermit when he gets old. She no longer went roving round; she no longer sat in the doorway, with those eyes of one possessed. Her son-in-law, when she fixed on him those eyes of hers, would start laughing, and draw out from his breast the bit of Madonna's dress, to cross himself. Maricchia stayed at home nursing the children, and her mother went to the fields, to work with the men, just like a man, weeding, hoeing, tending the cattle, pruning the vines, whether in the north-east wind or the east winds of January, or in the hot, stifling African wind of August, when the mules let their heads hang in dead weight, and the men slept face downwards under the wall, on the north side. *Between vesper bell and the night-bell's sound, when no good woman goes roving round*, Mrs. Pina was the only soul to be seen wandering through the countryside, on the ever-burning stones of the little roads, through the parched stubble of the immense fields, which lost themselves in the sultry haze of the distance, far off, far off, towards misty Etna, where the sky weighed down upon the horizon, in the afternoon heat.

'Wake up!' said *la Lupa* to Nanni, who was asleep in the ditch, under the dusty hedge, with his arms round his head. 'Wake up! I've brought thee some wine to cool thy throat.'

Nanni opened his eyes wide like a disturbed child, half-awake, seeing her erect above him, pale, with her arrogant bosom, and her eyes black as coals, and he stretched out his hand gropingly, to keep her off.

'No! No good woman goes roving round between vespers and night,' sobbed Nanni, pressing his face down again in the dry grass of the ditch-bottom, away from her, clutching his hair with his hands. 'Go away! Go away! Don't you come into the stackyard again!'

She did indeed go away, *la Lupa*, but fastening up again the coils of her superb black hair, staring straight in front of her, as she stepped over the hot stubble, with eyes black as coals.

And she came back into the stackyard time and again, and Nanni no longer said anything; and when she was late coming, in the hour between evensong and night, he went to the top of the white, deserted little road to look for her, with sweat on his forehead; and afterwards, he clutched his hair in his hand, and repeated the same thing every time: 'Go away! Go away! Don't you come into the stackyard again!'

Maricchia wept night and day; and she glared at her mother with eyes that burned with tears and jealousy; like a young she-wolf herself now, when she saw her coming in from the fields, every time silent and pallid.

'Vile woman!' she said to her. 'Vile, vile mother!'

'Be quiet!'

'Thief! Thief that you are!'

'Be quiet!'

'I'll go to the Sergeant, I will.'

'Then go!'

And she did go, finally, with her child in her arms, went fearless and without shedding a tear, like a madwoman, because now she also was in love with that husband of hers, whom they'd forced her to accept, greasy and grimy from the olives set to ferment.

The Sergeant went for Nanni, and threatened him with gaol and the gallows. Nanni began to sob and to tear his hair; he denied nothing, he didn't try to excuse himself. – 'It's the temptation,' he said. 'It's the temptation of hell!' and he threw himself at the feet of the Sergeant, begging to be sent to gaol.

'For pity's sake, Sergeant, get me out of this hell! Have me hung, or send me to prison; but don't let me see her again, never, never!'

'No!' replied *la Lupa* to the Sergeant. 'I kept myself a corner in the kitchen, to sleep in, when I gave her my house for her dowry. The house is mine. I won't be turned out.'

A little while later, Nanni got a kick in the chest from a mule, and was likely to die; but the parish priest wouldn't bring the Host to him, unless *la Lupa* left the house. *La Lupa* departed, and then her son-in-law could prepare himself to depart also, like a good Christian; he confessed, and took the

communion with such evident signs of repentance and contrition that all the neighbours and the busybodies wept round the bed of the dying man.

And better for him if he had died that time, before the devil came back to tempt him and to get a grip on his body and his soul, when he was well.

'Leave me alone!' he said to *la Lupa*. 'For God's sake, leave me in peace! I've been face to face with death. Poor Maricchia is only driven wild. Now all the place knows about it. If I never see you again, it's better for you and for me.'

And he would have liked to tear his eyes out so as not to see again those eyes of *la Lupa*, which, when they fixed themselves upon his, made him lose both body and soul. He didn't know what to do, to get free from the spell she put on him. He paid for Masses for the souls in Purgatory, and he went for help to the priest and to the Sergeant. At Easter he went to confession, and he publicly performed the penance of crawling on his belly and licking the stones of the sacred threshold before the church for a length of six feet.

After that, when *la Lupa* came back to tempt him:

'Hark here!' he said. 'Don't you come again into the stack-yard; because if you keep on coming after me, as sure as God's above I'll kill you.

'Kill me, then,' replied *la Lupa*. 'It doesn't matter to me; I'm not going to live without thee.'

He, when he perceived her in the distance, amid the fields of green young wheat, he left off hoeing the vines, and went to take the axe from the elm-tree. *La Lupa* saw him advancing towards her, pale and wild-eyed, with the axe glittering in the sun, but she did not hesitate in her step, nor lower her eyes, but kept on her way to meet him, with her hands full of red poppies, and consuming him with her black eyes.

'Ah! Curse your soul!' stammered Nanni.

CAPRICE

Once, when the train was passing near Aci–Trezza, and you were looking out of the carriage window, you exclaimed: 'I'd like to stay a month here!'

We came back, and we stayed, not a month, but forty-eight hours; the natives, who stared at your huge trunks in such astonishment, must have thought you were going to stay a year or two. On the morning of the third day, tired of seeing the same eternal green and blue, and of counting the carts that went down the road, you were at the station again, impatiently fidgeting with the chain of your scent-bottle, as you stretched your neck looking for a train which seemed as if it never would appear.

In those forty-eight hours we did everything there is to be done in Aci–Trezza: we walked in the dust of the road, and we clambered on the rocks; under pretext of learning to row, you made blisters on your hands beneath your gloves, and they had to be kissed; we passed a most romantic night on the sea, throwing out the nets chiefly in order to do something that would seem to the boatmen worth the risk of getting rheumatism; and dawn surprised us at the top of the tall lonely rock in the sea, a pallid, modest dawn which I can still see when I close my eyes, hollowed with wide violet grooves on a sea of heavy green; caught like a caress on that cluster of mean houses which slept as if curled up in sleep on the shore; and on top of the rock, on the transparent depths of the sky, your little figure was sharply printed, with the cunning lines your dress-maker gave it, and the fine and elegant profile which was your own. You wore a grey dress which seemed made on purpose to tone with the colours of the dawn. A beautiful picture, indeed! and one could tell you knew it yourself, from the way you posed yourself inside your shawl, and smiled with wide, heavy, tired eyes at the strange spectacle, and at the double strangeness of finding yourself present at it. What thoughts came into your little head while you watched the rising sun?

Perhaps you were asking him, in what other hemisphere he would find you, within a month? But all you said, ingenuously, was: 'I don't understand how anyone can live here all their life.'

Yet, you see, it's easier than it seems. You've not got to have an income of four thousand pounds a year, in the first place; and, to make up for that, you've got to feel your share of the hardships and misery that exist between those huge rocks set in the depths of blue, which made you clap your hands with admiration. That's all it needs for those poor devils who dozed while they waited for us in the boat, to find, in their tumbledown, picturesque houses which from the distance looked to you sea-sick, like everything else, all that you go to so much trouble to seek, in Paris, in Nice, in Naples.

It's a curious thing; but perhaps it is just as well it should be so – for you, and for all the others like you. That heap of wretched houses is inhabited by fishermen, 'sea-folk,' they say, as others say 'gentlefolk': men whose skin is harder than the bread they eat, when they've got any to eat, for the sea is not always kind, as it was when it kissed your gloves. . . . On its black days, when it fumes and growls, all you can do is to stand on the beach and look at it, with your arms folded, or to lie stretched out on your stomach, which perhaps is better when you've had no dinner; those days when there's a crowd round the door of the inn, but very few pennies ring on the zinc of the bar; and the children who swarm in the village, as if want were a good fertilizer, screech and squabble as though the devil was in them.

From time to time, typhoid, cholera, bad seasons, storms come and sweep away a good deal of the bunch who, you would think, would ask nothing better than to be swept away, and to disappear; nevertheless, they multiply again in the same place, always; it would be hard to say how, or why.

Did you ever chance, after an autumn rain, to upset an army of ants as you were thoughtlessly tracing the name of your last partner at the dance on the sand of the avenue? One or two of the poor little creatures would remain stuck to the ferrule of your umbrella, twisting in the last gasp; but all the

others, after five minutes of panic and helter-skelter, would have gone back to clutch desperately again at their little brown heap.

You would never go back, it is true; neither should I; but to understand such persistency, which has its heroic aspect also, one has to make oneself tiny, tiny, close the whole horizon between two clods, and look through the microscope at the little things that make little hearts beat. Would you like to have a look too, through this lens? – you who watch life through the wrong end of the telescope? The spectacle will seem strange to you, but perhaps it will amuse you.

We have been most intimate, you and I, do you remember? and you once asked me to dedicate some work of mine to you. But why? *A quoi bon?* as you say. What can anything I write matter to the people who know you? and to those who don't know you, what do you matter?

For all that, I was reminded of your caprice the other day when I saw again that poor woman whom you used to give money to under pretext of buying her oranges that were set in a row on the little bench outside the door. Now the little bench has gone, they have cut down the medlar tree in the courtyard, and the house has a new window. Only the woman herself has not changed, she has merely moved a little further along, and squatted on the heap of stones that barricades the old 'station' of the national guards, to stretch out her hand from there to the passing carters. And I, strolling round with my cigar in my mouth, remembered that even she, poor as she is, had seen you go by all white and proud.

Don't be angry that I should be reminded of you in such a way and in such a connection. Besides the pleasant memories you have left me, there are a hundred others, vague, confused, discordant, gathered here and there, one no longer knows where. Perhaps some of them are memories of dreams dreamed open-eyed; and in the muddle which they made in my mind, while I was going down that mean little street where so many pleasant and painful things have happened, the scrap of a shawl of that chilly, miserable woman squatting

there, cast a gloom over me, I couldn't tell you, and made me think of you, you, surfeited with everything, even with the homage which the fashionable newspapers lay at your feet, often quoting you at the head of the society columns – tired, by now, also of the whimsical desire to see your name on the pages of a book.

By the time I write the book, probably you'll have forgotten all about your whim. All the same, the memories I send you, though foreign to you in every sense, you who are intoxicated with flowers and feasts, will come to you like a delicious fresh breeze, into the hot nights of your eternal carnival. On that day when you come back here, if ever you do come back, and we sit side by side again, kicking the stones with our feet and fancies with our minds, perhaps we shall talk of other intoxications which life holds elsewhere.

You may imagine, if you will, that my thoughts dwell so persistently on that out-of-the-way corner of the world just because you have set foot in it – or so that I can get the glitter out of my eyes, which follows you everywhere, glitter of jewels or of fevers; – or because I have sought you in vain in all the places which fashion makes pleasant. See then how you always occupy the first place, here as at the theatre!

Do you remember, too, that old man who held the tiller of our boat? You owe him so much tribute, he prevented you ten times at least from wetting your beautiful blue stockings. Now he is dead, away there in the city hospital, poor devil, in a great white ward, between white sheets, chewing white bread, served by the white hands of the Sisters of Mercy, who had no other fault but that of not being able to understand the petty woes which the poor old fellow mumbled in his semibarbarous dialect.

But if he'd been allowed to want anything, he would have wished to die in that corner by the fire, where his couch had stood for so many years, 'under his own roof'; so much so that when they carried him away he cried with a whimpering noise, as old people do. He had lived all his life between those four walls, facing that beautiful and treacherous sea with which he had to fight every day to get his living out of it,

without leaving it his bones; nevertheless, in those moments when he was quietly enjoying his own spell of sunshine, squatted on the boat's stretcher, with his arms round his knees, he wouldn't have turned his head to look at you, and you could seek in vain, in those absent eyes of his, for even the proudest reflection of your beauty; not like when so many haughty heads bow to make way for you, in the glittering *salons*, and you see yourself mirrored in the envious eyes of your best women-friends.

Life is rich, as you see, in its inexhaustible variety; and you can enjoy without a qualm that portion of wealth which has fallen to you, do as you like with it. That girl, for example, who was peeping behind the pots of sweet basil, when the rustling of your skirts made a revolution down the mean little street, if she chanced to see another well-known face at the window opposite she would smile as if she too were dressed in silk. Who knows what poor little joys she was dreaming of as she leaned at that window-sill behind the sweet-scented basil, her eyes intent upon the house opposite, with its trailing vine? And the smile in her eyes would not have died out in bitter tears, away there in the big town far from the stones which knew her and had seen her born, if her grandfather had not died in the hospital, and her father had not been drowned, and all her family scattered by a gust of wind which had come down on them – a cruel gust of wind, which had carried away one of her brothers even to the prisons of Pantelleria: 'in trouble,' as they say down there.

Those that died were better off; one of them at sea at Lissa, in the war; he was the biggest, the one who seemed to you a David in bronze, standing erect with his harpoon in his fist, rudely lit up by the flame of the torch. Big and strong as he was, even he flushed red in the face, if you fixed your burning eyes on him; all the same, he died like a good sailor, on the spar of the forestay, fast to the shrouds, lifting his cap high and saluting the flag for the last time, with his wild, male, islander's shout. The other one, the man who was afraid to touch your foot, that day on the islet, when he had to free you from the cord of the rabbit-snare which you had got yourself tangled

up in, like the careless creature you are, he was lost on a black winter night, alone, among the huge waves, when between his boat and the shore on which his folk were looking for him, running back and forth like mad people, there were seventy miles of darkness and of storms. You would never have imagined that the man who let himself be intimidated by the masterpiece of your shoemaker, would have been capable of fighting his death with such desperate and sombre courage.

Better off are those that are dead, and don't have to eat 'the King's bread,' like that poor fellow kept there on Pantelleria, or that other bread which the sister eats, and who don't have to go around like the woman with the oranges, living on what God sends; which is little enough, at Aci-Trezza. The dead, anyhow, want for nothing! As the landlady's son said, the last time he went to the hospital to ask about the old man, and to take him covertly a few of those stuffed snails which are so good to suck when you haven't any teeth, and he found the bed empty, with the blankets smooth and straight, and he slyly contrived to get out into the courtyard and take his stand outside a door stuck all over with rags of paper notices, where he could peep through the keyhole into a great empty place, cold and sonorous even in summer, and see the end of a long marble table, over which was thrown a sheet, heavy and rigid. And saying to himself that those in there didn't want for any-thing, he began to suck the snails one by one, to pass the time away, for they were no use to anybody now. You, pressing your blue-fox muff to your breast, you will be glad to remember that you gave the poor old man five pounds.

Now there are left behind those little ragamuffins who escorted you like jackals and set siege to the oranges; they are left to buzz round the beggar-woman, pulling and feeling in her skirts as if she must have bread in her pockets, picking up cabbage-stalks, orange-peel, cigar-stumps, all those things which are thrown away but which still must have some value or other, since there are always poor people who live on them; even live on them so well that those sturdy, hungry beggar-brats will grow up in the mud and dust of the street, till they

are big and strong as their father and their grandfather, and they will people Aci-Trezza with more beggar-brats, who will joyfully hang on to life as long as they can, like their old grandfather, without wanting more than to hang on; and if they would like to do anything different from what he did, it would be to close their eyes there where they opened them, in the hands of the village doctor who comes every day on his donkey, like Jesus, to help the good people who are going.

'After all, the ideal of the oyster!' you will say.

Exactly the ideal of the oyster; and we have no other reason for finding it ridiculous than that we didn't happen to be born oysters ourselves. On the other hand, the tenacious attachment of those poor people to the rock on which fortune has left them, while sowing princes here and duchesses there, this courageous resignation to a life of hardship, this religion of the family, which reflects on to the occupation followed, on to the house, and on to the stones which surround it, seem to me – perhaps for a quarter of an hour – most serious and most worthy of respect. It seems to me that the restlessness of a wandering mind would soothe itself to sleep gratefully in the peace of those meek, simple feelings which go on from generation to generation calm and unchanged. It seems to me I might see you pass by, at the quick trot of your horses, to the jingling of their harness, and I might salute you quietly.

Perhaps because I have tried too hard to see my way amid the turmoil which surrounds you and follows you, I now fancy I can read a fatal necessity in the tenacious affections of the weak, in the instinct which small things have to cling together in order to resist the tempests of life, and so I have tried to decipher the modest and obscure drama which must have thrown into confusion the plebeian actors whom we knew together. A drama which perhaps I will one day relate to you, and whose whole point seems to me to lie in this: that when one of those little beings, either more weak, or more incautious, or more egoistic than the others, tries to detach himself from the group, in order to follow the allure of

the unknown, or out of desire to better himself, or out of curiosity to know the world, then the world of sharks, such as it is, swallows him, and his kin along with him. And from this point of view you will see that the drama is not lacking in interest. For the oyster, the most interesting argument must be that which treats of the insinuations of the crab, or of the knife of the diver who prises it from the rock.

JELI THE HERDSMAN

Jeli, the boy who herded the horses, was thirteen years old
when he first knew Don Alfonso, the young squire; but he
was so little, he didn't come up to the belly of Whitey, the
old mare who carried the bell of the herd. He was always to
be seen about the countryside, on the hills or in the plain,
wherever his creatures were at pasture, standing erect and
motionless on some bank, or squatting on a big stone. His
friend Don Alfonso, while he was in the country at holiday-
time, came to join him every mortal day that dawned at
Tebidi, and shared with him his bit of chocolate, and the
barley bread of the herd-boy, and the fruit they stole in the
neighbourhood. At first Jeli called the young squire *Excellency*,
as they do in Sicily, but after the two of them had had a real
good scrap, and had fought it out, their friendship was solidly
established. Jeli taught his friend how to climb right up to the
magpies' nests, at the top of the walnut trees taller than the
belfry at Licodia, and how to hit a sparrow in flight, with a
stone, and how to mount in one leap on to the bare back of
his half-wild horses, seizing by the mane the first one that
came galloping along, without letting yourself be frightened
by the angry neighings of the unbroken colts, or by their wild
rearing. Ah! the splendid scampers over the mown fields, with
mane flying in the wind! the lovely days of April, when the
wind piled waves in the green grass, and the mares neighed in
the pasture; the beautiful noons of summer, in which the
countryside, gone pallid, was all silent, under the dim sky, and
the grasshoppers crackled between the clods as if the stubble
were bursting into fire; the lovely sky of winter between bare
almond boughs, which shuddered in the north-east wind,
and the stony lane that rang frozen under the hoofs of the
horses, and the larks which sang on high, in the warmth, amid
the blue! the fine summer evenings which rose up slowly,
slowly, like mist; the scent of the hay in which you buried
your elbows, and the melancholy humming of the insects of

evening, and those two notes of Jeli's pipe, always the same: Yoo! yoo! yoo! making you think of far-off things, of the Feast of St. John, of Christmas night, of the ringing of bells at dawn, of all those wonderful things gone by, which seem sad, so far off, making you look up into the sky, with your eyes wet, so that all the stars kindling above seemed to be raining down on your heart, and swamping it.

Jeli, for his part, didn't suffer from this melancholy; he sat squatting on the bank, with his cheeks puffed out, absolutely intent on playing yoo! yoo! yoo! Then he gathered the herd together again with a wild yelling and flinging of stones, and drove them into the stabling-place, away there beyond the *Hill of the Cross*.

Panting, he ran up the steep slope, across the valley, and shouted sometimes to his friend Alfonso: 'Call the dog! Hi! call the dog!' – or else: 'Throw me a good stone at the bay, he's playing the lord, and dawdling as slow as he can, taking his time over every bush in the valley!' – or else: 'Tomorrow morning bring me a good thick needle, one of those from Mrs. Lia.'

For he could do anything he liked with a needle, and he had a little hoard of rags in his canvas sack, to patch up his breeches or his jacket-sleeves when necessary; also he could weave braids and cords of horse-hair, and he washed his own handkerchief, that he wore round his neck when it was cold, washed it with the chalky earth from the valley-bed. Altogether, provided he had his own sack over his shoulder, he stood in need of nobody, whether he was away in the woods of Resecone, or lost in the depths of the plain of Caltagirone. Mrs. Lia would say: 'You see Jeli the herd-boy? he's always been alone in the land, as if his own mares had foaled him, and that's why he's so handy, and can cross himself with both hands.'

As a matter of fact, Jeli really had need of nobody, yet all the hands at the farmstead would willingly do anything for him, for he was an obliging lad, and there was always something to be got from him. Mrs. Lia cooked his bread for him, out of neighbourly love, and he paid her back with pretty little

wicker baskets, in which she could put her eggs, or with cane winders, for her spinning, and other bits of things. 'We're like his own horses,' said Mrs. Lia, 'that scratch one another's necks.'

At Tebidi they had all known him from a child, from the time when you couldn't see him, among the horses' tails, as the creatures were feeding on the Litterman's Pastures; and he had grown up, as you may say, under their eyes, although nobody ever noticed him, and he was always gone, straying here and there with his herd. 'Heaven had sent him like rain, and earth had taken him up,' as the proverb says; he really was one of those who have neither parents nor home. His mother was in service at Vizzini, and only saw him once a year, when he went with the colts to the fair on St. John's Day; and the day she died, they sent to fetch him, one Saturday evening, and on the Monday Jeli came back to his horses, so that the peasant who had taken his place with the herd didn't even lose his day's work on the fields; but the poor lad had come back so upset, that at times he let the colts get into the wheat. 'Hey there, Jeli!' Farmer Agrippino yelled at him from the yard; 'do you want to try a dance with the horse-whip?' Jeli set off running after the scattered colts, and drove them little by little towards the hill; but always in front of his eyes he saw his mother, with her face tied up in a white handkerchief, never to speak to him again.

His father herded the cows at Ragoleti, beyond Licodia, 'where the malaria was so thick you could mow it,' as the peasants of the neighbourhood said; but in malaria country the pasture is good, and cows don't take the fever. Jeli therefore remained out with his herd all the year round, either at Don Ferrando, or in the Commenda closes, or in the Jacitano valley, and the huntsmen or the wayfarers who took the by-tracks could always catch sight of him, somewhere or other, like a dog with no master. He didn't mind, for he was used to be with his horses, that fed in front of him moving on step by step, snatching at the clover, and with the birds that swept round him in flocks, all the while the sun was making its slow journey through the day, so slowly, till the shadows grew long,

and then disappeared; he had time to watch the clouds pile up little by little, and to imagine mountains and valleys; he knew how the wind blows when it is going to snow. Everything had its own look and its own meaning, and there was always something to see and something to hear, all the hours of the day. And so towards evening, when the herd-boy sat down to play on his pipe of elderwood, the black mare drew near, carelessly chewing her clover, and then stood still to look at him, with her big, pensive eyes.

Where he did feel a little melancholy was in the sandy wastes of Passanitello, where never a bush nor shrub rises up, and in the hot months never a bird flies past. The horses gathered together in a ring, with their heads dropped, to make a shadow for one another, and in the long days of the summer threshing-time that great silent light rained down changeless and stifling for sixteen hours.

However, where the feed was plenty and the horses liked to linger, the boy busied himself with some little thing or other; he made cane cages for grasshoppers, and pipes with carving on them, and rush baskets; he could rig up a bit of a shelter with four branches, when the north-wind drove long files of ravens down the valley, or when the cicalas rubbed their wings in the sun which burned the stubble; he roasted acorns from the oak-wood in the embers of sumach twigs, and fancied he was eating roast chestnuts, or over the same fire he toasted his big slices of bread, when the mould began to grow hairy on it, since when he was at Passanitello in the winter the roads were so bad that sometimes a fortnight would go by without his seeing a living soul on the waste.

Don Alfonso, whose parents kept him in cotton-wool, envied his friend Jeli the canvas sack in which he had all his possessions, his bread, his onions, his little flask of wine, the kerchief for the cold, the store of rags for mending, with the thick needles and the thread, the tin box with the flint and tinder; he envied him, moreover, the superb speckled mare, flea-bitten roan as they're called, the creature with a tuft of hair erect on her forehead, and with wicked eyes, who swelled out her nostrils like a surly mastiff when anyone wanted to

mount her. But she let Jeli ride her and scratch her ears, which she wouldn't let anybody else touch, and she went sniffing round him, to hear what he had to say. 'Don't meddle with the speckled roan,' Jeli recommended him; 'she's not wicked, but she doesn't know you.'

After Scordu the Bucchierese had taken away the Calabrian mare which he'd bought at St. John's fair, with the agreement that she was to stay with the herd till grape-harvest, the dark-bay colt, being left an orphan, wouldn't be pacified, but went scouring away to the tops of the hills, with long lamentable neighings, his chin lifted to the wind. Jeli ran after him, calling him with loud cries, and the colt stopped to listen, his neck tense and his ears uneasy, lashing his flanks with his tail. 'It's because they've taken his mother away, and he doesn't know what to do with himself,' observed the herd-boy. 'Now I shall have to keep my eye on him, for he's capable of falling over the precipice. Like me, when my mother died and left me, I couldn't see where I was going.'

Then, after the colt had begun to sniff at the clover, and to take a mouthful in spite of himself: 'You see! bit by bit he begins to forget it all!'

'But he will be sold just the same! Horses are made to be sold; like lambs are born for the butcher, and clouds bring rain. Only the birds have nothing to do but sing and fly around all day long.'

His ideas did not come to him clear and in order, one after the other, for he'd rarely had anyone to talk to, and for that reason he was in no hurry to root out and disentangle what was in his mind, but was used to let it all lie till it budded and peeped forth little by little, like the buds of the trees under the sun. 'Even the birds,' he added, 'have to find their own food, and when there's snow on the ground, they die.'

Then he thought for a while. 'You are like the birds; only when winter comes, you can stay by the fire without bothering.'

Don Alfonso, however, replied that he too had to go to school, to learn. Then Jeli opened his eyes wide, and listened

with all his ears if the young squire began to read, watching the book and the youth suspiciously, and motionlessly listening, with that slight blinking of the eyelids which indicates intensity of attention in those creatures which come nearest to man. He liked poetry, that caressed his ears with the harmony of an incomprehensible song, and sometimes he knotted his brows and sharpened his chin, and it seemed as if a great working was going on in his inside; then he nodded his head, yes, yes, smiling a knowing smile, and scratching his head. But when the young squire would begin to write, to show what he could do, Jeli would have stood for days to watch him, and all at once he shot a suspicious glance. He couldn't persuade himself that you could repeat on paper those words he had said, or that Don Alfonso had said, and even those things which he had never let out of his mouth, so he ended up with smiling that knowing smile.

Every new idea that tapped at his head, to enter, roused his suspicions, and it seemed as if he sniffed at it with the savage mistrust of his speckled roan. However, he showed no surprise at anything in the world; you could have told him that in town horses rode in carriages, and he would have remained imperturbable, with that mask of oriental indifference which is the dignity of the Sicilian peasant. It seemed as if he entrenched himself in his own ignorance, as if it were the strength of poverty. Every time he was short of an argument he repeated: 'Nay, I know nothing about it. I'm poor, I am' with that obstinate smile which wanted to be crafty.

He had asked his friend Alfonso to write the name of Mara on a bit of paper he had found, heaven knows where, for he picked up everything he saw on the ground, and he had put it with his bunch of rags. One day, after having been silent for a time, looking absorbedly here and there, he said to his friend in utmost seriousness:

'I've got a sweetheart.'

Alfonso, although he knew how to read, opened his eyes wider.

'Yes!' repeated Jeli. 'Mara, the daughter of Farmer Agrippino who was here; and now he's at Marineo, that great building on the plain, which you can see from the Litterman's Pastures, up there.'

'So you're going to get married, are you?'

'Yes, when I'm big, and I get four pounds a year wages. Mara doesn't know yet.'

'Why haven't you told her?'

Jeli shook his head, and fell into a muse. Then he turned out his roll of rags and unfolded the paper which his friend had written for him.

'It's right, though, that it says Mara; Don Gesualdo the field-overseer read it, and so did Brother Cola the Franciscan, when he came down to get some beans.'

'Anybody who knows how to read,' he observed later, 'is like one who keeps words in his flint-and-steel box, and can carry them round in his pocket, and even send them where he wants to.'

'But now, what are you going to do with that bit of paper, you who don't know how to read?' Don Alfonso asked him.

Jeli shrugged his shoulders, but continued to fold his written leaflet carefully in his roll of rags.

He had known Mara since she was a baby, and they had begun by fighting with one another as hard as they could, one day when they had met down the valley, picking blackberries in the bramble hedges. The girl, who knew she was 'in her own rights,' had seized Jeli by the collar, as if he were a thief. For a while they pummelled one another on the back, one for you and one for me, like the cooper on the rings of the barrel, but when they were tired they began to calm down gradually, though still holding each other by the hair.

'What's your name?' Mara asked him.

And as Jeli, still the wilder of the two, didn't say who he was:

'I am Mara, daughter of Farmer Agrippino, who works all these fields here.'

Then Jeli gave it up entirely, and the little girl began to pick up again the blackberries which she had dropped in the fight, peeping from time to time at her adversary, out of curiosity.

'On the other side the bridge, in the garden hedges,' added the little girl, 'there's lots of big blackberries, and only the hens eat them.'

Jeli meanwhile was withdrawing silently and softly, and Mara, after she had followed him with her eyes as far as she could in the oak-grove, turned and took to her heels also, towards the house.

But from that day onwards they began to be familiar with one another. Mara would go and sit on the parapet of the little bridge, to spin her tow, and Jeli gradually, little by little urged the herd towards the sides of the Bandit's Hill. At first he kept away from her, ranging around, looking at her from the distance with furtive looks, then little by little he drew near, with the cautious approach of a dog which is used to having stones hurled at it. When at last they were near to one another, they remained long hours without saying a word, Jeli observing attentively the intricate work of the stockings which her mother had put round Mara's neck, or she watching him cut fine zigzags on an almond-stick. Then they departed one in this direction, the other in that, without saying a word, and the little girl, the moment she came in sight of the house, started to run, making her petticoats fly up over her little red legs.

When the prickly pears were ripe, however, they penetrated into the depths of the cactus grove, and there they stayed the livelong day, peeling the cactus fruit. They wandered together under the century-old walnut trees, and Jeli beat down so many walnuts that they fell like hail; and the little girl ran here and there with shouts of delight, gathering up more than she could carry; and then she made off, silently and softly, holding the two corners of her apron stretched out, and waddling like a little old woman.

During the winter Mara did not dare to put her nose out of doors, for the hard cold. Sometimes, towards evening, you would see the smoke of the little fires of sumach wood which Jeli lit for himself on the Litterman's Pastures, or on the Hill of Macca, so that he shouldn't freeze stiff, like those tits which morning found behind a stone, or in the shelter of

a furrow. Even the horses were glad to wave their tails a bit round the fire, and pressed up close to one another, to keep warmer.

But with March the larks came back to the pasture, the sparrows to the roof, and nests and leaves to the hedges. Mara started going for walks again with Jeli, in the new grass, among the flowering blackthorn bushes, under the trees which still were bare but which were beginning to dot themselves with green. Jeli penetrated into the thorn-brake like a bloodhound, to find the thrushes' nests, and the birds looked at him in dismay, with their peppercorn eyes; the two children often carried in the bosom of their shirts little rabbits that had only just come out into the world, and were almost naked, but which had already the long, uneasy ears. They scoured the fields, following the bunch of horses, and passed into the mown places, behind the men with the scythes, keeping pace step by step with the horses, pausing every time a mare stopped to snatch a mouthful of grass. At evening, back again at the little bridge, they separated in opposite directions, without a word of farewell.

So they passed the summer. Meanwhile the sun began to draw behind the Hill of the Cross, and the robins flew after him towards the mountains, as twilight came on, following him in the cactus grove. The grasshoppers and the cicalas were heard no more, and in that hour a great sadness spread through the air.

It was at this time that Jeli's father, the cowherd, appeared at Jeli's tumble-down hut. He had got the malaria at Ragoleti, and couldn't even sit up on the ass that had brought him. Jeli lit the fire, as quick as he could, and ran to 'the houses' to get a few eggs. 'Better spread a bit of bedding by the fire,' his father said to him. 'I feel the fever coming back on me.'

The attacks of fever were so violent that Master Menu, buried under his great cloak, the woollen saddle-bags, and Jeli's sack, trembled like the leaves in November, in front of that grand blaze of brushwood which showed his face as deathly-white as a dead man's. The peasants from the farmstead came to ask him: 'How do you feel, neighbour Menu?'

The poor fellow only gave a thin whine, like a sucking pup, in answer. 'It's the sort of malaria as kills you better than if you were shot,' said his friends, as they warmed their hands at the fire.

They actually sent for the doctor, but it was money thrown away, for the illness was so familiar and obvious that even a child would have known how to cure it, and if the fevers hadn't been the sort that kill you anyhow, with the usual sulphate it would have been better in no time. Master Menu spent the eyes out of his head, buying sulphate, but he might as well have thrown it down the well. 'Take a good tea of *eccalibbiso*, which won't cost you anything,' suggested Farmer Agrippino, 'and if it doesn't do you any good, at least you won't ruin yourself spending your money.' So he took the eucalyptus tea also, but the fever came back just the same, and even worse.

Jeli helped his parent as best he could. Every morning, before he went off with the colts, he left him the tea ready in the jug, the bundle of brushwood by the hearth, eggs in the hot ashes, and every evening he came home early, with more wood for the night, and the little flask of wine, and some bits of mutton which he'd even scoured as far as Licodia to get. The poor lad did everything carefully, like a good housewife, and his father, watching with tired eyes the boy's activities about the one room of the hut, smiled from time to time, thinking the lad would be able to look after himself, when he was left with no one.

On the days when the fever abated for an hour or so, Master Menu got up, reeling, his face tied up tight in a kerchief, and sat in the doorway to wait for Jeli, while the sun was still hot. As Jeli let drop the bundle of faggots by the door, and went to set the eggs and the little flask on the table, his father said to him: 'Put the *eccalibbiso* on to boil for tonight' – or else: 'Remember that Aunt Agatha has got your mother's gold, and is keeping it for you, when I am gone.' Jeli nodded assent.

'It's no good!' Farmer Agrippino repeated every time he came to see how Master Menu was getting on with the fever. 'Your blood is full of pest.'

Master Menu listened without blinking, his face whiter than his stocking-cap.

After a while he got up no more. Jeli cried when he wasn't strong enough to help his father turn over in bed; and gradually Master Menu was so that he didn't even speak any more. The last words he said to his son were:

'When I'm dead you must go to him who owns the cows at Ragoleti, and make him give you the three guineas and the twelve bushels of wheat which is due from May to now.'

'No,' replied Jeli. 'It is only two guineas and a quarter, because it's more than a month since you left the cows, and we must reckon fair with the master.'

'It's right!' agreed Master Menu, half-closing his eyes.

'Now I'm all alone in the world like a strayed colt, that the wolves will eat!' thought Jeli, when they had carried away his father to the cemetery at Licodia.

Mara had to come as well, to see the house of the dead man, drawn by the acute curiosity which fearful things arouse. 'You see how I'm left?' Jeli said to her, and the little girl drew back, terrified lest he should make her enter the house where the dead man had been.

Jeli went to draw his father's money, then he set off with the herd for Passanitello, where the grass was already high on the land left fallow, and feed was plenty; so that the colts remained a long time at pasture there. And so Jeli grew up, and even Mara would have grown, he thought to himself often when he was playing on his pipe; and when he came back to Tebidi, after such a long time, slowly driving the mares before him, along the little lanes that were slippery with the overflow of old Cosimo's spring, he kept straining his eyes for the little bridge in the valley, and for the hut in the vale of the Jacitano, and the roof of the 'big houses' where the pigeons were always fluttering. But just at that time the squire had turned out Farmer Agrippino, and all Mara's family were busy with the removal. Jeli found the girl at the door of the court-yard, keeping her eye on her own things as they were loaded on to the cart, and he saw she was taller and prettier. Now the empty room seemed darker and more smoked than

ever. The table, the bed, the chest of drawers, and the pictures of the Virgin and of St. John, even the nails from which the seed-pumpkins had hung, had left their mark upon the walls where they had been for so many years. 'We are going away,' Mara said to him as she saw him looking. 'We are going down to Marineo, where that great big building is, on the plain.'

Jeli started in to help Farmer Agrippino and Mrs. Lia load the cart, and when there was nothing else to carry out of the room, he went to sit with Mara on the wall of the watering-trough.

'Even houses,' he said to her, when he had seen the last basket piled on to the wagon, 'even houses don't seem the same any more, when you take the things out of them.'

'At Marineo,' replied Mara, 'we shall have a better room, my mother says, as big as the storeroom for the cheeses.'

'Now you'll be gone, I shan't want to come here any more; it'll seem to me like winter again, to see the door shut.'

'At Marineo, though, there'll be other people as well, red-haired Pudda, and the squire's daughter; it'll be jolly; there'll be more than eighty harvesters come for the reaping, with bagpipes, and they'll dance in the yard.'

Farmer Agrippino and his wife had set off with the cart, Mara ran behind gleefully, carrying the basket with the pigeons. Jeli wanted to go with her as far as the little bridge, and as the cart was disappearing around the valley bend, he called: 'Mara! Oh! Mara!'

'What do you want?' she said.

He didn't know what he wanted.

'You, what are you going to do, all alone here?' the girl asked him then.

'I shall stop with the colts.'

Mara went skipping away, and he remained fixed, as long as he could hear the noise of the cart as it jolted on the stones. The sun touched the high rocks of the Hill of the Cross, the grey puffs of the olive-trees fumed upon the twilight, and in the vast open country, far spreading, was heard not a sound save the bell of Whitey, in the everdeepening silence.

Mara, having found a lot of new people at Marineo, in the busy season of the grape-harvest, forgot all about him; but Jeli thought constantly of her, since he had nothing else to do, in the long days he spent watching the tails of his creatures. Now he had no excuse for slipping down the valley, across the little bridge, and no one saw him any more at the farmstead. And so it was that for a time he knew nothing about Mara's engagement to be married; for in the meantime much water had flowed and flowed under the little bridge. He only saw the girl again the day of St. John's Feast, when he went to the fair with the colts for sale: a feast that was turned to poison for him, and took the bread out of his mouth, owing to an accident which happened to one of the master's colts, God help us!

On the day of the fair the factor was waiting for the colts since dawn, going up and down in his well-blacked boots behind the rear of the horses and the mules, that stood in rows on either side of the high-road. The fair was nearly over, and still there was no sign of Jeli, around the bend in the road. On the parched slopes of the *Calvary* and the Windmill Hill there were still left a few bunches of sheep, huddled together in an enclosure, with their noses to the ground and their eyes dead, and a few yoke of long-haired oxen, the sort that are sold to pay the rent of the land, waiting motionless under the burning sun. Away below, towards the valley, the bell of St. John's was ringing for the High Mass, to the accompaniment of a long crackling of firework squibs. Then the fair-ground seemed to shake, as there rang out a cry which continued among the awnings of the hucksters who had spread out their wares on the Cocks' Steps, and descended through the streets of the village, and seemed to return again to the valley where the church lay: *Viva San Giovanni!* Long live Saint John!

'Of all the devils,' squealed the factor. 'That assassin of a Jeli will make me lose the fair!'

The sheep lifted their noses astonished, and began to bleat all together, and even the oxen moved a few slow paces, looking around with their great intent eyes.

The factor was in such a rage because that day he was due to pay the rent of the big closes, 'as St. John arrives beneath the elm-tree,' said the contract, and to complete the payment he had made an assignment upon the sale of the colts. Meanwhile, of colts, horses and mules there were as many as ever the Lord had made, all brushed and shining, and trimmed up with gay-coloured tufts, and little tassels, and small bells, all switching their sides with their tails to switch away their boredom, and turning their heads after every one who passed by, as if really they were waiting for some charitable soul to come and buy them.

'He'll have gone to sleep somewhere, that assassin!' the factor kept on shouting; 'and there he leaves me saddled with those colts!'

On the contrary, however, Jeli had walked all through the night, so that the colts should arrive fresh, and should take up a good stand when they got to the fair-ground; and he had reached the Raven's Levels before the *Three Kings* were set, for they were still shining above Mount Arthur, that has its arms folded. There was a continual stream of carts and people on horseback passing along the road, all going to the feast; and so the youth kept his eyes sharp open, so that the colts, frightened by all this unaccustomed traffic, shouldn't break away and scatter, but keep together along the border of the highway, behind Whitey, who walked peacefully ahead, the bell tinkling at her neck. From time to time, when the road ran along the tops of the hills, you could hear far away the bell of St. John, so that even in the darkness and the silence of the country you felt the festival, and all along the road, away in the distance, as far as ever there were people on foot or on horseback going to Vizzini, you could hear the continual cry: *Viva San Giovanni!* Long live Saint John! – and the rockets shot up straight and shining, behind the hills of Canziria, like the shooting-stars of August.

'It's like Christmas night!' Jeli kept saying to the boy who was helping him drive the herd. 'All the farmsteads are lit up and festivating; you can see fires sometimes all over the country.'

The boy was dozing, slowly, slowly putting one leg before the other, and he made no reply; but Jeli felt all his blood quiver when he heard that bell, he couldn't keep still, it was as if every one of those rockets that slid silent and shining on to the darkness from behind the hill, had blossomed out of his own soul.

'Mara will have gone to the Feast of St. John as well,' he said, 'because she goes every year.'

And without caring that Alfio, the boy, never made any reply, he continued:

'Don't you know? Mara's grown that tall, she's bigger than her mother who made her, and when I saw her again, I couldn't believe she was the same as I used to go getting prickly pears with, and beating the walnuts down.'

And he began to sing at the top of his voice all the songs he knew.

'Oh, Alfio, are you asleep?' he called, when he had finished. 'Watch that Whitey keeps behind you, don't forget.'

'No, I'm not asleep,' replied Alfio, in a hoarse voice.

'Can you see *la puddara*, the Venus star, winking away yonder, over Granvilla, as if she was shooting out rockets for Saint Domenica as well? It'll not be long before day comes; so we's'll get to the fair in time to take a good stand. Hi! my little black beauty! tha sh'lt ha'e a new halter, wi' red tassels, for the fair; an' thee an' all, Starface.'

So he kept on speaking to the colts, to hearten them with the sound of his voice, in the dark. But it grieved him that Black and Starface should go to the fair to be sold.

'When they're sold, they'll go off with their new master, and we shall see them no more in the herd; like Mara, after she went to Marineo.'

'Her father's well-off at Marineo; when I went to see them they set bread and cheese in front of me, and wine, and everything you could wish for, because he's almost like a factor there; he's got the keys of everything, and I could have eaten the whole place up if I'd had a mind. Mara, she hardly knew me, it was that long since we'd seen one another, and she shouted all of a sudden: "Why, look! there's Jeli as keeps the

horses, him from Tebidi!" It's like when you come back from a long way off, you've only got to see the top of a mountain and that's enough for you to know again in an instant the country where you were brought up. Mrs. Lia didn't want me to say *thee* and *thou* to Mara any more, now that her daughter is grown up, because the folks at the farm wouldn't understand how it was, and they talk so easy. But Mara only laughed and went as red as if she'd just been putting the bread in the oven; she pulled the table forward, and spread the cloth, not like the same girl. "Thou'st not forgotten Tebidi altogether then?" I asked her as soon as Mrs. Lia had gone out to tap a new barrel of wine. "No, no, I can remember," she said to me; "at Tebidi there was the farm-bell in a little belfry that looked like the handle of the salt-cellar, and you rang it from the platform, and there were two stone cats on the top of the garden gateway." I could feel it all inside me, as she said it. Mara looked me up and down as if she was fair surprised, and she kept saying: "Thou'st grown so tall!" and then she began to laugh, and gave me a clout on the side of the head, here –'

And that was how Jeli, the herdsman of the horses, came to lose his daily bread, for just at that moment there was a carriage, which they'd not heard before, and just as it got down to the level it started to trot, with a lot of whip-cracking, and jingling of bells, as if the devil was driving in it. The colts, terrified, scattered in a flash, like an earthquake, and it took some calling and some shouting, and some Hi! Hi! Hi! on Jeli's part and the boy's, before they could gather them again around Whitey, who was trotting away scared, even she, with the bell round her neck. As soon as Jeli had counted his creatures, he saw that Starface was missing, and he clutched his hands in his hair, for just there the road ran along the top of the ravine, and in this ravine it was that Starface broke his back, a colt that was worth twelve guineas like twelve angels of Paradise! Weeping and shouting, he ran calling the colt: Ahoo! ahoo! ahoo! for there was no sign of it. Starface replied at last, from the bottom of the ravine, with a painful whinny, almost as if he could speak, poor brute!

'Oh, Mother! Oh, Mother!' Jeli and the boy kept crying. 'Oh, what's happened? Oh, Mother!'

The passers-by who were going to the fair, and heard all this crying in the dark, stopped to ask what they had lost; and when they knew, they went on their way again.

Starface lay there where he had fallen, his hoofs in the air, and as Jeli was feeling him all over, weeping and speaking to him as if he could make him understand, the poor beast lifted his neck painfully and turned his head towards the youth, and then you could hear the panting of convulsive pain.

'There'll be something broken!' whimpered Jeli, desperate because he could see nothing in the dark; and the colt, helpless as a stone, let his head fall again with the weight of it. Alfio, who had remained on the road in charge of the herd, was the first to calm himself, and he got his bread out of his sack. Now the sky was all pallid, and the mountains around seemed as if they were coming into being one by one, dark and tall. From the turn of the road you began to make out the village, with the Hill of Calvary and the Windmill Hill printed upon the dawn, but still dimly, scattered with the whitish scars of the sheep, and as the oxen feeding on the top of the hill, in the blueness, moved from place to place, it seemed as if the profile of the mountain itself stirred and swarmed and was alive. The bell was heard no more from away below, travellers had become more rare, and those few that did pass by were in a hurry to get to the fair. Poor Jeli did not know which Saint to turn to, in that solitude; the lad Alfio was no good, just by himself; for which reason Alfio was silently and meekly nibbling his hunk of bread.

At last they saw the factor coming on horse-back, swearing and raving in the distance and running forward, as he saw the horses standing on the road, so that young Alfio took to his heels up the hill. But Jeli did not move from the side of Starface. The factor left his mule on the road and scrambled down the declivity, to try to help the colt to rise, pulling it by the tail. 'Leave him alone!' said Jeli, white in the face, as if he too had broken his back. 'Leave him alone! Can't you see he can't move, poor creature!'

And in truth, at every movement and every effort they forced him to, Starface had a rattling in the throat, as if he were human. The factor started kicking and clouting Jeli, and dragged all the angels and the saints of Paradise around by the feet. Then Alfio, a little reassured, came back to the road, so as not to leave the horses with nobody, and he took care to put the blame off himself, saying: 'It's not my fault! I was going on in front with Whitey.'

'We can do nothing here,' said the factor at last, after he was sure he was only wasting his time. 'There's nothing to do here but take the skin while it's good.'

Jeli began to tremble like a leaf when he saw the factor go and unfasten the gun from the mule's saddle. 'Get out of here, you good-for-naught!' the factor yelled at him. 'I don't know how to keep myself from laying you out alongside that colt there, who was worth such a lot more than you are, for all the baptizing you've had.'

Starface, not being able to move, turned his head with great staring eyes, as though he understood everything, and his hair rose in successive waves along his ribs, as if shivers of cold ran beneath. And so the factor killed the star-faced colt upon the spot where he lay, to get at least the skin, and Jeli seemed to feel within his own body the dull noise which the shot, fired at close quarters, made within the living flesh of the animal.

'Now if you want my advice,' the factor flung at him, 'you'll not show your face again before the master, asking for wages due to you, because he'd give 'em you hotter than you fancy.'

The factor went off together with Alfio, and with the colts, who didn't so much as turn to see where Starface was, but went along pulling at the grass of the roadside. Starface was left alone in the ravine, waiting for them to come and skin him, and his eyes were still staring wide, and his four hoofs were stretched out at last, for only now had he been able to stretch them. As for Jeli, since he had seen how the factor could take aim at the colt that turned its head with such pain and terror, and how he'd had the heart to shoot, now no

longer wept, but sat on a stone, staring with a hard face at Starface, till the men came for the skin.

Now he could walk round and please himself, enjoying the feast, or standing in the square all day long to see the gentry in the café, just as he liked, since he no longer had either bread or roof, and must seek another master, if anyone would have him, after the disaster of Starface.

And that's how things are in this world: while Jeli went with his sack over his shoulder and his stick in his hand, looking for another master, the band played gaily in the square, with feathers in their hats, amid a crowd of white stocking-caps thick as flies, and the gentry sat enjoying it in the café. Everybody was dressed up for the feast, as the animals for the fair, and in a corner of the square there was a woman in short skirts and flesh-coloured stockings, so that you'd think she had bare legs, and she beat on the big box, in front of a great sheet painted with a scene of the torture of Christians, blood flowing in torrents, and in the crowd that stood gaping open-mouthed stood also Farmer Cola, whom Jeli had known when he was at Passanitello, and he said he'd find him a place, because Master Isidoro Macca was looking for a swineherd. 'But don't you say anything about Starface,' Farmer Cola suggested. 'A misfortune like that might happen to anybody. But it's better not to mention it.'

They went round looking for Master Macca, who was at the dance, so while Farmer Cola went in to play ambassador, Jeli waited outside on the road, among the crowd that stood staring through the doorway of the shop. In the bare room was a swarm of people jumping and enjoying themselves, all red in the face and gasping, making an enormous threshing of heavy boots on the brick floor, so that they drowned even the *ron-ron* of the big bass, and hardly was one piece finished, costing every one a farthing, than they lifted their finger to show that they wanted another; and the fellow who played the big bass made a cross on the wall with a piece of charcoal to keep the reckoning up to the last piece, and then they began over again. 'Those in there are spending without giving it a thought,' Jeli was saying to himself. 'Which means

they've got a pocketful, and aren't tight put like me, for lack of a master; they sweat and wear themselves out jumping about for their own pleasure, as if they were paid by the day for it!' Farmer Cola came back to say that Master Macca didn't need anybody. Then Jeli turned his back and went off slowly.

Mara lived out towards Sant' Antonio, where the houses clamber up the steep slope, facing the valley of the Canziria, all green with prickly-pear cactus, and with the mill-wheels foaming at the bottom in the torrent; but Jeli hadn't the courage to go out there, now that they wouldn't have him even to mind the pigs, so he wandered aimlessly among the crowd that hustled and shoved him heedlessly, and felt himself more alone than when he was away with the colts in the wastes of Passanitello, and he wanted to cry. At last he was met in the square by Farmer Agrippino, who was going around with his arms dangling, enjoying the feast, and who shouted after him: 'Hi! Jeli! Hey!' and took him home with him. Mara was in a grand get-up, with long ear-rings swinging against her cheeks, and she stood there in the doorway with her hands spread on her stomach and loaded with rings, waiting for twilight, to go and see the fireworks.

'Oh!' Mara said to him. 'Have you come as well for the Feast of St. John?'

Jeli didn't want to go in, because he wasn't dressed up, but Farmer Agrippino pushed him by the shoulders, saying this wasn't the first time they'd seen him, and that they knew he came to the fair with his master's colts. Mrs. Lia poured him out a full glass of wine, and they made him go with them to see the illuminations, along with the neighbours and their wives.

When they came into the square, Jeli stood open-mouthed with wonder; the whole square seemed like a sea of fire, like when you're burning-off the stubble, because of the great number of squibs which the devout were letting off under the eyes of the saint, who for his part stood all black under the little awning of silver, there in the entrance to the Rosary Walk, to enjoy it all. His devotees came and went through the

226

flames like so many devils, and there was even a woman with her dress undone, her hair wild, her eyes starting out of her head, lighting squibs along with the rest, and a priest in his black gown, without his hat, who seemed like one possessed, he was so worked up with devotion to the saint.

'That young fellow there is the son of Farmer Neri, the factor of the Salonia lands, and he's spent more than ten shillings in fireworks!' said Mrs. Lia, pointing to a youth who was going round the square with two gushing rocket-squibs in his hands, like two candles, so that all the women were wild about him, and screamed to him: *Viva San Giovanni!* Long live Saint John!

'His father's rich, he's got more than twenty head of cattle,' added Farmer Agrippino.

Mara added also that he had carried the big banner, in the procession, and he held it straight as a die, he was such a strong, fine fellow.

The son of Farmer Neri seemed as if he heard them, and he lighted his fiery squibs for Mara, dancing around her; and after the squibs were over he joined her party and took them all to the dance, to the Cosmorama, where you saw the old world and the new, paying for them all, even for Jeli, who followed behind the train like a dog without a master, to see the son of Farmer Neri dance with Mara, who wheeled round and curtsied like a dove on the roof, and who held out the corner of her apron so prettily, while the son of Farmer Neri leaped like a colt, so that Mrs. Lia wept like a child for sheer pleasure, and Farmer Agrippino kept nodding his head as if to say, Yes, things are going very well.

At last, when they were tired, they wandered about, 'promenading,' dragged along by the crowd as if they were in the midst of a torrent, to see the illuminated transparencies, where they were cutting off St. John's head, so that it would have melted a very Turk to see it, and the saint kicked like a wild goat under the butcher's knife. Quite near, the band was playing, under a wooden stand like a great umbrella, all lit up with lights, and there was such a crowd in the square that never had so many people been seen at the fair.

Mara walked around on the arm of Farmer Neri's son, like a young lady, and spoke in his ear, and laughed as if she was enjoying herself thoroughly. Jeli was absolutely tired out, and sat down to sleep on the causeway, until the first explosions of the fireworks woke him. At that moment Mara was still at the side of Farmer Neri's son, leaning on him with her fingers clasped upon his shoulder, and in the light of the coloured fires she seemed now all white, and now all red. When the last rockets rushed in a crowd into the sky, Farmer Neri's son, green in the face, turned to her and gave her a kiss.

Jeli said nothing, but at that moment all the feast, which he had enjoyed so much till now, turned into poison for him, and he began to think of his own troubles again, after having forgotten them: how he was without a job, and didn't know what to do, nor where to go, having neither bread nor roof, and the dogs could eat him as they would Starface, who was left down there in the ravine, skinned to the very eyes.

Meanwhile people were still prancing about all around him, in the darkness which had come on. Mara and her girl friends skipped and danced and sang down the stony little street, on the way home.

'Good night! Good night!' the friends kept saying as they left them on the way.

Mara said Good night! as if she were singing it, her voice was so happy, and Farmer Neri's son seemed as if he really wouldn't ever let her go, while Farmer Agrippino and Mrs. Lia were quarrelling about opening the house door. No one took any notice of Jeli, only Farmer Agrippino remembered him, and asked him:

'Now where shall you go?'

'I don't know,' said Jeli.

'Tomorrow come for me, and I'll help you look for a place. For tonight, go back into the square where we were listening to the band; you'll find a place on some bench, and you must be used to sleeping in the open.'

Jeli was used to that, but what hurt him was that Mara never said a word to him, and left him standing on the doorstep as if

he was a beggar; so the next day, when he came for Farmer Agrippino, the moment he was alone with the girl he said to her:

'Oh, Miss Mara! you do forget your old friends!'

'Oh, is it you, Jeli?' said Mara. 'No, I didn't forget you. But I was that tired, after the fireworks.'

'But you like him, though, don't you Farmer Neri's son?' he asked, turning his stick round and round in his hand.

'What *are* you talking about!' replied Miss Mara roughly. 'My mother's in there and she'll hear every word.'

Farmer Agrippino found him a place as shepherd at Salonia, where Farmer Neri was factor, but as Jeli was new to the job he had to accept a big drop in his wages.

Now he looked after his sheep, and learned how to make cheese, and ricotta, and caciocavallo, and every other fruit of the flock; but amid all the talk and gossip that went on at evening in the courtyard, among all the herdsmen and peasants, while the women were shelling broad-beans for the soup, if the son of Farmer Neri, the one who was marrying Farmer Agrippino's Mara, happened to join in the talk, then Jeli said no more, hardly dared to open his mouth. Once when the field-tenant was teasing him, saying that Mara had given him the go-by, after everybody had said that they'd be husband and wife one day, Jeli, who was watching the pot in which he was heating the milk, replied, as he slowly and carefully stirred in the rennet:

'Mara's got a lot better-looking since she's grown up; she's like a young lady now.'

However, as he was patient and a worker, he soon learned everything that had to do with his job, better than many born to it, and since he was used to being with animals, he loved his sheep as he had loved his colts, and then the 'sickness' wasn't so bad at Salonia, and the flock prospered so that it was a pleasure to Farmer Neri every time he came to the farmstead, so that at the year's end he persuaded the master to raise Jeli's wages, till the youth now got almost as much as he had when he herded the horses. It was money well spent, too, for Jeli didn't stop to count the miles if he was looking

for better pasture for his animals, and if the sheep were bringing forth young, or if they were sick, he carried them to grass in the saddle-bags on the ass, and he put the lambs on his own shoulder, where they bleated into his face with their noses out of the sack, and sucked his ears. In the famous snow of St. Lucy's night, the snow fell nearly four feet deep in the Dead Lake at Salonia, and when day came there was nothing else to be seen for miles and miles around, in all the country; and as for the sheep, not so much as their ears would have been left if Jeli hadn't got up three or four times in the night to chase them around in the enclosure, so that the poor creatures shook the snow off their backs, and escaped being buried as so many of the neighbours' flocks were – according to what Farmer Agrippino said when he came to have a look at a little field of broad-beans which he had at Salonia, and he said moreover that about that other tale of Farmer Neri's son going to marry his daughter Mara, there was nothing in it, Mara had got quite different intentions.

'They said they were going to get married at Christmas,' said Jeli.

'Not a bit of it; they're not going to get married to anybody; all a lot of envious talk of people who want to meddle in other people's affairs,' replied Farmer Agrippino.

However, the man who was boss of the fields, who knew all about it, having heard the talk in the square when he went to the village on Sunday, told the real facts of the case, after Farmer Agrippino had gone: the marriage was off, because Farmer Neri's son had got to know that Mara was carrying on with Don Alfonso, the young squire, who had known Mara since she was a little thing, and Farmer Neri said that he wanted his son to be respected as his father was respected, and he was having no horns in his house save those of his own oxen.

Jeli was there and heard it all, sitting in a circle with the others at the morning meal, and at that moment slicing the bread. He said nothing, but his appetite left him for that day.

While he led his sheep to pasture, he thought again of Mara as she was when she was a little girl, when they were together all day long, and went to the Vale of the Jacitano, or to the Hill of the Cross, and she would stand with her chin in the air watching him as he climbed for the nests at the tops of the trees; and he thought too of Don Alfonso, who used to come out to him from the villa not far off, and they would lie on their stomachs on the grass, stirring up the grass-hoppers' nests with a straw. All these things he kept carefully recalling for hours on end, seated on the edge of the ditch with his knees between his arms, seeing in his mind the high walnut-trees of Tebidi, the thickets in the valley, the slopes of the hill-sides green with sumach trees, the grey olive-trees which rose one upon another like mist in the valley, the red roofs of the buildings, and the belfry 'that looked like the handle of the salt-cellar' among the orange-trees of the garden. Here the country spread in front of him naked and desert, blotched by the dried-up grass, fuming silently in the distant heat-haze.

In spring, just when the pods of the broad-beans were beginning to bend their heads, Mara came to Salonia with her father and mother, and the lad and the donkey, to gather beans, and they came to the farmstead to sleep all together for the two or three days that the bean-gathering would last. Therefore Jeli saw the girl morning and evening, and often they sat side by side on the low wall of the sheep-pens, chatting together, while the lad counted the sheep. 'I could think I was back at Tebidi,' said Mara, 'when we were little, and we used to sit on the bridge of the narrow road.'

Jeli remembered it all well enough, though he said nothing, having always been a sensible lad of few words.

The bean-gathering over, the evening before her departure Mara came to say good-bye to the youth, just when he was making the ricotta, and was busy catching the whey in the ladle. 'I'll say good-bye to thee now,' she said. 'Tomorrow we're going back to Vizzini.'

'How have the beans turned out?'

'Badly! The pest has taken them all this year.'

'They depend on the rain, and there was hardly any,' said Jeli. 'We had to kill the lambs, there was nothing for them to eat; on all the Salonia there hasn't been three inches of grass.'

'But it makes no difference to you. You have your wages the same, good year or bad.'

'Yes, it's true,' he said. 'But for all that I don't like handing the poor things over to the butcher.'

'Do you remember when you came for the Feast of St. John, and you were without work?'

'Yes, I remember.'

'It was my father who got you a place then, with Farmer Neri.'

'And you, why haven't you married Farmer Neri's son?'

'Because it wasn't God's will. My father's been unlucky,' she continued after a pause. 'Since we've been at Marineo everything has turned out badly. The beans, the wheat, that bit of vineyard that we have up there. Then my brother has gone to be a soldier, and we've lost a mule worth twenty guineas.'

'I know,' replied Jeli. 'The bay mule.'

'Now we've lost so much, who'd want to marry me?'

Mara was breaking to bits a sprig of blackthorn, as she spoke, her chin down on her breast, her eyes lowered, her elbow occasionally nudging Jeli's elbow, without her heeding. But Jeli also said nothing, his eyes fixed on the churn; and she resumed:

'At Tebidi they used to say we should be husband and wife, do you remember?'

'Yes,' said Jeli, and he put the ladle down on the side of the churn. 'But I'm nothing but a poor shepherd, and I can't expect to get a farmer's daughter like you.'

Mara was silent for a moment, then she said:

'If you care for me, I'd have you willingly.'

'Really?'

'Really!'

'And Farmer Agrippino, what would he say?'

232

'My father says you know your job now, and you're not one of those that spend their wages as soon as they get them, but turn one penny into two, and you eat less, so as to save bread, and so you'll have sheep of your own one day, and will be rich.'

'If it's like that,' said Jeli, 'I'll take you willingly, as you say.'

'Hey!' Mara said to him when the darkness had fallen, and the sheep little by little were settling down to quiet. 'If you'd like a kiss now I'll give you one, now we're going to be husband and wife.'

Jeli took it in silence, and then, not knowing what to say, he added:

'I've always cared for you, even when you wanted to leave me for Farmer Neri's son; but I hadn't the heart to ask you about the other chap.'

'Don't you see! we were destined for one another,' concluded Mara.

Farmer Agrippino actually said yes, and Mrs. Lia began to put together as quick as she could a new jacket, and a pair of velvet breeches for her son-in-law. Mara was pretty, and fresh as a rose, looking like the Paschal lamb in her little white head-shawl, and with that amber necklace that made her throat look whiter; so that when Jeli walked the street at her side, he was as stiff as a poker, dressed up in new cloth and velvet, and didn't dare to wipe his nose with the red silk handkerchief, for fear folks should stare at him; and the neighbours and all the others who knew about Don Alfonso laughed in his face. When Mara said *I will*, and the priest, with a great sign of the Cross, gave her to Jeli as a wife, Jeli took her home, and it seemed to him they had given him all the gold of the Madonna, and all the lands his eyes had ever seen.

'Now that we are man and wife,' he said to her when they got home, and he was sitting opposite her and making himself as little as he could, 'now that we are man and wife, I can say it to you: it doesn't seem to me real as you could ever want me, when you could have had so many others better than me . . . when you're that pretty and taking, like you are!'

The poor devil didn't know what else to say, and hardly could contain himself, in his new clothes, he was so overjoyed to see Mara going round the house, arranging everything and touching everything, making herself the mistress of the place. He could scarcely tear himself away from the door, to return to Salonia; when Monday had come, he kept dawdling about, arranging the saddle-bags on the donkey's pack-saddle, then his cloak, then the waxed umbrella. 'You ought to come to Salonia with me,' he said to his wife, who stood watching him from the threshold. 'You ought to come along with me!' But the woman only began to laugh, and said she wasn't made for minding sheep, and there was nothing for her to go to Salonia for.

It was a fact, Mara was not made for minding sheep, nor was she used to the north wind of January, when your hands stiffen on your stick, and it feels as if your finger-nails were coming out, nor to the furious downpours of rain, when you're wet to the bone, nor to the suffocating dust of the roads, when the sheep walk under the burning sun, nor to the hard biscuit and the mouldy bread, nor to the long, silent, lonely days, when in all the burnt-up country you see nothing except, at rare intervals, in the distance, some peasant blackened by the sun, silently driving his ass in front of him along the white and endless road. At least Jeli knew that Mara was warm under the bed-quilt, or that she was spinning in front of the fire, gossiping in a group with the neighbours, or sunning herself on the balcony, while he was coming back from the pasture weary and thirsty, or wet through with rain, or when the wind drove the snow into the hut and put out the brush-wood fire. Every month Mara went to draw his wages from the master, and she was short of nothing, neither eggs in the hen-house, nor oil in the lamp, nor wine in the flask. And just twice a month Jeli came to her, and she stood on the verandah to look for him, with her distaff in her hand; and after he had tied the donkey in the stable, and taken off his pack-saddle, put him some feed in the manger, and packed the wood under the shed in the yard, or put whatever else he had brought in the kitchen, Mara helped him to hang his cloak on the nail, to

234

take off his goat-skin leggings, in front of the fire, and poured him some wine, set the soup or the macaroni to boil, and laid the table, going about it all softly and intently, like a good housewife, at the same time telling him all her news, about the eggs she had set under the hen, what cloth she had on her loom, about the calf they were raising, all without forgetting a thing of what she was doing. When Jeli was in his own house, he felt grander than the Pope.

But on Saint Barbara's night he came home unexpectedly, when all the lights were out in the little street, and the town clock was striking midnight. He came because the mare which the master had left out at pasture had turned sick all of a sudden, and he plainly saw that she'd have to go to the vet at once, and he'd had some work to get her as far as the village, what with the rain that fell in torrents, and the roads where you sank up to your knees. Then in spite of his loud knocking and calling to Mara at the door, he had to wait half an hour under the rain that poured off the roof, till the water simply ran from his heels. His wife opened for him at last, and began to abuse him worse than if it was she who'd had to be scouring the country in that weather

'Why, what's a-matter wi' you?' he asked her.

'You've frightened me to death, at this time of night! What sort of time do you think this is, to come? Tomorrow I shall be bad.'

'Go back to bed. I'll light the fire.'

'No. I've got to get some wood in.'

'I'll do it.'

'No, you won't.'

When Mara returned with the wood in her arms, Jeli said:

'Why did you open the yard door? Was there no wood in the kitchen?'

'No! I had to get it from the shed.'

She let him kiss her, but coldly, turning her face away from him.

'His wife lets him soak outside the door, when she's got the cuckoo inside with her,' said the neighbours.

But Jeli saw nothing, he was such a clown, and the others took care not to tell him, for it was evident he didn't mind, seeing he'd taken on the woman for what she was worth, after Farmer Neri's son had dropped her because of the talk about Don Alfonso. Jeli for his part lived happy and contented, in spite of all the things they said about him, and got as fat as a pig, 'because though horns are thin, yet they keep the house fat.'

But at last one day the lad who helped with the flock told him to his face, when they were squabbling about the pieces of cheese which had had slices stolen from them: 'Now that Don Alfonso has taken your wife from you, you think you're his brother-in-law, and you show off as if you were a crowned king, with that horn you've got on your head.'

The factor and the field-boss expected to see blood flow at these words; but Jeli only stupidly went on with what he was doing, as if he hadn't heard, or as if it wasn't his business, with such an ox face that horns really would have suited him.

Now Easter was at hand, so the factor sent all the farm-hands to confess, hoping that for fear of God they wouldn't steal any more. Jeli went as well, and when he came out of church he looked for the lad who had said those things to him, and when he found him he threw his arm round his shoulder and said to him: 'The father-confessor told me to forgive you; but I'm not angry with you for what you said; and if you won't snip pieces off the cheese any more, I don't care about what you said to me that time in a rage.'

It was from that moment that they nicknamed him. The Golden Horn, and the name stuck to him and to all his family, even after he had washed the horn in blood.

Mara also went to confession, and came away from the church wrapped tight in her mantle, and with her eyes to the ground, so that she looked a very Saint Mary Magdalene. Jeli, who was waiting for her on the balcony, taciturn, saw her coming like that, obviously with the Communion bread inside her, and he turned pale as death, looking at her from head to foot, as if he had never seen her before, or as if they had given him another Mara; and while she spread the cloth and put the

soup-plates on the table, quiet and cleanly as usual, he hardly dared lift his eyes to her.

However, after he'd thought about it for a long time, he asked her:

'Is it true that you're carrying on with Don Alfonso?'

Mara fixed him with her coal-black eyes and crossed herself. 'Why do you want to make me sin this day of all others?' she cried.

'I didn't believe it, because we were always together with Don Alfonso, when we were children, and there wasn't a day he didn't come to Tebidi, when he was staying in the country at the villa. And besides he's rich, with shovelfuls of money, so if he wanted women he could get married, and he'd not run short of nothing, neither to wear nor to eat.'

But Mara began to get in a rage, and started abusing him to such a pitch that the poor wretch didn't dare lift his nose from his plate.

At length, so that the good food they were eating shouldn't turn into poison, Mara began to talk of something else, and asked him if he had remembered to hoe that bit of flax which they'd sown on the bean-field.

'Yes,' said Jeli. 'The flax will do well.'

'If it does,' said Mara. 'I'll make you two new shirts this winter that'll keep you warm.'

In short, Jeli didn't understand what 'horns' means, and he didn't know what jealousy was, every new idea had such hard work to enter into his head, and this one especially was such a big novelty that it was fearful hard work to take it in, especially when he saw his Mara before him, so beautiful and white, and clean, and he knew she had wanted him herself, and he'd thought of her for years and years, since he was a little lad, so that the day they'd told him she was going to marry somebody else he'd not had the heart to eat nor to drink, all the day and then when he thought of Don Alfonso, with whom he'd been together so much, and who always brought him sweets and white bread, he could see him as plain as if he were there, in his new little suit and curled hair, his smooth, pale face like a girl's; and though afterwards he hadn't seen him

any more, himself being a poor shepherd, all the year round out in the country, yet he still kept him in his heart the same. But the first time Jeli saw Don Alfonso again, to his own sorrow, after so many years, he felt his inside boil within him; and now he had a fine curly beard, like his hair, and a velvet jacket, and a gold chain on his waistcoat. Nevertheless, he recognized Jeli, and clapped him on the shoulder when he spoke to him. He had come with the owner of the farmstead, along with a bunch of friends, for a jaunt into the country at shearing-time; and Mara turned up as well, under pretext that she was pregnant and she longed for fresh ricotta.

It was a lovely hot day out in the fresh blond fields, where the hedges were in flower, and the vines were sending out long green threads, the sheep jumping and bleating with pleasure at being free from all that wool, and in the kitchen the women were making a big fire to cook all the stuff the master had brought for dinner. The gentlemen who were waiting for the dinner gathered meanwhile in the shadow of the dark carob-trees, calling for bagpipes and tom-tom drums, and then they danced with the women of the farmstead, all at their ease. Jeli, all the time he was shearing the sheep, felt something inside him like a thorn, he didn't know what it was, like a nail, like scissors clipping him up fine in his inside, like a poison. The master had ordered them to cut the throats of two kids, and of a yearling sheep, and to kill chickens and a turkey. You could tell he wanted to do things on a grand scale, without counting the cost, so that he would look big in the eyes of his friends, and while all those creatures squealed with pain, and the kids screamed under the knife, Jeli felt his knees trembling, and in waves it seemed to him as if the wool he was shearing and the grass in which the sheep were jumping flamed red into blood.

'Don't you go!' he said to Mara, as Don Alfonso called to her to come and dance with the rest. 'Don't you go, Mara!'

'Why not?'

'I don't want you to. Don't you go!'

'Can't you hear them calling me?'

He gave her no intelligible answer, as he bent over the sheep he was shearing. Mara shrugged her shoulders, and went off to dance. She was flushed and excited, her black eyes like two stars, and she laughed and showed her white teeth, and all the gold she was wearing shook and glittered against her cheeks and bosom till she seemed a very Madonna, nothing less. Jeli had risen erect from his stooping, holding the long scissors in his hand, and deadly-white in the face, as white as once he had seen his father, the cowherd, when he trembled with fever by the fire in the hut. All at once, seeing Don Alfonso with his curly beard, his velvet jacket and the gold chain on his waist-coat, taking Mara by the hand to lead her to the dance, only then, when he saw him touch her, did he leap on him and cut his throat in one stroke, just like killing a kid.

Later, when they were taking him before the judge, bound, and overcome, without having proffered the least resistance:

'Why!' he said. 'Didn't I have to kill him? . . . If he'd taken Mara from me! . . .'

ROSSO MALPELO
or
THE RED-HEADED BRAT

They called him Malpelo, which means 'evil-haired,' because he had red hair: and he had red hair because he was a bad, malicious boy, with every promise of growing up into a first-rate rascal. And so all the men at the red-sand pit called him Malpelo, till even his mother had wellnigh forgotten his baptismal name, hearing him always called by the other.

For the rest, she only saw him on Saturday evenings, when he came home with the few pence of his week's earnings; and seeing that he was *malpelo*, there was always the risk that he'd kept back a few of the same pennies; so that, to make doubt sure, his elder sister always received him with clouts and abuse.

However, the owner of the pit had confirmed what he said, that the wages were so much, and no more; and too much at that, in all conscience, for a little brat whom nobody else would have had around, whom everybody avoided like a mangy dog, giving him the taste of their boot when they found him in reach.

He was in truth an ugly chip, surly, snarling, and wild. At midday, while all the other workmen of the pit were sitting together eating their soup, and having a bit of talk, he would go off to squat in some corner, with his basket between his legs, to gnaw there alone his supply of bread, after the manner of animals of his sort: and the others called out something jeering to him, or threw stones at him, till the boss sent him back to work with a kick. All the same, he grew fat between the kicks, and he let them work him like the grey donkey, without daring to complain. He was always ragged and dirty with red sand, since his sister had got married, and had other things to think of; at the same time he was as well known as the dandelion is, by everybody in Monserrato and Carvana, so much so that the pit where he worked was called Malpelo's

pit, which annoyed the owner considerably. Altogether they kept him out of pure charity, and because his father, Master Misciu, had been killed in the pit.

He had been killed in this way: one Saturday he wanted to stay behind to finish a job he was doing as piece-work, which was a pillar of solid sand they had left long ago to keep up the roof of the pit, and now was no longer needed, and which, he had estimated roughly with the master, would contain some thirty-five or forty loads of sand. But there was Master Misciu digging away for three days, and the thing even then wasn't finished, but would take another half-day on Monday. It had turned out a mean piece of work and only a poor owl like Master Misciu would have let himself be taken in to such an extent by the master; but it was for that very reason they called him Dummy Misciu, he was the jackass for all the hard work in the sand-pit. He, poor devil, let them talk, and was satisfied to earn his bread with his two hands, instead of turning his fists against his companions and starting trouble. Malpelo used to make an ugly little face, as if all those frauds and insults fell on his shoulders, and little as he was, his eyes darted such looks as made the men say to him: 'Get out! *You*'ll never die in your bed, like your father.'

However, neither did his father die in his bed, good-natured creature as he was. Uncle Mommu, with the lame hip, had said that he wouldn't have tackled that pillar not for twenty guineas, it was so dangerous; but then, on the other hand, everything is risky in a pit, and if you were going to stop to think of danger, you'd better go and be a lawyer, and have done with it.

So on the Saturday evening Master Misciu was still scraping away at his pillar, after the *Ave Maria* bell had rung long ago, and all his fellow-workmen had lit their pipes and gone off home, telling him to wear his guts out for love of the boss if he liked, and advising him to mind he didn't get trapped, like a rat. He, who was used to jokes, took no notice, replying only with the *Ah! Ah!* of his heavy, full-length strokes with the pick; but inside he said: 'That's for the bread! That's for the wine! That's for the new frock for Nunziata!' and so he

went on keeping count of how he would spend the money for his 'stint', his job.

Outside the pit the sky was swarming with stars, and down there the lantern smoked and swung like a comet; and the great red pillar, disembowelled by the strokes of the pick, twisted and bent forward as if it had belly-ache and were also saying *Oh dear! Oh!* Malpelo kept clearing away the dirt, and he put the empty sack and the wine-flask and the mattock safely aside. His father, who was fond of him, poor little chap, kept saying: 'Go back!' or 'Look out! Look out! Watch if any little stones or coarse sand fall from the top!' All at once he said no more, and Malpelo, who had turned to put the irons back in the basket, heard a deep and suffocated noise, like the sand makes when it comes down all at once; and the light went out.

In the evening when they came in a great hurry to fetch the engineer who directed the work in the pit, he happened to be at the theatre, and he wouldn't have changed his seat in the stalls for a throne, for he was devoted to the play. Rossi was playing Hamlet, and there was a splendid audience. Outside the door all the poverty-stricken women-folk of Monserrato were gathered, screaming and beating their breasts for the great misfortune which had happened to Mrs. Santa, she alone, poor thing, saying nothing, her teeth chattering as if it were icy January. When they told the engineer that the accident had happened about four hours ago, he asked them what was the good of coming for him, four hours after? Nevertheless, he set off, with ladders and torches, taking two hours more, which made it six, and then the lame man said it would take a week to clear the pit of all the stuff that had fallen.

Talk about forty loads of sand! Sand had come down like a mountain, all fine and burnt small by the lava, so that you could knead it with your hands, and it would take double of lime. You could go on filling cart-loads for weeks. A fine thing for Dummy Misciu!

The engineer went back to see Ophelia buried; and the other miners shrugged their shoulders, and went home one by

one. Amid all the dispute and the chatter they took no heed of a childish voice, which no longer sounded human, and which cried wildly: 'Dig for him! Dig here, quick, quick!' 'Ha!' said the lame old man. 'It's Malpelo! Where has Malpelo sprung from? If you hadn't been Malpelo, you wouldn't have escaped either! No, my boy!' The others began to laugh, and somebody said he had his own devil to look after him, another said he had as many lives as a cat. Malpelo answered nothing, neither did he cry, but away there in the hole he was at it digging out the sand with his finger-nails, so that nobody knew he was there: only when they drew near with the light they saw him, his face distorted, his eyes glassy, his mouth foaming, so that they were afraid; his finger-nails were torn, and hung bloody and ragged from his hands. Then when they wanted to take him away, there was a terrible scene; since he could no more scratch, he bit like a mad dog, and they had to seize him by the hair and drag him, to get him away alive.

Nevertheless, he came back to the pit after a few days, when his mother came crying, bringing him by the hand; since you can't always find bread lying about, ready to eat. Now, moreover, they couldn't keep him away from that gallery in the pit, and he dug away furiously, as if every basket of sand he removed were lifted from his father's breast. Sometimes, as he was working with the pick, he suddenly stopped still, with the pick in the air, his face grim and his eyes wild, and it seemed as if he were listening to something which his familiar demon was whispering in his ears, from beyond the mountain of fallen sand. Those days he was more gloomy and wicked than usual, so that he hardly ate anything, and threw his bread to the dog, as if it were not good food. The dog liked him, because dogs only care for the hand that gives them bread. But on the grey donkey, poor creature, so crooked and thin, was vented all the force of Malpelo's wickedness; he beat it mercilessly, with the handle of his pick, muttering: 'So you'll croak all the sooner!'

After the death of his father it was as if the devil had entered into him, he worked like those ferocious buffaloes which you have to manage by the ring in their nose. Knowing that he

was *malpelo*, he set himself out to be as bad as he could, and if any accident happened, if a miner lost the wedges, or if a donkey broke its leg, or if a piece of the gangway fell in, they always knew he had done it; and he for his part took all their ill-treatment without a word, exactly like the donkeys which curve their backs under the blows, and then go on in their own way again. With the other lads, again, he was downright cruel, and it seemed as if he wanted to avenge himself upon those weaker than himself, for all the ills he imagined had been done to him and to his father. Certainly he took a strange pleasure in recalling one by one all the injuries and exactions that had been put upon his father, and the way they had let him die. And when he was alone, he would mutter: 'They're just the same with me! and they called my father Dummy because he didn't do the same to them!' Another time, when the boss was going by, the boy followed him with a sinister look: 'He did it, for thirty-five loads!' And again, looking after the lame old man: 'Him as well! and he laughed into the bargain! I heard him, that night!'

By a refinement of malignity he seemed to have taken under his protection a poor lad who had come to work a short while back at the pit, a boy who had injured his thigh in a fall from a bridge, and was no longer able to be a bricklayer's labourer. This poor youth hobbled as he carried his basket of sand on his shoulder, till you'd think he was dancing a tarantella, which set all the men in the pit laughing, so that they nicknamed him Frog; nevertheless, working underground there, frog though he was, he earned his daily bread; and Malpelo even gave him some of his, for the pleasure of being able to tyrannize over him, the men said.

To tell the truth, he tormented him in a hundred ways. Now he beat him without reason or pity, and if Frog didn't defend himself, he hit him harder, with greater rage, saying to him: 'Oh, you dummy! You dummy! If you haven't got the spunk to defend yourself from me, when I don't hate you, how do you think you're going to let the other lot jump on your face!'

Or if Frog was wiping away the blood from his nose and mouth: 'Now if it hurts you when somebody hits you, you'll learn how to hit 'em yourself!' When he drove a loaded ass up the steep incline from the underground works, and saw it digging in its hoof-toes, loaded beyond its strength, curved up under the weight, panting, its eye dead, then he beat it mercilessly with the handle of his pick, and the blows sounded dry upon the shins and the exposed ribs. Sometimes the animal bent itself double under the beating, but, put forth its strength as it might, it could not take another step, and fell on its knees, and there was one of them that had fallen so many times, it had two raw places on its legs: and then Malpelo confided to Frog: 'A donkey gets thrashed because it can't do any thrashing itself; if it could beat us, it would trample us under its feet and tear the flesh off us.'

Or again: 'If you have to hit, watch you hit as hard as you can; and then them as you're hitting will know you're one better than they are, and so you'll have less to put up with.'

When he was working with the pick or the mattock he went at it with fury, as if he had a grudge against the sand, and he struck and hacked with shut teeth, going *Ah! ah!* at each blow, as his father had done. 'Sand is treacherous,' he said to Frog, in an undertone; 'it's like all the rest, if you're weaker than it is, it tramples on your face, but if you're stronger than it, or if you go for it a lot of you together, like that lame fellow does, then you can beat it. My father always beat it, and he never beat anything else besides the sand, and so they called him Dummy, and then the sand caught him unawares and ate him up, because it was stronger than he.'

Every time Frog had a heavy job on hand, and whimpered like a girl, Malpelo punched him in the back and shouted: 'Shut up, you baby!' and if Frog didn't leave off, then Malpelo lent him a hand, saying with a certain pride: 'Here, let me do it! I'm stronger than you are.' Or another time he gave him his half an onion, and chewed his own bread dry, shrugging his shoulders and adding: 'I'm used to it.'

He was used to everything, he was: knocks on the head, kicks, blows with the mattock-handle, or with the saddle-strap; used to being insulted and played tricks on by everybody, used to sleeping on the stones, with his arms and back feeling broken by fourteen hours' work on end; even he was used to fasting, when the boss, who owned the pit, punished him by stopping his bread or his soup. He used to say that the boss had never stopped his rations of ill-treatment. However, he never complained; but he avenged himself on the sly, unawares, with one of his tricks that made you think the devil really had put a tail on him; and therefore the punishment always fell on him, even when he was not guilty; since if he wasn't guilty this time, he might just as well have been; and he never justified himself, for what would have been the use! And sometimes, when Frog was terrified and wept and begged him to tell the truth and exculpate himself, he repeated: 'What's the good? I'm *malpelo!*' and nobody could have said whether that perpetual ducking of his head and shoulders came from defiant pride or from desperate resignation, and you couldn't even tell whether his nature was driven by savagery or by timidity. What is certain is that even his mother had never received a caress from him, and hence she never gave him one.

On Saturday evenings, as soon as he turned up at home with his ugly little face daubed with freckles and with red sand, wearing clothes that hung from him in rags all over, his sister seized the broom-handle if he dared show himself in the doorway in that state, for it would have frightened away her young man if he had seen the sort of brat he was going to have foisted off on him for a brother-in-law; the mother was always at one neighbour's house or another, so he went off to curl himself up on his rough sack like a sick dog. And so on Sundays, when all the other lads of the place put on a clean shirt to go to Mass, or to play in the yard, he seemed to have no other pleasure but to go slinking through the gardens and the paths among the olives, hunting and stoning the poor lizards, which had never done anything to him, or else foraging in the hedges of prickly-pear cactus. But in truth, to

join in the foolery and stone-throwing of the other boys didn't amuse him.

Master Misciu's widow was in despair at having such a bad character for a son, for everybody called him that, and he was verily reduced to the state of those dogs which, always having to flee from kicks and stones on every hand, at last put their tails between their legs and scuttle away from the first living soul they see, and become ravenous, hairless, and savage as wolves. At least underground, in the sand-pit, ugly and ragged and half-naked as he was, they didn't make fun of him, and he seemed made on purpose for his job, even to the colour of his hair and to his sly cat's eyes that blinked if they saw the sun. There are donkeys like that, that work in the pit for years and years without ever going out, for in those underground workings where the pit-shaft is vertical, they let them down on a rope, and they stay down all the rest of their lives. They are old donkeys, it is true, bought for ten or twelve shillings, ready to be taken off to the Beach to be strangled; but they are still good for the work they have to do down underground; and Malpelo, certainly, was worth more than they, and if he came out of the pit on Saturday evenings it was because he had hands to get up the rope with, and he had to take his mother his week's pay.

Certainly he'd have preferred to be a brick-layer's labourer, like Frog, to work singing upon the bridges up in the blue sky, with the sun on your back; or a carter, like neighbour Jaspar, who came to fetch the sand from the pit, swaying half-asleep on the shafts of the cart, with pipe in mouth, going all day long upon the fine country roads; or, better still, he'd have liked to be a peasant who passes all his life in the fields among the greenness, under the dark carob-trees, with the blue sea in the background, and the singing of birds above your head. But this had been his father's trade, and to this trade he was born. And thinking about it all, he showed Frog the pillar that had come down on his father, and which still yielded fine, burnt sand that the carter came to fetch, with his pipe in his mouth, and swaying on the shafts of the cart, and he said that when they had finished digging it away they would find the body

of his father, which should be wearing fustian breeches as good as new. Frog was frightened, but *he* wasn't. He told how he had been always there, since he was a child, and had always seen that black hole which went away underground, where his father used to lead him by the hand. Then he spread his arms to right and left, and explained how the intricate labyrinths of the underground workings spread beneath their feet everywhere in every direction right up to the distant black and desolate waste of the lavaflow, whose naked black-grey cinder-rock was sullied with dry scrub of broom; and that many men had been swallowed up in the workings, either crushed, or lost in the darkness, and that they walked for years, and are still walking, trying to find the ventilation shaft by which they had got in, and unable to hear the desperate calling of their children, who search for them in vain.

But one day, in filling the baskets, they came upon one of Master Misciu's shoes, and the boy was seized with such a trembling that they had to haul him up to the open air by the ropes, just like a dying donkey. But still they could not find either the good-as-new breeches, nor the remains of Master Misciu, although the old miners declared that that must be the exact place where the column had come down on him; and one workman, new to the job, remarked curiously how capricious the sand was, that it should have thrown the Dummy about so, his shoe in one direction and his feet in another.

After the finding of that shoe, Malpelo was seized with such a terror of seeing the naked foot of his father appear also among the sand, that he wouldn't give another stroke of the pick; so they gave him a taste of the pick-handle on his head. He went to work in another part of the gallery, and refused to go back to the old place. Two or three days later they did actually discover the corpse of Master Misciu, wearing the breeches and stretched out face downwards as if he had been embalmed. Uncle Monmu observed that he must have been a long while dying, because the pillar had bent in a curve over him, and had shut him in alive; you could even see still how

Master Dummy had instinctively tried to get out by digging in the sand, and he had his hands torn and his finger-nails broken 'just like his son Malpelo!' repeated the lame man. 'He was digging inside here while his son was digging outside.' But they said nothing to the boy, knowing him to be malign and vengeful.

The carter carted away the corpse from the workings, as he carted away the fallen sand and the dead donkeys, except that this time, over and above the stink of the carcass, you had to remember that the carcass was 'baptized flesh'; and the widow cut down the breeches and the shirt to fit Malpelo, who was thus for the first time dressed as good as new, and the shoes were put aside to keep until he was big enough, since you can't cut shoes down, and the sister's young man didn't want a dead man's shoes. When Malpelo stroked those good-as-new fustian breeches upon his legs, it seemed to him they were as soft and smooth as the hands of his father, when they used to stroke the son's hair, rough and red though it was. The shoes he kept hung upon a nail, upon the rough sack, as if they had been the Pope's slippers, and on Sundays he took them down and polished them, and tried them on; then he put them on the floor, side by side, and sat contemplating them by the hour, his chin in his hands and his elbows on his knees, hunting up heaven knows what ideas in his weird little brain.

He had some queer ideas, had Malpelo! Since they had handed over to him also his father's pick and mattock, he used them, although they were too heavy for his age; and when they had asked him if he wanted to sell them, they were willing to pay the price of new ones for them, he said No! his father had made the handles so smooth and shiny with his own hands, and he wouldn't be able to make others more smooth and shiny, not if he used them for a hundred years, and then another hundred on top of that.

About that time, the grey donkey had died at last of hard work and old age, and the carter had carted him away to throw him in the distant *sciara*. 'That's how they are,' grumbled Malpelo. 'Things they can't use any more, they

throw' em as far away as they can.' He went to pay a visit to the corpse of the Grey One at the bottom of the lava crack, and he forced Frog to go with him, though he didn't want to; but Malpelo told him that in this world you've got to look all things in the face, fair or ugly; and he stood there with the greedy curiosity of a wastrel watching the dogs which came running from all the farmsteads in the neighbourhood, to fight over the flesh of the Grey One. The dogs made off, yelping, when the boys appeared, and they circled ravenously on the bank across the gap, but the red-headed brat would not let Frog drive them off with stones.

'You see that black bitch,' he said, 'who's not a bit frightened of your stones? She's not frightened because she's more hungry than the others. See her ribs?' But now the grey donkey suffered no more, but lay still with his four legs stretched out, and let the dogs enjoy themselves clearing out his deep eye-sockets and stripping bare his white bones, and all the teeth that tore his entrails could no longer make him arch up his spine as did the merest blow with the mattock-handle which they used to give him to put a bit of force into him when he was going up the steep gang-way. And that's how things are! Oh, the Grey One had had blows from the pick and slashes on the withers, and even he, when he was bent under the load and hadn't breath to go on, would look back with glances from his big eyes that seemed to say as they were beating him: 'No more! no more!' But now the dogs could eat his eyes; and his stripped mouth, nothing but teeth, grinned henceforward at all beatings and slashes on the withers. And it would have been better if he had never been born.

The lava bed spread melancholy and desert as far as the eye could see, and rose and sank in peaks and precipices, black and wrinkled, without a grasshopper chirping upon it, or a bird flying over. You could hear nothing, not even the blows of the picks of the men at work underneath. And all the time, Malpelo kept repeating that below there it was all hollowed out in galleries, everywhere, towards the mountain and

towards the valley; so that once, a miner who had gone in with his hair black, had come out with his hair all white, and another one, whose torch had gone out, had called for help in vain, no one could hear him. He alone heard his own shouts, said the boy, and though he had a heart harder than the *sciara*, at this thought he shuddered. 'The boss often sends me a long way in, where the others daren't go. But I am Malpelo, and if I don't come back, nobody will look for me.'

However, on fine summer nights the stars shone bright even over the *sciara*, and the country round was just as black as it was, but Malpelo was tired with his long day's work, and lay down on his sack with his face to the sky, to enjoy the peace and the glitter of the upper deeps; for that reason he hated moonlit nights, when the sea swarmed and sparkled, and the country showed up vaguely here and there: then the *sciara* seemed even more naked and desolate. 'For us who've got to live underground,' Malpelo thought to himself, 'it ought to be always dark and everywhere dark.' The owl hooted above the lava bed, and flew hovering around; then he thought: 'Even the owl smells the dead that are in the underground here, and is desperate because she can't get at them.'

Frog was afraid of owls and bats; but the red-head abused him, because anybody who's got to live alone has no business to be frightened of anything, and even the grey donkey was not afraid of the dogs that stripped his bones, now that his flesh no longer felt the pain of being eaten. 'You were used to working on the roofs like the cats,' he said to him. 'But now it's different. Now that you've got to live underground, like the rats, you don't have to be frightened of rats, neither of bats, which are only old rats with wings, and rats like to live where there are dead people.'

Frog, however, took a real pleasure in explaining to him what the stars were doing up above; and he told him that away up there was Paradise, where the dead go who have been good and not vexed their parents. 'Who told you?' asked Malpelo, and Frog said his mother had told him.

Malpelo scratched his head, with a cunning smile, and made the face of a malicious brat who knows a thing or two. 'Your mother tells you that, because you ought to wear skirts instead of breeches.'

Then after he had thought awhile:

'My father was good and hurt nobody, although they called him *Dummy*. But you see, he's down below there, and they've even found the tools and the shoes, and the breeches I've got on.'

Some time afterwards, Frog, who had been ailing a long while, fell really ill, so that at evening they had to carry him out of the pit on the back of a donkey, stretched between the baskets, trembling with fever like a wet chicken. One of the workmen said that lad *would never have made old bones* at that job, and if you were going to work in a mine without going to pieces, you'd got to be born to it. When Malpelo heard that, he felt proud that he was born to it, and that he kept so strong and well. He helped Frog through the days, and cheered him up as best he could, shouting at him and punching him. But once when he punched him on the back, Frog had a mouthful of blood, and then Malpelo, terrified, looked everywhere in his mouth and in his nose, to see what he'd done to him, and swore that he couldn't have hurt him so much, with that little punch, and to show him, he gave himself hard blows on the chest and the back, with a stone; and a workman who was present fetched him a great kick between the shoulders, a kick which resounded like a drum, yet Malpelo never moved, and only when the miner had gone did he add: 'You see? It didn't hurt me! And he hit me a lot harder than I hit you. I'm sure he did.'

Meanwhile Frog got no better, and continued to spit blood and have fever every day. Then Malpelo stole some pennies from his own week's pay, to buy him wine and hot soup, and he gave him his good-as-new breeches because they'd keep him covered. But Frog still coughed, and every time it seemed as if he would suffocate, and in the evenings there was no getting the fever down, neither with sacks, nor covering him with straw, nor laying him before a blaze of twigs. Malpelo

stood silent and motionless, leaning forward over him, his hands on his knees, staring at him with concentrated eyes, as if he wanted to make his portrait, and when he heard him moan faintly, and saw his worn-out face and his deadened eyes, just like the grey donkey when he panted, spent, under a load, climbing the gangway, he muttered to the sick boy: 'It's better if you peg out quick! If you've got to suffer like that, it's better if you croak.' And the boss said Malpelo was quite capable of knocking the lad on the head, and they'd better keep an eye on him.

At last one Monday Frog didn't come to the pit, and the boss washed his hands of him, because in the state he was in he was more trouble than he was worth. Malpelo found out where he lived, and on Saturday he went to see him. Poor Frog was almost gone, and his mother wept and despaired as if her son had earned her ten shillings a week.

This Malpelo could not understand at all, and he asked Frog why his mother carried on like that, when for two months he hadn't earned even what he ate? But poor Frog made no response, and seemed to be counting the beams on the ceiling. Then the red-head racked his brains and came to the conclusion that Frog's mother carried on in that way because her son had always been weak and ailing, and she'd kept him like one of those brats who never are weaned. Not like him, who was strong and healthy, and was *malpelo*, and his mother had never wept for him because she'd never been afraid of losing him.

A short while after they said at the pit that Frog was dead, and Malpelo thought that now the owl hooted for him too, in the night, and he went again to visit the stripped bones of the Grey One, in the ravine where he used to go along with Frog. Now there was nothing left of the Grey One but the scattered bones, and Frog would be the same, and his mother would have dried her eyes, since even Malpelo's mother had dried hers when Master Misciu was dead, and now she was married again, and had gone to live at Cifali; also the sister was married, and the old house was shut. From that time on, if he was beaten, his folks cared nothing, and he didn't either, and when

he'd be like the Grey One or like Frog, he'd feel nothing any more.

About that time there came to work in the pit a man whom they had never seen before, and he kept himself hidden as much as he could; the other workmen said among themselves that he'd escaped from prison, and that if he was caught they'd shut him up again for years and years. Malpelo learned on that occasion that prison was a place where they put thieves and rascals like himself, and kept them always shut up and watched.

From that time he felt an unhealthy curiosity about that man who had tried prison and escaped. After a few weeks, however, the fugitive declared flatly and plainly that he was sick of that mole's life, and he'd rather be in prison all his life, because prison was paradise in comparison, and he'd rather walk back there on his own feet. 'Then why don't all the men who work in the pit get themselves put in prison?' asked Malpelo. 'Because they're not *malpelo* like you,' replied the lame man. 'But don't you fret, you'll go there, and you'll leave your bones there.'

However, Malpelo left his bones in the pit, like his father, only in a different way. It happened that they had to explore a passage which they maintained was a communication with the big shaft on the left, towards the valley, and if that was so, it would save a good half of the work of getting the sand out of the mine. But if it was not true, there was danger of getting lost and never finding the way back. Therefore no father of a family would make the venture, and not for all the money in the world would they let their own flesh-and-blood run such a risk.

But Malpelo had nobody who would take all the money in the world for his skin, even if his skin had been worth all the money in the world; his mother was married again and gone to live at Cifali, and his sister was married as well. The house-door was shut, and he owned nothing but his father's shoes, hung on a nail; hence they always gave him the most danger-ous work to do, and the most risky undertakings were allotted to him, and if he took no care of himself, the others certainly

took no care of him. When they sent him to explore that passage, he remembered the miner who had got lost, years and years ago, and who still walks on and on in the dark, calling for help, without anybody being able to hear him; but he said nothing. Anyhow, what would have been the good? He took his father's tools, pick, mattock, lantern, the sack with bread, the flask of wine, and he set off; nor was anything more ever known of him.

And so were lost even the bones of Malpelo, and the lads of the pit lower their voices when they speak of him in the workings, terrified lest he should appear before them, with his red hair and his wicked grey eyes.

Dear Farina, I'm sending you here not a story, but the out-
lines of a story. So it will have at least the merit of being brief,
and of being true – a human document, as they say nowadays;
interesting, perhaps, for you and for all those who would study
the great book of the heart. I'll tell it you just as I picked it up
in the lanes among the fields, more or less in the same simple
and picturesque words of the people who told it me, and you,
I am sure, will prefer to stand face to face with the naked,
honest fact rather than have to look for it between the lines of
the book, or to see it through the author's lens. The simple
human fact will always set us thinking; it will always have the
virtue of *having really happened*, the virtue of real tears, of fevers
and sensations which have really passed through the flesh. The
mysterious process by which the passions knot themselves
together, interweave, ripen, develop in their own way under-
ground, in their own tortuous windings that often seem con-
tradictory, this will still constitute for a long time to come the
attractive power of that psychological phenomenon which we
call the theme of a story, and which modern analysis seeks to
follow with scientific exactitude. I shall only tell you the
beginning and the end of the story I am sending you today,
but for you that will be enough, and perhaps one day it will be
enough for everybody.

Nowadays we work out differently the artistic process to
which we owe so many glorious works of art, we are more
particular about trifles, and more intimate; we are willing to
sacrifice the grand effect of the catastrophe, or of the psycho-
logical crisis, which was visioned forth with almost divine
intuition by the great artists of the past, to the logical devel-
opment, and hence we are necessarily less startling, less dra-
matic, but not less fatal; we are more modest, if not more
humble; but the conquests in psychological truth made by us
will be not less useful to the art of the future. Shall we never
arrive at such perfection in the study of the passions, that it

will be useless to prosecute further that study of the inner man? The science of the human heart, which will be the fruit of the new art, will it not develop to such a degree and to such an extent all the resources of the imagination that the novels and stories of the future will merely record *the various facts* of the case?

But in the meantime I believe that the triumph of the novel, that most complete and most human of all works of art, will be reached when the affinity and the cohesion of all its parts will be so complete that the process of the creation will remain a mystery, a mystery as great as that of the development of the human passions; and that the harmony of its form will be so perfect, the sincerity of its content so evident, its method and its *raison d'être* so necessary, that the hand of the artist will remain absolutely invisible, and the novel will have the effect of a real happening, and the work of art will seem *to have made itself*, to have matured and come forth spontaneously like a natural event, without preserving any point of contact with its author; so that it may not show in any of its living forms any imprint of the mind in which it was conceived, any shadow of the eye which visioned it, any trace of the lips that murmured the first words, like the *fiat* of the Creator; let it stand by itself, in the single fact that it is as it must be and has to be, palpitating with life and immutable as a bronze statue, whose creator has had the divine courage to eclipse himself and to disappear in his immortal work.

Several years ago, down there along the Simoneto, they were in pursuit of a brigand, a fellow called Gramigna, if I'm not mistaken; a name accursed as the grass which bears it, and which had left the terror of its fame behind it from one end of the province to the other. Carabiniers, soldiers, and mounted militia followed him for two months, without ever succeeding in setting their claws in him: he was alone, but he was worth ten men, and the ill weed threatened to take root. Add to this that harvest time was approaching, the hay was already spread in the fields, the ears of wheat were already nodding yes! to the reapers who had the sickle already in their hand, yet none

257

the less there was not a proprietor who dared poke his nose over the hedges of his own land, for fear of seeing Gramigna crouching between the furrows, his gun between his legs, ready to blow the head off the first man who came prying into his affairs. Hence the complaints were general. Then the Prefect summoned all the officers of the police, of the carabiniers, and of the mounted militia, and addressed a few words to them that made them prick up their ears. The next day there was a general upheaval: patrols, small bands of armed men, outposts everywhere, in every ditch and behind every drystone wall; they drove him before them like an accursed beast across all the province, by day and by night, on foot, on horseback, by telegraph. Gramigna slipped through their hands, and replied with bullets if they got too close on his heels. In the open country, in the villages, in the farmsteads, under the bough-shelter of the inns, in the clubs and meeting-places, nothing was spoken of but him, Gramigna, and of that ferocious hunt, of that desperate flight; the horses of the carabiniers fell dead tired; the militiamen threw themselves down exhausted in every stable; the patrol slept standing; only he, Gramigna, was never tired, never slept, always fled, scrambled down the precipices, slid through the corn, ran on all-fours through the cactus thicket, extricated himself like a wolf down the dry beds of the streams. The principal theme of conversation in the clubs, and on the village door-steps, was the devouring thirst which the pursued man must suffer, in the immense plain dried up under the June sun. The idlers widened their eyes when they spoke of it.

Peppa, one of the handsomest girls of Licodia, was at that time going to marry Neighbour Finu, 'Tallow-candle' as they called him, who had his own bit of land and a bay mule in his stable, and was a tall lad, handsome as the sun, who could carry the banner of Saint Margaret as if he were a pillar, without bending his loins.

Peppa's mother wept with satisfaction at her daughter's good fortune, and spent her time turning over the bride's trousseau in the chest, 'all white goods, and four of each,'

good enough for a queen, and ear-rings that hung to her shoulders, and golden rings for all the ten fingers of her hands; she had as much gold as St. Margaret herself, and they were going to get married just on St. Margaret's day, that fell in June, after the hay-harvest. Tallow-candle left his mule at Peppa's door every evening as he returned from the fields, and went in to say to her that the crops were wonderful, if Gramigna didn't set fire to them, and that the little corn-chamber that opened its gate-door opposite the bed would never be big enough for all the grain this harvest, and that it seemed to him a thousand years, till he could take his bride home, seated behind him on the bay mule.

But one fine day Peppa said to him: 'You can leave your mule out of it; I'm not going to get married.'

Poor Tallow-candle was thunderstruck, and the old woman began to tear her hair as she heard her daughter turning down the best match in the village.

'It's Gramigna I care for,' the girl said to her mother, 'and I don't want to marry anybody but him.'

'Ah!' The mother rushed round the house, screaming, with her grey hair flying loose like a very witch. 'Ah! that fiend has even got in here to bewitch my girl for me.'

'No,' replied Peppa, her eyes fixed and hard as steel. 'No, he's not been here.'

'Where have you seen him?'

'I've not seen him. I've heard about him. Hark, though! I can feel him here, till it burns me.'

It caused a great talk in the village, though they tried to keep it dark. The goodwives who had envied Peppa the prosperous cornfields, the bay mule, and the fine lad who carried St. Margaret's banner without bending his loins, went round telling all kinds of ugly stories, that Gramigna came to her at night in the kitchen, and that they had seen him hidden under the bed. The poor mother had lit a lamp to the souls in Purgatory, and even the priest had been to Peppa's house, to touch her heart with his stole, and drive out that devil of a Gramigna who had taken possession of it. Through it all she insisted that she had not so much as set eyes on the fellow; but

that she saw him at nights in her dreams, and in the morning she got up with her lips parched as if she were feeling in her own body all the thirst he must be suffering.

Then the old woman shut her up in the house, so that she should hear no more talk about Gramigna, and she covered up all the cracks in the house-door with pictures of the saints. Peppa listened behind the blessed pictures to all that was said outside in the street, and she went white and red, as if the devil were blowing all hell in her face.

At last she heard say that they had tracked down Gramigna to the cactus thickets at Palagonia. 'They've been firing for two hours!' the goodwives said. 'There's one carabinier dead, and more than three of the militia wounded. But they fired such showers of bullets on him that this time they've found a pool of blood, where he was.'

Then Peppa crossed herself before the old woman's bed-head, and escaped out of the window.

Gramigna was among the prickly-pear cactuses of Palagonia, nor had they been able to dislodge him from that cover for rabbits, torn, wounded though he was, pale with two days' fasting, parched with fever, and his gun levelled: as he saw her coming, resolute, through the thickets of the cactus, in the dim gleam of dawn, he hesitated a moment, whether to fire or not. 'What do you want?' he asked her. 'What have you come here for?'

'I've come to stay with you,' she said to him, looking at him steadily. 'Are you Gramigna?'

'Yes, I am Gramigna. If you've come to get those twenty guineas blood-money, you've made a mistake.'

'No, I've come to stay with you,' she replied.

'Go back!' he said. 'You can't stay with me, and I don't want anybody staying with me. If you've come after money you've mistaken your man, I tell you, I've got nothing, see you! It's two days since I even had a bit of bread.'

'I can't go back home now,' she said. 'The road is full of soldiers.'

'Clear out! What do I care! Everybody must look out for their own skin.'

While she was turning away from him, like a dog driven off with kicks, Gramigna called to her. 'Listen! Go and fetch me a bottle of water from the stream down there. If you want to stay with me, you've got to risk your skin.'

Peppa went without a word, and when Gramigna heard the firing he began to laugh bitingly, saying to himself: 'That was meant for me!' But when he saw her coming back, a little later, with the flask under her arm, herself pale and bleeding, he first threw himself on her and snatched the bottle, and then when he had drunk till he was out of breath, he asked her:

'You got away, then? How did you manage?'

'The soldiers were on the other side, and the cactuses were thick this side.'

'They've made a hole in you, though. Is it bleeding under your clothes?'

'Yes.'

'Where are you wounded?'

'In the shoulder.'

'That doesn't matter. You can walk.'

Thus he gave her permission to stay with him. She followed him, her clothes torn, her body burning with the fever of her wound, shoeless, and she went to get him a flask of water or a hunk of bread, and when she came back empty-handed, in the thick of the firing, her lover, devoured by hunger and by thirst, beat her. At last, one night when the moon was shining on the cactus grove, Gramigna said to her: 'They are coming!' and he made her lie down flat, at the bottom of the cleft in the rock, and then he fled to another place. Among the cactus clumps continual firing was heard, and the darkness flushed here and there with brief flames. All at once Peppa heard a noise of feet near her and she looked up to see Gramigna returning, dragging a broken leg, and leaning against the broad stems of the cactus to load his gun. 'It's all up!' he said to her. 'They'll get me now' and what froze her blood more than anything was the glitter in his eyes that made him look like a madman. Then when he fell on the dry branches like a bundle of wood, the militiamen were on him in a heap.

Next day they dragged him through the streets of the village on a cart, all torn and blood-stained. The people who pressed forward to see him began to laugh when they saw how little he was, pale and ugly like a figure in a Punch-and-Judy show. And it was for him that Peppa had left Neighbour Fino, the 'Tallow-candle'! Poor Tallow-candle, he went and hid himself as if the shame was his, and Peppa was led away between the soldiers, handcuffed, as if she were another robber, she who had as much gold as Saint Margaret herself. Peppa's poor old mother had to sell 'all the white goods' of the trousseau, and the golden ear-rings, and the rings for the ten fingers, to pay the lawyers to get off her child; then she had to take her back into the house, poor, sick, disgraced, and herself as ugly now as Gramigna, and with Gramigna's child at her breast. But when they gave her back her daughter, at the end of the trial, the poor old woman repeated her *Ave Maria*, there in the darkening twilight of the naked barracks, among all the carabiniers, and it was as if they had given her a treasure, poor old thing, for this was all she had, and she wept like a fountain with relief. Peppa, on the contrary, seemed as if she had no more tears, and she said nothing, nor was she ever seen in the village, in spite of the fact that the two women had to go and earn their bread labouring. People said that Peppa had learned her trade out in the thickets, and that she went stealing at night. The truth was, she stayed lurking shut up in the kitchen like a wild beast, and she only came forth when her old woman was dead, worn out with hard work, and the house had to be sold.

'You see!' said Tallow-candle, who still cared for her. 'I could knock my head against the stones when I think of all the misery you've brought on yourself and on everybody else.'

'It's true,' replied Peppa. 'I know it! It was the will of God.'

After she had sold the house and the few bits of furniture that remained to her, she left the village, in the night, as she had returned to it, without once turning back to look at the roof, under which she had slept for so many years; she went to fulfil the will of God in the city, along with her boy, settling

near the prison where Gramigna was shut up. She could see nothing but the iron gratings of the windows, on the great mute façade, and the sentinels drove her off, if she stood to gaze searchingly for some sign of him. At last they told her he'd been gone from there for some time, that they'd taken him away over the sea, handcuffed and with the basket round his neck. She didn't say anything. She didn't change her quarters, because she didn't know where to go, and had nobody to go to. She eked out a living doing small jobs for the soldiers and the keepers of the prison, as if she too had been a part of that great, gloomy, silent building; and then she felt for the carabiniers who had taken Gramigna from her, in the cactus thicket, and who had broken his leg with a bullet, a sort of respectful tenderness, a sort of brute admiration of brute force. On feast days, when she saw them with their scarlet tuft of feathers sticking up in front of their hats, and with glittering epaulettes, all standing erect and square in their dress uniforms of dark-blue with the scarlet stripes, she devoured them with her eyes, and she was always about the barracks, sweeping out the big general rooms, and polishing boots, till they called her 'the carabinier's shoe-rag.' Only when she saw them fasten on their weapons after nightfall, and set off two by two, their trousers turned up, the revolver on their stomach; or when they mounted on horseback, under the street-lamp that made their rifles glitter, and she heard the tread of horses lose itself in the distance, and the clink of sabres; then every time she turned pale, and as she shut the stable door she shuddered; and when her youngster was playing about with the other urchins on the level ground in front of the prison, running between the legs of the soldiers, and the other brats shouted after him: 'Gramigna's kid! Gramigna's kid!' she got in a rage, and ran after them, throwing stones at them.

All at once, while Saint Rocco was going peacefully down his own street, under the baldachino, with the dogs in leash and a great number of lighted candles all around him, and the band playing, the procession following, the throng of devotees pressing behind, all at once there was an uproar, a helter-skelter, a devils' kitchen; priests bolting with their cassocks flying, trumpets and clarionets brandished, women screaming, blood in torrents and thwacks of cudgels falling like ripe pears right under the nose of blessed Saint Rocco himself. The magistrate, the mayor, the carabiniers rushed to the scene, broken bones were carried to the hospital, the most riotous spirits went to prison for the night, the saint went back to his church at a run rather than at the solemn pace of a procession, and it all ended like a Punch-and-Judy comedy.

And all this because of the envy and jealousy of the people of the Saint Pascal parish. That year the devotees of Saint Rocco had spent the very eyes out of their head to do the thing on a grand scale; they had hired the city band, they had let off more than two thousand firework cannons, and there even was a new banner, all embroidered with gold, weighing over a hundred pounds, so they said, and waving over the thick of the crowd it seemed a very 'foam of gold.' All of which must have riled the Saint Pascal people considerably, till at last one of them lost patience, and, pale as a dead man, he began to yell: *Viva San Pasquale! Long live Saint Pascal!* which was too much for the Saint Rocco devotees, and cudgels began to smack.

For truly, to go and say *Long live Saint Pascal!* in the very face of Saint Rocco himself was simply asking for it; it's like coming and spitting in a person's house, or like somebody amusing himself by pinching the woman whom you've got on your arm. Under such circumstances neither Christs nor devils count, and you even trample underfoot the bit of respect you've got for the very saints who, after all, are all relations of one another. If it's in church, the seats and benches

start flying, in procession, the candle-ends whizz like bats, and at home at table, it's the soup-plates that fly.

'Of all the devils!' yelled Neighbour Nino, all bruised and torn. 'I'd just like to see anybody who'll shout *Long live Saint Pascal!* I'd just like to see him!'

'I will!' yelled Turi the 'tanner,' in fury, the very lad who was going to be Nino's brother-in-law, and who was beside himself with a blow he'd got in the fray, that had half-blinded him. 'Long live Saint Pascal, for ever!'

'For the love of God! For the love of God!' screamed his sister Saridda, rushing between her brother and her young man, for the three of them had been walking lovingly and pleasantly together till that moment.

Neighbour Nino, the engaged young man, shouted in derision: 'Long live my boots! Long live Saint Shoe-leather!'

'What!' yelled Turi, foaming at the mouth, his eye swelling up livid like a young pumpkin. 'Hell to Saint Rocco, you and your boots! Take that!'

So they began dealing each other blows that would have felled an ox, until their friends succeeded in separating them with blows and kicks. Saridda had got worked up as well; she screamed *Long live Saint Pascal!* and for two pins the engaged couple would have started slapping each other's faces as if they were already man and wife.

On these occasions parents and children go for each other, and wives leave their husbands, if by misfortune a person of the Saint Rocco parish has married one from Saint Pascal.

'I don't want ever to hear the name of that fellow again,' Saridda held forth, her fists on her hips, when the neighbours asked her how it was the engagement was broken off. 'Not if they offered me him dressed in gold and silver all over, you understand!'

'Saridda can go mouldy, as far as I'm concerned,' said Neighbour Nino on his side, while they were washing the blood off his face at the inn. 'A lot of beggars and cowardly tripe, in that tannery parish! I must have been drunk before I ever went to look for a girl there.'

'Since that's what it comes to!' the mayor had concluded,

'and you can't carry a saint to the square without a lot of fighting, till it's an absolute swinery, we'll have no more feasts, nor double holidays, and if they start out with one candle, I'll show 'em candles! I'll have 'em all in prison.'

The affair had grown to such dimensions, really, because the bishop of the diocese had granted the priests of Saint Pascal the privilege of wearing the lilac bishop's gown. The Saint Rocco people, whose priests hadn't been granted the lilac gown, had gone even to Rome, to kick up a dust at the feet of the Holy Father, with documents in hand, on official paper, and all the rest; but it had been in vain, because their adversaries of the lower parish, whom everybody could remember barefoot and poverty-stricken, had got as rich as pigs with the new tanning industry, and we all know that in this world justice is bought and sold like the soul of Judas.

For the feast of Saint Pascal they were expecting the delegate from Monsignore, who was a man of consequence, and had two silver buckles weighing half a pound each, on his shoes, and who had seen the bishop, and was coming to bring the lilac gown to the canons; therefore they also had hired the city band, to go and meet Monsignore's delegate three miles out of the village, and it was said that in the evening there would be fireworks in the square, with '*Viva San Pasquale*' blazing in great box letters.

The inhabitants of the upper quarter of Saint Rocco were therefore in a great ferment, and some of the more excitable of them started peeling cudgels of pear-wood or of cherry, as big as fence-posts, and muttering:

'If there's going to be music, you've got to bring the baton.'

The bishop's delegate ran a great risk of issuing from his triumphal entry with his head cracked. But the reverend gentleman slyly left the band to wait for him outside the village, whilst he climbed up by the short cuts on foot, and so arrived quietly and stealthily at the priest's house, where he called a meeting of the heads of the two parties.

When those gentlemen found themselves face to face with one another, after such a long time that they'd been at outs, they began to look one another in the white of the eye, as if

they felt a great desire to tear each other's eyes out, and it needed all the authority of the reverend gentleman, who had put on his new cloth cloak for the occasion, to get the ice-cream and other refreshments served without disturbance.

'This is all right!' said the mayor approvingly, with his nose in his glass. 'When they want me for peace's sake, they'll always find me ready.'

The delegate said that he had indeed come as a reconciliator, with the olive-twig in his mouth, like Noah's dove; and doing it zealously he went round distributing smiles and hand-shakes, and he kept saying: 'You gentlemen will do me the favour of taking chocolate with me in the vestry, on the day of the festivities.'

'Let us leave out the festivities,' said the assistant-magistrate. 'If we don't, there'll be more trouble.'

'There'll be more trouble if this impudence goes on, and a man isn't allowed to amuse himself as he pleases, spending his own money,' exclaimed Bruno the wainwright.

'I wash my hands of it. The government orders are precise. If you hold festivities, I shall send for the carabiniers. I want order.'

'I will be responsible for order,' replied the mayor sententiously, knocking on the ground with his umbrella, and staring around at the company.

'Bravo! As if everybody wasn't aware that you and your brother-in-law Bruno are hand-and-glove,' snapped back the assistant-magistrate.

'And you go contrary out of spite, because of that fine for the washing which you've never got over.'

'Gentlemen! Gentlemen!' the delegate kept pleading. 'This will get us nowhere.'

'We'll make a revolution, we will!' shouted Bruno, throwing up his fists in the air.

Luckily the priest had put the glasses and cups aside, quietly and unobserved, and the verger had dashed off to dismiss the band, which, having learned of the arrival of the delegate, was rushing up to welcome him, puffing into the cornets and the clarionets.

'This'll get us nowhere!' muttered the delegate, annoyed because the harvest was already ripe, where he came from, and he looked like losing a lot of time between neighbour Bruno and the assistant-magistrate, who were daggers-drawn. 'What's all this about a fine for the washing?'

'The usual brazen impudence! Now you can't hang a pocket-handkerchief in the window to dry, without their jumping on you and fining you! The wife of the assistant-magistrate, trusting to her husband's being in office – for up till now there's always been a bit of respect showed to the authorities – used to dry her week's washing on the little terrace – you know, her bit of a wash! But now, with the new law, it's a mortal sin, and even dogs and fowls are forbidden, and all the other animals which, if I may say so, have always kept the streets clean up to now; and the first time it rains, it's heaven help us if we're not going sunk up to the eyes in all the filth. But the real fact of the matter is that Bruno, who is the assessor, has got a grudge against the assistant-magistrate for giving a decision against him, once.'

The delegate, in order to reconcile these warring spirits, remained shut up like an owl in the confession-box from morning till night, and all the women wanted to be confessed by the bishop's representative, who had plenary absolution for every sort of sin, as if he had been Monsignore in person.

'Father!' said Saridda, her nose against the grating of the confession-box. 'Neighbour Nino causes me to sin, every Sunday, in church.'

'In what way, my daughter?'

'He was supposed to be going to marry me, before there was all this row in the place, but now it's broken off he goes and stands near the high altar to look at me and make game of me with his pals, all the time during Holy Mass.'

Then, when the reverend gentleman tried to touch the heart of Neighbour Nino:

'It's her who turns her back on me every time she sees me, as if I was a beggar,' replied the peasant.

But as a matter of fact, if Miss Saridda was crossing the square on a Sunday, it was he who pretended to be absolutely

taken up with the sergeant, or some other consequential person, and wouldn't so much as notice her. Saridda was up to the eyes in work, making little lanterns of coloured paper, and she arrayed them all there on the window-sill in his face, pretending she was setting them out to dry. Once when they were both taking part in a baptism, they didn't so much as nod to one another, as if they had never seen one another before, and Saridda flirted instead with the man who had stood godfather to the girl-child.

'Godfather for working your guts out!' sneered Nino. 'Godfather to a girl! When a woman's born, even the rafters of the roof give way.'

And Saridda, pretending to be talking to the midwife: 'Things aren't always bad when they seem bad. Sometimes when you think you've lost your treasure on earth, you come to thank God for it. God and Saint Pascal; and before you can really know a person, you've got to eat seven pecks of salt' or else: 'You've got to take the good with the bad, nothing's worse than fretting for things that aren't worth it. When one Pope dies, they make another.'

Or else: 'Babies are born as fate makes them, and the same with marriage; you'd far better marry a man as really cares for you and hasn't got any other designs on you, even if he's got no money, nor land, nor mules, nor anything.'

In the square a drum sounded: the middle drum.

'The mayor says there'll be festivities,' buzzed the crowd.

'I'll fight it till the end of time! I'll spend the shirt off my back, and make myself as poor as Job, but that five-shilling fine I'm not going to pay, no! not if I have to leave the lawsuit in my will.'

'Oh, blazing hell! what sort of a festival do they think they'll make if we're all going to starve this year!' cried Nino.

Since the month of March not a drop of rain had fallen, and the sickly yellow crops, which crackled like tinder, 'were dying of thirst.' Bruno the cartwright, however, declared that when Saint Pascal had been round in procession, it would rain for sure. But what did he care about rain, if he was a wagon-builder, and all the other tannery fellows of his party the

same! . . . But they did indeed carry round Saint Pascal in procession, to east and to west, and they stood him on the hill facing the land, to bless the fields, one sultry, overcast day in May; one of those days when the peasants tear their hair before their 'burnt' fields, and the ears of corn bend down as if really they were dying.

'Saint Pascal!' shouted Nino, spitting into the air and running like a madman through his crops. 'You've ruined me, Saint Pascal! You've left me nothing but my sickle to cut my throat with.'

In the upper quarter of the village there was desolation, one of those long years when the famine begins in June, and the women stand in the doorways unkempt and idle, staring fixedly in front of them. When Miss Saridda heard that Neighbour Nino's mule was being sold in the square, to pay the rent of his land, which had yielded nothing, she felt her anger evaporate in an instant, and sent her brother Turi in all haste and anxiety with the bit of money which she had laid aside, to help him.

Nino was in a corner of the square, his eyes abstracted and his hands in his pockets, while they were selling his mule, in all its gay little tassels and its new halter.

'I want nothing from you,' he replied surlily. 'I've still got arms to work with, please God! A nice saint, that Saint Pascal, what?'

Turi turned away so as not to start a row, and went off. But the truth was, folks were exasperated, now that Saint Pascal had been carried in procession to east and to west, with this grand result. Worst of all was that many from the San Rocco quarter had brought themselves to the point of accompanying the procession, beating themselves like donkeys, and wearing the crown of thorns, for love of their crops. So that now they were saying all the insulting things possible, and had come to such a pitch that the bishop's delegate had had to clear out on foot and without any music, as he had come.

The assistant-magistrate, to get a smack back at the wainwright, telegraphed that the populace was roused and public

safety in danger; so that one fine day they woke up to learn that the militia had arrived during the night, and anybody who wanted could go and see them in the stable-yard.

But others said: 'They have come because of the cholera. Down in the city people are dying like flies.'

The apothecary put the padlock on his shop, and the doctor fled the first, so that they shouldn't fell him like an ox, later.

'It won't be anything,' said the few remaining inhabitants of the village, those who had not been able to flee away into the country. 'Blessed Saint Rocco will guard his own village, and the first person we find straying round at night, we'll put an end to him.'

And even the people of the lower quarter had climbed up barefoot to the church of Saint Rocco. Nevertheless, a little while, and then the dead began to fall like those big drops which announce a thunderstorm, and of one dead man the people said he was a pig, and had killed himself gorging a bellyful of prickly pears, of another they said he had come in from the country after dark. In fact, the cholera had come, and come badly, in spite of the soldiers, and right under Saint Rocco's nose, and notwithstanding that an old woman who lived in an odour of sanctity had dreamed that Saint Rocco came to her and said:

'Be not afraid of the cholera, for I will take charge of it, and I am not like that useless fellow, Saint Pascal.'

Nino and Turi had not met since that affair about the mule; but as soon as the peasant heard that sister and brother were both ill, he hurried to their house, and found Saridda black in the face and hardly recognizable, at the back of the wretched room, next her brother, who, fortunately, was getting better, but who was tearing his hair, not knowing what to do.

'Ah, Saint Rocco!' Nino began to cry; 'I never expected this! Oh, Saridda, don't you know me? It's Nino, whom you used to go out with.'

But Saridda looked at him with eyes so sunken that you needed a lantern to discover them, and Nino had two

fountains at his own eyes. 'Ah, Saint Rocco!' he said. 'This is a worse turn than Saint Pascal ever did me.'

However, Saridda got better, and while she sat in the doorway, her face tied up in a kerchief, and yellow as beeswax, she kept saying to him:

'Saint Rocco has done me a miracle, and you must come with me to carry a candle for his festival.'

Nino, his heart swollen, nodded assent: but meanwhile he too had taken the sickness, and was likely to die. Then Saridda scratched her face, and said she wanted to die with him, and she would cut off her hair and put it in the coffin with him, so that no one should see her face again while she lived.

'No, no!' replied Nino, from his wasted face. 'Your hair will grow again; but the one who won't see you again will be me, for I shall be dead.'

'A nice miracle Saint Rocco has done for you!' said Turi to him, to console him.

And when they both were convalescent, Nino and Turi, and they stood leaning against the wall, warming themselves in the sun, a long-faced pair, they threw Saint Rocco and Saint Pascal at each other all the time, mockingly.

Once Bruno the wainwright went by, coming home from the country now the cholera was over, and he said:

'We want to make a great festival to thank Saint Pascal for having saved us from the cholera. From now on there'll be no more agitators nor opposition, now that that assistant-magistrate is dead, and has left the lawsuit in his will.'

'Yes, you can make a feast for those who've died,' sneered Nino.

'And what about you? Did Saint Rocco keep you alive, eh?'

'Will you drop it!' Saridda broke in; 'or the cholera will have to come again to make peace!'

BROTHPOT

It is as if we were at the Cosmorama, when it's the village feast, and we put our eye to the peepglass to see the famous characters pass one after the other, Garibaldi and then Victor Emmanuel; so now comes 'Brothpot,' for he too is a famous character, and he looks very well among the rest of the mad folks who have had their wits in their heels instead of their heads, and have done everything that a Christian body shouldn't do, if he wants to eat his bread in blessed peace.

Now if we have to examine the conscience of all the good folks who have got themselves talked about in the farmyard during the gossiping hour after midday meal; and if we must do as the factor does every Saturday evening, when he says to one: 'How much is due to you for your daywork?' and to another: 'What have you done this week?' we can't pass by 'Brothpot' without having it out with him, what he's been up to, and a nasty piece of work it is, and folks gave him that pretty nickname because of that ugly business, you know what I mean.

We all know that jealousy is a defect everybody suffers from; it makes the young cocks tear one another's feathers out, before they get their crests, and makes mules let out kicks in the stable. But when a person has never had that vice and has always bowed his head in blessed peace, Saint Isidore defend us! then you don't see why he should go off his head all of a sudden, like a bull in the month of June, and do absolutely mad things, like somebody in a blind frenzy with toothache, for such things are just like your teeth, which cost you a martyrdom enough to drive you mad while they're coming, and then afterwards don't hurt you any more, and are good to chew your food with, and he had chewed his food so well that he'd laid on a paunch, like a gentleman, and looked a very priest; for which reason people called him 'Brothpot,' because his wife Venera kept a full pot going for him, with Don Liborio.

He had wanted to marry Venera at any cost, though she hadn't a thing to bless herself with, and his only capital was his two arms, with which he earned his bread. In vain did his mother, poor thing, keep telling him: 'You leave that Venera alone, she's not your sort; she wears her shawl half-way back on her head, and she shows her feet when she goes down the street.' Old people know better than we do, and we should listen to them for our own good.

But he couldn't forget that little shoe and those bold eyes which hunted for a husband from under her head-shawl; therefore he took her without hearing anything against her, and his mother had to leave the house where she'd lived for thirty years, because mother-in-law and daughter-in-law together in one house are like two wild mules at the same manger. The daughter-in-law, with that plaintive little mouth of hers, said so much and behaved in such a way that at last the poor, grumbling old woman had to clear out and go to die in a hovel; and there was a row between the husband and wife every time the month's rent for the hovel had to be paid. And then when the son ran breathless, hearing that they'd brought the *Viaticum* to the little old woman, he couldn't receive her blessing, nor even get the last word from the dying mouth, for the lips were already glued together by death, and the face was all changed, in the corner of the wretched house where twilight was falling, and only the eyes remained alive, that seemed to want to say so many things to him. 'Eh? Eh?'

Those who don't respect their parents bring on themselves their own misfortune, and come to a bad end.

The poor old woman had died in bitterness because her son's wife had turned out such a bad piece of goods; and God had been good to take her from this world, to remove her to the other world with all she'd got on her stomach against her daughter-in-law, knowing how the creature had made her son's heart bleed. And as soon as the daughter-in-law was mistress in her own house, with nobody to bridle her, she had carried on in such a fashion that nowadays folks never called her husband anything but by that ugly nickname, and when

the thing came to his ears, and he ventured to complain to his wife: 'Why? do you mean to say you believe it?' she said to him; and he didn't believe it, pleased as punch not to.

He was such a poor-spirited chap, and except in this respect, he did no harm whatsoever to anybody. If you'd have shown him the thing with his own eyes, he'd have said it wasn't true. Either because of his mother's curse Venera had gone out of his heart and he cared for her no more; or else because he was away working in the country all the year round, and only saw her on Saturday nights, she had become disagreeable and unloving towards her husband, and he had ceased to like her; and when we don't like a thing any more, we think nobody else will want it either, and we don't care who has it; and altogether, jealousy was a thing that never entered his head, not if you drove it in with a peg, and for a hundred years he'd have gone himself to fetch the doctor, who was Don Liborio, every time his wife wanted him fetched.

Don Liborio was also his partner, they went halves in a piece of land; they had some thirty sheep in common; they rented pasture-land in their joint names, and Don Liborio gave his own name as guarantee, when they went before the notary. 'Brothpot' brought him the first beans and the first peas, chopped his wood for the kitchen, and trod out his grapes for him in the winepress; and for his own part he lacked for nothing, neither corn in the bin, nor oil in the jar, nor wine in the barrel; his wife, white and red like an apple, sported new shoes and silk kerchiefs; Don Liborio didn't charge for his visits, and had stood godfather to one of the babies. In short, they were one household, and he called Don Liborio '*Signor compare*,' and he worked conscientiously – you couldn't say a word against 'Brothpot' in this respect – to make the company of the '*Signor compare*' and himself flourish, which had its advantages for him too, and so they were pleased all round, for sometimes the devil's not as black as he's painted.

And then this peace of angels was turned into a turmoil of devils all at once, in one day, in one moment, when the other peasants who were working on the arable land sat talking in

the shade, at evening, not knowing that 'Brothpot' was on the other side of the hedge, and the talk chanced to turn on him and his wife and the life they led. He had thrown himself down to sleep, and no one knew he was there, which shows that folks are right when they say: 'When you eat, shut the door, and when you're going to talk, look around first.'

This time it really seems as if the devil had given 'Brothpot' a nudge while he was asleep, and whispered in his ear all the nasty things they were saying of him, and which went into his brain like a nail. 'And that booby "Brothpot,"' they were saying, 'who dances round Don Liborio! and eats and drinks from his dirty leavings, and gets fat as a pig on it!'

He got up as if a mad dog had bitten him, and started off full speed towards the village in a blind fury, the very grass and stones blood-red in his eyes. In the doorway of his house he met Don Liborio, who was just quietly leaving, fanning himself with his straw hat. 'Hark here! *Signor compare!*' he said to him, 'if I see you in my house again, as sure as God's above, you'll pay for it!'

Don Liborio gazed at him as if he were speaking Turkish, and thought his brain must have turned with the heat, for really you couldn't imagine 'Brothpot' taking it into his head to be jealous all of a sudden, after he'd kept his eyes shut all that time, and was the best-natured fellow and husband in the world.

'Why, what's amiss to-day, *Compare*?' he asked him.

'What! Why, if I see you again in my house, as true as God's above, you'll pay for it!'

Don Liborio shrugged his shoulders, and went off with a laugh. The other went wildly into the house, and repeated to his wife: 'If I see the *Signor compare* here again, as true as God's above, he'll pay for it!'

Venera stuck her fists on her hips and began to go for him, saying insulting things to him. He kept nodding his head, yes! yes! leaning against the wall like an ox that's got the fly, and wouldn't listen to reason. The children started crying, seeing such an unusual state of affairs. At last his wife took the door-bar and drove him out of the house to get rid of him, and said

she was mistress in her own house to do as she pleased and fancied.

'Brothpot' could no longer work on his own land; his mind dwelt always on the same thing, and he had such a sour face you couldn't recognize him. Before the dark fell, on the Saturday evening, he stuck the mattock in the earth and went off without drawing his week's pay. When he came home with no money, and two hours earlier than usual into the bargain, his wife started abusing him again, and wanted to send him to the square, to buy salted anchovies, because she felt a pricking in her throat. But he wouldn't leave the kitchen, sat there with the baby on his knee, and the poor little thing whimpered and daren't move, her father frightened her so with that face. Venera had got the devil on her back that evening, and the black hen, which was perching on the ladder, kept on cluck-clucking as if something bad was going to happen.

Don Liborio usually called after he'd been on his round, before he went to the café to play a game of cards; and that evening Venera said she wanted him to feel her pulse, for she'd felt feverish all day with that tickling in her throat. 'Brothpot' remained quite still, sitting where he was. But as he heard in the little street the slow step of the doctor, who was coming very leisurely, tired a little with visiting his patients, puffing with the heat, and fanning himself with his straw hat, 'Brothpot' got the bar with which his wife had driven him out of the house when he was in her way, and he took his stand behind the door. Unfortunately Venera never noticed him, because at that moment she'd gone into the kitchen to put an armful of kindling under the boiling pot. The moment Don Liborio set foot in the room, his partner lifted the bar and brought it down with such force just on the back of his neck, that it killed him like an ox, without any need either of doctor or druggist.

And so it was that 'Brothpot' went to end his days in prison.

THE HOW, WHEN, AND WHEREFORE

Signor Polidori and Signora Rinaldi loved one another – or they thought they loved one another – which on occasion amounts to exactly the same thing; and honestly, if ever love exists on earth, these two were made for one another; Polidori rejoiced in an income of two thousand pounds a year, and the worst possible reputation as a *mauvais sujet*, while Signora Rinaldi was a charming, emotional little thing whose husband slaved his life away so that she should live as if she too possessed an income of two thousand a year. However, not the very slightest breath of scandal had as yet wafted her way, although all the friends of Polidori had passed in review before the proud beauty, with a flower in their button-holes. Now at last the proud beauty had fallen – chance, fate, the will of God, or the will of the devil had plucked her by the skirts.

When we say 'fallen,' we only mean that she had let fall upon Polidori that first languid look, soft and lost, which makes the knees of the serpent tremble as it lies on the watch under the tree of seduction. Headlong downfalls are rare, and they often frighten away the Serpent altogether. Before Signora Rinaldi came down from one bough to another, she wanted to see where she was putting her foot, and she had a thousand coquettish little ways of pretending she wanted to flee to the highest tips of the tree. For about a month she had been perched upon the bough of epistolary correspondence, a tremulous and dangerous little branch shaken by all the perfumed zephyrs of the sky. They had begun with the excuse of a book they wanted to borrow or to return, or of a date they wanted to make sure of, and all the rest of it – and the fair one would have liked to remain on that bough for quite a time, twittering gracefully, for women always twitter to a marvel, thus cradled between heaven and earth; Polidori, who had run rather dry, soon became arid, laconic, categorical, most disappointing. The poor little thing closed her eyes and her wings and let herself slip a few twigs lower.

'I didn't read your letter; I'm not going to read it!' she said to him when they met at the last ball of the season, as they were following the file of couples. 'If you don't want to be what I thought you would be, then let me be what I wish to be myself.'

Polidori looked at her with great gravity, twisting his moustache, but frowning a little. The other dancers, who had no reason for loitering talking in the doorway, pushed them towards the ball-room. The woman blushed as if she had been caught in a private tête-à-tête with him.

Polidori – the serpent – noted that fugitive flush. 'You know I will obey you in everything,' he replied simply.

The diamond cross on her bosom sparkled suddenly, swelling up in triumph. All that evening Signora Rinaldi danced like a madwoman, passing from one partner to another, drawing after her a swarm of adorers whose eyes were intoxicated with the game, glittering like the gems that clustered on her panting bosom. Then all at once, coming up face to face with her own reflection in one of the great mirrors, she became serious and wouldn't dance any more. She told them all she was tired; and mechanically she looked round for her husband. Of course he was nowhere to be seen! During those ten minutes while she sat weakly upon the sofa, indifferent to the fact that her dress was bunched up unbecomingly, strange fancies passed before her eyes, along with the couples dancing the waltz. Only Polidori was not dancing, nor was he anywhere in sight. 'What sort of a man was he, really?' At last she discovered him sitting in a deserted drawing-room, tête-à-tête with a head of hair that certainly wouldn't have much to say to him, and smiling like a man to whom even smiles are now indifferent. She would rather have surprised him with the loveliest woman at the dance, she swore to herself she would. Polidori took no caution. He rose, eager as usual, and offered her his arm.

And of course, precisely at that moment her husband had to appear on the scene, looking for her. Then, abruptly, as she was adjusting her low-cut dress at the back, with a light shrug of the shoulders she said in a low tone to Polidori, so low

that the rustle of the silk almost covered the sound of her voice:

'Very well; tomorrow at nine, in the Park.'

Polidori bowed low and let her pass, radiant and excited, upon the arm of her husband.

Never had a spring morning seemed so mysteriously lovely to Signora Rinaldi, even when she was away in her delightful villa, 'La Brianza,' and never had she looked with such a dreamy eye through the crystal glass of her *coupé*, as when the carriage was rapidly crossing the Piazza Cavour. The sunlight bathed the avenues of the park, fell warm and gilded upon the grass that was just putting forth new green; the sky was of a deep blue. These impressions, all unknown to her, were reflected in her big dark eyes, which were gazing into the distance, she herself did not know where to, nor at what, as she leaned her hand and her white brow on the cushion. From time to time a shiver made her shrug her shoulders, a shiver of tiredness or of cold.

Hardly had the carriage stopped at the park gates, than she shuddered, and drew back sharply, as if her husband had suddenly looked in at the window. She still hesitated before she got out, letting her hand rest on the handle, thinking vaguely of the new aspect her husband had taken on, in her own mind; then she set foot to earth and lowered her veil; a thick, black, closely-spotted veil, through which her eyes took on a feverish look, and her features a ghostly rigidity. The carriage went away at a walk, noiselessly, as a discreet and well-educated carriage should do.

The park, too, seemed to have wakened before its hour, and to be surprised at starting its day so soon. Men in shirt-sleeves were washing it and combing it, making its morning toilet. The few people one met looked as if it was the first time they had ever been there at that hour, and now it was only by doctor's orders; they dared to stare curiously at the veil of this early-walking woman and to guess at the perfume on the handkerchief hidden in the muff she pressed so hard on her breast. An old man who was dragging himself slowly along,

come forth for the March sun, stopped, leaning on his shaky stick, to look after her when she had passed, and sadly he shook his head.

Signora Rinaldi came to a halt on the edge of the pool, glancing with cautious glances to right and left, evidently seeking something or somebody. The fresh murmur of the water and the slight humming of the horse-chestnut trees isolated her completely; then she raised her veil a little, and drew from her glove a note smaller than a playing-card. For two or three minutes the water continued to run from the pool, and the trees to vibrate unheeded. The woman's eyes were dazed, avid, moist with dreams.

All at once a hasty step made her lift her head, and the blood swept to her cheeks, as if the burning eyes of the new-comer had touched her face with a kiss. Polidori was going to raise his hat, when she stopped him with an imperceptible look, and passed him by quite near, without noticing him.

She walked on with her head bent, listening to the squeak of the sand under her little boots, not looking ahead. From time to time she put her handkerchief to her mouth, in order to get her breath, as if her heart were greedily consuming all the air around her. The little slow stream accompanied her softly, murmuring under its breath, putting to sleep her last fears, the shade of the cedar-trees and the silence of the deserted avenue penetrated her vaguely with subtle voluptuousness.

When she stopped in front of the leopard-cage, her breast suddenly stifled and her knees trembled violently, for at her side Polidori had also stopped, and was looking attentively at the superb animal in the cage, with as much curiosity as would have been shown by a peasant straying into that place, and he said to her in a low voice: 'Thanks!'

She did not reply, became very red, and clutched very hard the iron of the railing against which she was leaning her fore-head. The sensation was pleasing on her bare hands. Who would have thought that simple word, uttered by stealth, away there in that lonely place, would have vibrated so deliciously! No! really! It was enough to make you lose your head. She felt herself blushing to the nape of her neck, which he, standing

behind her, could see softly flush; a wave of disconnected, tumultuous words rushed to her head, and intoxicated her; she spoke of the ball which she had enjoyed so much; of her husband who had departed at dawn, when she had not even closed her eyes. 'But I'm not tired! The fresh air does one good, such a lot of good! one feels oneself revive, don't you think?'

'Yes, really!' said Polidori, looking full into her face, but she dared not look up from the ground.

'When I am at Brianza I shall get up every day with the sun. In town we lead impossible lives. But I suppose you gentlemen prefer it.'

She spoke hurriedly, in a voice rather too high and shrill, smiling often and meaninglessly; she was unconsciously grateful that he did not presume to interrupt her, did not presume to mingle his voice with hers. At length Polidori said to her: 'But why wouldn't you receive me at your home?'

She looked into his eyes for the first time since they had been there, surprised, painfully surprised. Up till then, in all that they had done or said the sin had only vaguely glimmered in the atmosphere, or in their intentions, with an exquisite delicacy which her refined senses savoured deliciously, as the leopard stretched out at their feet enjoyed the warm ray of the sun, blinking his large golden pupils, with the same unconscious and voluptuous stretching of the membrane. Recalled so rudely to reality, she pressed her hands and her lips together with a painful expression; her eyes were almost veiled over, following into space the broken charm; and then she turned a bewildered look on him. All Polidori's experience could not help him to discover what she saw in his face. 'Ah!' she said at length, in a changed voice. 'It would have been more prudent!'

'You are cruel!' murmured Polidori.

'No!' she replied, raising her head, flushed a little, speaking in a firm tone of voice. 'I am not like all the other ladies, I am not prudent! . . . When I am going to break my neck, I want to enjoy the horror of the precipice below me! All the worse for you, if you don't understand!'

Then he forcibly took possession of her hand, devouring all her palpitating beauty with a thirsty gaze, and stammered:

'Will you? . . . will you?'

She did not reply, and made an effort to withdraw her hand.

Polidori implored her favour in wild, delirious words. He begged of her one thing, made her one prayer, always the same, in changing tones of voice which sought out the woman in the most intimate fibres of all her being; she felt the passion, she felt herself enveloped and devoured, overcome by a mortal and delicious languor; and she tried to free herself, pale, lost, her lips trembling, looking up and down the avenue with eyes wild with terror, writhing under that possessive clasp, trying with all her might, with both her feverish hands, to free herself from that other hand that seemed to burn beneath the glove.

At last, vanquished, beside herself, she stammered:

'Yes! Yes! Yes!' and fled before the approach of some one whose step she could hear on the gravel.

As she left the park she was so overwrought that she almost threw herself under the horses of a carriage. She had had a clandestine meeting! She had made an assignation! And she repeated mechanically to herself: 'That's what it was! That's what it was!' She felt herself filled and intoxicated by the word, and her blanched lips worked without uttering any sound, vaguely savouring her guilt.

She hurried staggering to the first carriage she met, and was driven to her friend Erminia, as if in search of help. Her friend, seeing her face looking so strange, ran to the door of the sittingroom towards her. 'What's the matter with you?'

'Nothing! Nothing!'

'How lovely you're looking! What is it?'

She, instead of replying, threw herself on her friend's breast and gave her two wild kisses.

Signora Erminia was used to the extravagancies of her dear Maria. They began to look at photographs they had already looked at a hundred times before, and at the flowers which had been standing in their pots on the terrace a month already.

At that moment, by a coincidence, Polidori drove by in his friend Guidetti's phaeton, and he saluted Signora Erminia in the same way as he might have saluted Maria, if he had discovered her cowering among the shrubs, pressing her hands on her breast, that seemed as if it were going to explode. It was a trifling event, but one of those trifles that penetrate deep into the being of a woman, like the point of a needle. So, when she got home, Signora Rinaldi wrote Polidori a long, calm and dignified letter, in which she prayed him to renounce that assignation, the promise of which he had wrung from her in a moment of aberration, a moment which now she remembered with confusion and shame, to her punishment. The contradiction in her feelings was so sincere, that her 'moment of aberration,' after a bare hour had elapsed, seemed infinitely far removed, and if a certain vividness vibrated still between the lines of her letter, it was merely the lament for dreams which faded away so promptly. She made an appeal to his honour and delicacy, to allow her to forget her error and to retain her own self-esteem.

Polidori more or less expected this letter; Signora Rinaldi was too green not to repent ten times before she had really any reason for repenting at all; he did a thing which proved how much that green little woman had reawakened in him a strong, sharp feeling that had all the freshness of first passions; he sent her back her letter, with this brief reply:

'I love you with all the respect and tenderness which your innocence must inspire. I send you back the letter you wrote me, because I am not worthy of keeping it, and I dare not destroy it. But the imprudence you have committed in writing such a letter is the best proof of the esteem in which you must hold a man of sincere feeling.'

'My husband!' exclaimed Maria, in a strange tone of voice. 'My husband is the happiest of men! The bank-rate rises and falls just to please him, the silk-worms have done well, orders rain in from every side. There's a fifty-per-cent. net profit.'

Erminia stared at her open-mouthed.

'Look here, child, you are feverish. We'll make some tea.'

Two days later, to cure the fever which Erminia had discovered she'd got, she said to her friend:

'I'm going out to the Brianza villa with Rinaldi. Fresh air and oxygen, and quiet, and birds singing, and family life. . . . What a pity we've no children to mind!'

Out there under the thick trees, looking across the wide open country, she felt a curious irritation against that peace which slowly invaded her, against her will, from outside. She often went towards sunset on to the picturesque rocky heights, to ruin her shoes, and to turn her head deliberately with sentimentalities borrowed from novels. Polidori had had the good taste to efface himself gracefully, remaining in Milan without doing anything conventional or theatrical, like a man who can even be courteous in letting himself be forgotten. Neither could she have said whether she really thought any more about him; but she felt vague yearnings which kept her company in the solitude, folding her softly and persistently in a dangerous inertia, and speaking for her in the solemn silence which surrounded her, and bored her. She relieved herself by writing long letters to her friend Erminia, praising the unknown charms of the country, the tinkling of the Ave Maria bell from the valley, the sunrise upon the mountains; keeping count of the eggs which the housekeeper brought in, and of the wine which would be barrelled this year.

'Tell me about your books and your riding on horseback,' replied Erminia. 'Tell your husband he is not to let you go to the hen-house, or else he must go with you.'

And one fine day, after a spell of silence, Erminia set out, feeling a little anxious, to go and see her dear Maria.

'Did I frighten you?' said the latter. 'Did you think me a forlorn soul on the way to extinction?'

'No! But I thought you were bored. This is a veritable Thebaïd; you could only go to God or the devil here. Come with me, to Villa d'Este. You will let me steal her from you, won't you, Rinaldi?'

'Why, yes. I want her to be gay and have a good time.'

At Villa d'Este there was indeed everything to make her gay:

music, dances, regattas, trips on the steamer, excursions in the surroundings of the lake, a crowd of people, exquisite toilets, and Polidori, who was the soul of all the amusements.

Signora Rinaldi didn't know he was there; and Polidori, if he could have foreseen her arrival, would have done her the service of absenting himself from Villa d'Este. But as it was he had accepted certain responsibilities in the organizing of the regatta, and could not depart until this had taken place, without making his departure too conspicuous. He explained all this to Signora Rinaldi, briefly and delicately, the first time he met her in the large drawing-room, making her in some way veiled excuses, and so sliding back towards the past, with clever ease. When she had overcome the first moments of agitation, Maria felt herself not only boldly recovering her former attitude, but, by a strange reaction, found her heart moved with mad surges of irony against his self-contained reserve. He said he would be leaving immediately after the regatta, because he had promised to join some friends in Piedmont for a great hunt, but truly he regretted leaving so many lovely ladies at Villa d'Este.

'Really!' said Signora Rinaldi, with an odd little laugh. 'Which one do you like best?'

'Why all of them,' Polidori replied quietly. 'Your friend Erminia, for example.'

Exactly! And she had never thought of it! her friend Erminia was exactly the one above all the rest to turn the gentlemen's heads, with her *piquant* face, and her mocking spirit; caring nothing for the homage to which she was naturally accustomed, being a Marchesa into the bargain – one of those Marchesas who wear their coronet so proudly, that every mortal man would be only too happy to let himself be smitten dead in order to receive one flower from her.

She and her friend Erminia were always together, on the lake, up the mountain, in the drawing-room, under the trees. And now Maria watched her as if she saw her for the first time; studied her, imitated her, and sometimes envied her some trifle or other. Without wishing to, she had discovered that her Erminia, with all her queenly airs, was just a bit of

a flirt, that sort of flirting that doesn't mean anything, but in the flame of which nevertheless all the men singe their wings. It was really serious! One couldn't take a step without coming across Polidori, the handsome Polidori, who was courted like a king by all those ladies, and who, without seeming to notice it, was compromising Erminia horribly – the worst of it was that Erminia herself didn't notice it either, though not everybody was going to shut their eyes to the way she laughed at him. Signora Rinaldi thought to herself that if it had not been such an extremely delicate point, she would have made her friend listen to her own laughter, and notice how false it rang.

However, she forced herself to conceal even the pain which all this skirmishing cost her, because she was so fond of Erminia, of course – she cared nothing about Polidori – he was a man, and was playing his own game, anyhow! and apparently he was one who soon found other consolation. But Erminia had everything to lose in such a game, with a husband like hers, who was so fond of her, and really an ideal husband. Whatever talisman could that fellow Polidori possess, to eclipse in the heart of a beautiful, intelligent, much-courted woman like Erminia a man like the Marchese Gandolfi! Some things are beyond explanation.

Not for anything in the world would she have had a living soul find out what was happening, and she would have liked to shut all her friends' eyes as she shut her own, but honestly, it was enough to make you lose your patience.

'My dear child, it seems as if I didn't know myself any more,' said Erminia to her, laughingly, calmly, as if she were not speaking of herself. 'What's wrong? Sometimes it seems to me I must have offended you without knowing it.'

Ah dear! that poor Erminia, how she deceived herself! – she had done nothing except worry her friend, who saw her thoughtlessly entangling herself in that affair, or rather letting herself get entangled, for that Polidori seemed to spread his net here and there with diabolical cleverness. The things he must have done, that man, to have become such a master-hand! he really must be an out-and-out bad lot.

'Dear Maria,' Erminia said to her one fine day, with a fine, close kiss, 'it seems to me that that Polidori trots through your thoughts a little oftener than he should. Look out! he's a dangerous individual, for a child like you!'

'Me?' she replied, completely taken aback. 'Me?' and she could not find another word to say, under the sharp scrutiny of Erminia's eyes.

'All the better! All the better! You gave me a great scare. It's all right then.'

For a child like me! thought Maria. Erminia doesn't show me a very great respect, I must say! Some things are really *too* much!

Signora Rinaldi was adamant to all elegant courtiers, to the *beaux* who hung round at the regular hours, in the walks or during the musical evenings, in fact to all conquistadors in suède gloves. Once when Polidori ventured to make some remark in his own defence, she burst out in a shrill laugh right in his face.

'Oh! Oh!'

He seemed to go pale, even he, at last. Since the rest of the ladies were always buzzing round him like bees, the fault lay with the ladies who spoiled him – then she added:

'Only don't get found out, or I shall be perfectly wretched.'

'On whose account?'

'On yours, on my own . . . and on the other person's – on everybody's account.'

This time he did not let her sarcasm disconcert him, and replied calmly:

'I only mind on your account.'

She would have liked to burst out in his face with another cruel and biting burst of laughter, but the smile died on her lips as she saw the expression which those two words gave to all his features.

'You may insult me,' he replied, 'but you have no right to doubt the feeling which you have roused in my heart.'

Maria dropped her head, beaten.

'Haven't I blindly respected your will, in everything? Have I ever asked you for an explanation? Haven't I foreseen your

desires? and haven't I succeeded in giving the impression of having forgotten that which no man on earth could forget from you? And if I have suffered on your account, is there anybody in the world who can say they've seen me suffer?'

He spoke in a calm voice, with a quiet earnestness which gave his reasonable words an irresistible eloquence.

'You! . . .' stammered Maria.

'I!' replied Polidori, 'who love you still, though I never would have told it you.'

She had stopped in her walk, pulling leaves from the shrubs, but now she hurried a few steps away from him, poor child. Polidori did not take a single step in pursuit.

Signora Rinaldi had become all at once melancholy and dreamy. She remained for long hours with her book open at the same page, or with her fingers straying over the keys of the piano, or with her embroidery forgotten in her lap, contemplating the water, the mountains, or the stars. The mirror of the lake gave back all the undefined fumings of her thoughts, and she took an exquisitely voluptuous pleasure in feeling them return and take place again within herself. And so she avoided all gay parties, and preferred to go alone in a boat on the lake, when the mountains threw large green shadows on the water, or when the sunset wistfully expired with lovely stripes of amaranth; then she drew the curtain between herself and the boatmen, and reclining upon the cushions, she enjoyed the sensation of feeling herself cradled on the abyss, almost submerging herself, dipping her hand in the water, feeling her whole self gradually invaded by a mysterious chill; she liked to gaze up deep into the fathomless dark, beyond the stars, and to imagine what it was that was lit up by some tiny point of light that trembled far off in the dark, on the slope of the mountain. She sought out the grassy walks, the mysterious silence of the woods, or watched the lake when the sun shone on it as on a mirror, or she went out when all the windows of the hotel were shut, and the dew glittered on the grass of the lawns, and the shadows were deep under the huge trees, and the crunching of the gravel under her own feet whispered

mysterious messages in her ear; she often went to read or to walk on the banks of the pool, in the remote avenues of the Champs Élysées, when the moon softly trod the lake and kissed her white hands, or when the windows of the drawing-room set big squares of cold light upon the darkness of the avenue, and the music from within sent arcane fancies straying under the great and silent, sleeping shadows outside. Beyond those mysterious shadows, behind these shining windows, the dimmed movement of the festival, thus veiled, took on a fusion of colours, lines and sounds that made it fascinating, something between the Bacchanal and the dance of winged spirits; and then, breathing in sheer giddiness, she stood there with her forehead against the window-glass, the roots of her hair all lightly stirring.

One evening, unexpectedly, she appeared in the middle of a ball like a fascinating vision, more pale and lovely than ever, and with something in her eyes and upon her mouth which had never been seen there before. The crowd opened almost startled before her; Erminia went to kiss her; a crowd of elegant young men pressed around her to extract the promise of a waltz or a quadrille; she remained motionless for an instant, with the same smile on her lips and those eyes shining like the fireflies of the night outside, seeking something, and when she perceived Polidori, she threw him her handkerchief.

'God save the Queen!' exclaimed Polidori, bending one knee.

'I'll rob you of your partner, shall I?' she said to her dear Erminia. 'I feel I want a waltz terribly, tonight.'

Polidori was one of those dancers whom women strive for with one another, with smiles and taps of the fan on the fingers when the smile has had too much effect. He had strength and grace, rush and softness at the same time; no one knew as he did how to sweep you away to the foaming spheres of rose-coloured intoxication, with a swoop of his hip, reposing you upon his right arm as upon a cushion of velvet. They said that he alone possessed the exquisite understanding of Strauss, which makes you lose your breath and your head,

and that he alone could put into his arm, his muscles, in all his body the real impetuosity and abandon and ecstasy. 'I don't want to dance any more! I don't want you to dance with anybody else!' Maria said to him, as she stood panting, her cheeks red and her eyes a little veiled. And that was all for that evening.

Ah, how triumphant she felt, how her heart danced in her breast as that envied cavalier led her through the admiring crowd! and as she wrapped herself tight in her black shawl, outside in the park, where the noise of the dance came faintly, and fancies arose, straying, formless, but thirsty still. She felt herself a prey to some delicious dream when following on the waltz came a nocturne of Mendelssohn, a nocturne which stroked her on the hair and brow, and between her shoulders, like a fresh and perfumed hand. All at once a dark form came between her and the light which fell from the windows upon the avenue; her dream rose up unexpectedly before her like a shadow. She rose, startled, dismayed, in a tumult, stammering a few disconnected words that meant to say no! no! and she fled back to refuge in the ball-room, hiding in all the noise and the light – the light which made her blink, dazzled, and the noise which gratefully deafened her, left her numbed and smiling, a little stiff and pensive. Erminia caressed her as if she were a pretty little thing; the other ladies said in one voice that she was really a dear – so surrounded by the most elegant of adventure-hunters, her back to the wall, like a fawn defending itself with its back to a rock, you might almost have said that in her eyes trembled the tears of defeat.

Polidori was the last to assail her, he being the huntsman destined by fate to give her the *coup de grâce*, and he seemed moved to pity of the victim, for he spoke to her with a perfectly grave face about the rain and the weather, and limited himself to courting her for a few moments by asking her with the greatest interest questions of the smallest importance: if she had been for her row on the water, if on the following day she would take her usual morning walk towards the Champs Élysées. She looked into his face without replying at all. He insisted no further.

Erminia had gone to the piano, and everybody was listening attentively to her; Maria had eyes only for her even when she fixed her gaze vaguely in the dream of the unknown, because it was she, Erminia, who evoked the dream in her and fascinated her; the whole room, glittering and hot, trembled with harmony. It was that fatal moment when the heart violently dilates within the breast, and overcomes the reason.

Maria quivered from head to foot, lying abandoned in an armchair, with her hand to her brow, and Polidori murmured over her head burning words which made the little curls on her white neck tremble like animate things. The poor little thing saw nothing any more, neither the glittering room, nor the excited throng, nor the bright and penetrating eyes of Erminia, and she abandoned herself to what she believed was her destiny, having no strength left, her eye gone glassy, like a dying woman.

'Yes! Yes!' she murmured on her breath.

Polidori went softly away, to allow her to collect herself, and went to smoke his cigarette in the billiard-room.

The breeze from the lake made the flames of the candles on her mantelpiece flutter the whole night long, for she lay and looked at herself for hours, in the looking-glass, without ever seeing herself, her eyes fixed and burning with fever.

Signor Polidori had already been walking for some time in the deserted avenue at an early hour that reminded him of going out shooting; he took no further heed of the enchanting landscape than to pierce it with long, impatient glances. From time to time he stopped to listen, and lifted his head just like a greyhound. At last he heard the light and timid tread of some elegant wild creature. Maria came forward, and the moment she perceived Polidori, although she knew he would be there, she stopped dead, dismayed, motionless as a statue. Her fine Arab profile seemed to cut her close veil. Polidori, bareheaded, bowed deeply, without daring to touch her hand, nor to offer her a single word.

She, panting, confused, felt by instinct how embarrassing the silence was. 'I am tired!' she murmured, in a broken voice. Emotion suffocated her.

So saying, she continued to advance along the avenue which wound its way up the mountain, and he went beside her, without saying anything, both of them overcome by a strong emotion. Thus they arrived at a sort of funeral monument, where Maria stopped all at once, leaning her shoulders against the rock, her face in her hands. At last she burst into tears. Then he took her hands, and softly pressed his lips to them, like a slave. When he felt that at last the trembling of those poor little hands was subsiding, he said to her softly, but with ineffable tenderness in his voice:

'Why are you afraid of me?'

'You don't despise me now?' said Maria. 'You don't, do you?'

He clasped his hands in a gesture of ardent passion, and exclaimed:

'I? Despise you? I?'

Maria raised her unhappy face and looked at him with big eyes, and with the tears still on her cheeks she murmured a confusion of senseless words: 'It is the first time! I swear to you! I swear to you, Signore!'

'Oh!' burst out Polidori. 'Why say that to me? – to me, who love you? – who love you so much!'

Those words quivered like something alive inside her; for a moment she pressed them under her hands deep into her breast, shutting her eyes; but instantly they flamed in her face, as if they had circulated through her blood in a flash, and had set fire to all her veins. 'No! No!' she repeated. 'I have been wrong, I have been very wrong! I've been foolish. Believe me, Signore! I am not guilty; I have only been foolish; I am really only a child, they all say so, even my own friends.' The poor little thing tried to smile, looking around wildly. 'I can't bear it if you despise me!'

'Maria!' cried Polidori.

She shuddered, and drew back suddenly, terrified at the sound of her own name. Polidori, leaning before her humbly, tenderly, lovingly, said to her:

'How lovely you are! and how lovely life is, while it holds such moments!'

Maria passed her hands over her eyes and hair, confused, dazed, and sank down upon herself as she repeated almost mechanically: 'If you knew how awful it was, coming down the avenue! that avenue that I walk in every day! I would never have thought it could be like that! Truly! I never would have thought it!' And she smiled, to gain courage, not daring to look at him, sunk back against the rock which supported her, pulling her gloves up her arms, which still were quivering a little, and she kept on babbling like a child which sings down the street at night because it is frightened . . . 'I have been unfortunate! yes, I know I'm a crazy creature. I have mad yearnings for that other world, which probably is nothing but a dream-world, and a dream of sick people even at that! Sometimes I feel I am stifled in the continual reasonableness of this world we live in; I want more air, I want to go high up, to breathe where it is more pure and blue. It's not my fault if I can't think it is only I who am mad, if I can't just accept life as it is, if I don't understand the things that matter so much to the other people. No! it's not my fault. I've done what I could. I am several centuries behind the times. I ought to have been born in the time of the knight-errants.' Her faint smile had a melancholy sweetness, and she let herself go without knowing it to the spell which she herself was helping to create. 'Happy you, who can live as you please!'

'I want to live at your feet.'

'All your life?' she asked, laughing.

'All my life.'

'Don't you think you'd get tired?' she answered gaily. 'You must often get tired,' Maria repeated, with a look which she tried to make bold and sure.

Polidori found her delicious in her embarrassment; only the embarrassment lasted a little too long.

Before coming to that rendezvous, even as she was passing through the door, Maria had experienced all the pungent emotions which arise from curiosity concerning the un-known, from the attraction of wickedness, and from the

spell of the excitement which ran in her veins with mysterious and irresistible thrills; with such a confusion of emotions and ideas, impulses and terror, that she had been driven to plunge into the unknown against her will, in a sort of somnambulism, without knowing precisely what she was about to do. If Polidori had stretched out his arms to her, the first moment he saw her, probably she would have beaten her head desperately against the rock upon which she now rested in soft abandon. Now, encouraged by seeing at her feet that much-contested and envied man, she felt a delicious sensation from the contact of the velvety moss against her shoulders, caressing her as the tender and fervent words he was saying caressed her ear, and she felt herself softly pervaded by it all, as by a delightful languor. He was so gentle, so respectful, and so good to her! he didn't so much as touch the tips of her fingers, and was content with breathing upon her the ardent breath of that passion which kept him prostrate before her as before an idol. And all without a suggestion of wrong, lovely, lovely! Then little by little Polidori had taken her hand, and she, without noticing, had let him have it. He, too, was sincerely and deeply moved at that moment, and sought for her eyes with a thirsty and intoxicated gaze. Without seeing him, she felt the flame of his eyes, and dared not lift her own, and the smile died on her lips; she had not the strength to draw back her hands, in spite of several efforts, for each time the sound of his voice lulled her mind and her conscience softly upon its sweetness, and carried her into an anguish of ecstasy; Polidori could never finish gazing upon her as she sat in that attitude, abandoned upon herself, her arms hanging inert, her face lowered and her breast panting; and at last he exclaimed in a burst of passion, throwing out his arms to her convulsively:

'You're so beautiful, Maria, and I love you so much!'

She drew herself up at once, serious and rigid, as if she heard those words said to her for the first time.

'You know I love you! that I've loved you a long time!' he repeated.

She did not reply; curving all her body backwards, her head

lowered, watching suspiciously, frowning, moving her hands mechanically, as if she wanted to fight something off, her lips pressed close and pale. All at once, raising her eyes to his convulsed face, and meeting his eyes, she uttered a stifled cry, and drew back right to the entrance of that sort of sepulchral monument, white with terror, defending herself with outstretched arms from that passion which overwhelmed her now that she saw what it was, looking him in the face for the first time, stammering:

'Signore! . . . Signore! . . .'

He repeated, beside himself, pleading, imploring her spell-bound in a delirium of love:

'Maria! Maria!'

'No!' she repeated, lost. 'No!'

Polidori stopped all at once, and passed his hand two or three times over his eyes and brow in desperation. Then he said in a hoarse voice:

'You never loved me, Maria?'

'No! No! Let me go!' she repeated, when Polidori had already drawn away. 'Signore! . . . Signore! . . .'

Polidori was overcome in spite of himself by the powerful emotion of that instant, and trembled as much as she, poor ingenuous thing.

'Listen! We've done wrong,' she repeated, in a convulsed voice. 'We've been wrong! I swear to you, I swear to you we have done wrong.' And she felt herself fainting.

At that moment, unexpectedly, they heard a voice among the shrubs, and the footsteps of some one approaching hesitated a little way off, and stopped.

'Maria!' called a voice that was so changed that neither of the two recognized it. 'Maria!'

Polidori, from moment to moment reassuming his former self, took Maria sharply by the arm and pushed her into the avenue from whence the voice had come, and in an instant had himself disappeared in the windings of the burial-place. When Maria got to the avenue she found herself face to face with Erminia, who also was pale, and trying in vain to hide her anxiety, wanting to explain something, assuming an air

of indifference. Maria looked at her with big eyes whose expression was very strange.

'What do you want?' she said simply, in a dull voice, after a few moments of silence that seemed an eternity.

'Oh, Maria!' cried Erminia, throwing her arms round her neck.

And that was all. They went back side by side, without saying a word, and with heads bent. When they were in sight of the hotel, they both at once assumed a conventional manner.

'Lucia told me you had gone down into the garden,' said Erminia, 'and so I thought I'd take an early walk as well, giving myself the excuse of coming to meet you.'

'Thanks!' replied Maria simply.

'But it's getting too late to walk – the sun is already hot.'

Maria indeed had got a touch of sunstroke, and was dazed and numbed. She was thoroughly shaken and upset. Sometimes she mechanically clutched her hands, as if to regain herself, or as if seeking something, some touch of the past, and she closed her eyes. When she met curious glances, and all glances seemed curious to her, even those of her friend, she flushed red. She remained lurking in her apartment as much as possible, and thus many thought she had left. The mere sight of Erminia made her frown darkly, and gave something almost sinister to her expression. She was, however, sufficiently a woman of the world to know how to hide her feelings more or less, no matter what they were. Erminia, who was not deceived by her, felt really hurt.

'I'm always your good friend Erminia, you know that,' she said to her, whenever she got a chance, taking her two hands affectionately. 'I am always your friend Erminia, the same as ever, as I have always been.'

Maria smiled from her lips only, kind but abstracted.

'You are wrong, you know!' repeated Erminia. 'You are mistaken! – you are mistaken if you think I don't like you better than before.'

Indeed she took almost a maternal care of Maria, a care which often annoyed the object of it, who almost seemed to

see in it a discreet and loving *surveillance*. One day Erminia found her just beginning a letter, and asked her if her husband had written; the question came so inopportunely that Maria almost blushed, as if she had been on the point of having to tell a lie.

'No. My husband doesn't spoil me so much. He's too busy.'

'Yes, he *is* too busy,' replied Erminia, without heeding the irony of the reply. 'He is seriously busy. Swamped in business, poor man!'

'What are you talking about? if business is his passion, his only passion?'

'Do you mean it?' asked Erminia, fixing her sharp eyes on her friend's face.

'Why, yes,' replied Maria, with a small smile that pulled down the corners of her mouth; then she added, as if correctively: 'But I've no reason to be jealous. My husband doesn't gamble, doesn't go to the club, he's not a sportsman, he doesn't care for horses, and he reads nothing but the Stock Exchange lists – nothing, I assure you.'

'It is true: he only loves you.'

Maria nodded with a little artificial smile; she didn't say anything for a while; then, bitterly:

'You are right. I'm an ungrateful creature even!'

'No! you're not an ungrateful creature; you're a spoilt little woman whose head has been turned, and you see some things wrong, and others you don't see at all. Your husband's only mistake is that he hasn't opened your eyes to the great fondness he feels for you.'

'Luckily he's commissioned you to tell me.'

'Yes, because I'm fond of you too, I am! Truly I am. Shall we leave tomorrow?'

'Oh-h!'

'You'd be sorry?'

'No; only the suddenness of it surprises me a little; it's like they do in the comedy, for the girl who has just started a *romance*.'

'Excuse me, then. I suggested you should come along with me. . . . But if you prefer to stay. . . .'

'No, I want to come. Only I'd like to find a plausible excuse, so as not to start all the inquisitive people believing in the *romance*, when they see our luggage ordered in such a hurry.'

'The excuse is ready found, all the more as it's the real reason for going. I'm going to meet my mother-in-law, who arrives tomorrow from Florence, and you naturally come with me, so as not to be left alone at Villa d'Este.'

'Splendid! And since we're going, the sooner the better. I'd like to go with the first train.'

They did indeed leave quite early. Maria's heart almost burst as she passed in front of those closed windows, on which the shadows of the great trees were still sleeping, and as she left that avenue where she had so often wandered dreaming.

The lake, in the peaceful morning hour, had a singular charm, and each detail in the landscape seemed alive, seemed to have lived with her, and was imprinted on the depths of her heart. As soon as she was in the train she opened the book she had brought on purpose, and hid her face and the tears in her eyes. Erminia wisely took no notice, and let her enjoy to the full the voluptuous pain of breaking off.

At the station Erminia's carriage was waiting, and she would take her friend home first. 'Rinaldi isn't in Milan,' she had said to Maria in response to her friend's look of surprise at finding no one to meet her. 'He has gone to Rome.'

'Without writing to me! without letting me know!' murmured Maria.

'Yes, he's written. My husband will have the letter.'

But she stopped at once, frightened by the alarm which was deepening on Maria's face. 'But sooner or later,' she said, 'you'll have to know. Rinaldi has hurried to Rome to see to his business affairs . . . you know how it is . . . when you're not on the spot they don't always go as they should. Your husband was worried. But when he gets there himself it'll be all right.'

'What has happened?' stammered Maria, all the more upset at the news because it came just when it did. 'What has happened?'

'Don't you worry; your husband is all right. It happens that one of the men who owes him a lot of money has gone bankrupt. It's all about money.'

'Ah!' said Maria, breathing freely; and a shadow of irony came back on to her face.

Her husband seemed to be behaving in a way to justify her bitter little smile. He was so deep in his business he had no thought for anything else in the world. Several days went by without a word from him. At last there came a telegram which alarmed his partner severely, so that he set off at once for Rome.

'Oh!' Maria exclaimed, in that biting tone which had become habitual to her during the last week. 'It really must be a serious business! But then business is always serious for my husband. But it means that my place at this moment is with my husband. He doesn't tell me so; but of course he doesn't write to me out of delicacy. But since his partner has gone off to join him, I'd better go too.'

In spite of her mocking manner, she was surprised and really troubled when she saw that Erminia approved. For a moment a dark thought came into her mind and made her go pale; but immediately she began to laugh nervously again, as before.

'If my husband hadn't trained me to leave him alone in his affairs, there might really be something alarming in it!'

'How alarming? a journey to Rome? in this fine weather, and through the loveliest country!'

'Yes, that's true. It will be almost like going for a holiday. Besides, Rome or the Brianza villa, it's all the same. Shan't you go back to Villa d'Este?'

'No.'

'Oh!'

'I'm going with my mother-in-law to Florence.'

'What a pity! ... I mention Villa d'Este because there must be a brilliant crowd there just now. You can tell your husband's mother she's got a wonderful daughter-in-law.'

The same evening she left for Rome; but she was in an inexplicably feverish state, and her anxiety increased as she

drew near the end of her journey, which seemed interminable. She found her husband so changed in that short time that at first sight of him she was frightened. Rinaldi clasped her hands with effusion; but he seemed more than surprised at her unexpected arrival. He was so upset he could do nothing but repeat: 'Why did you come? Why did you come?'

'I'd never seen my husband like that!' said Maria to Erminia, a few months later, the first time they met after she had got back to Milan. 'I never thought the face of the man could make such an impression on one, nor that he ever could say the things he did say, nor that the sound of his voice could go through you to your very soul. I'd never seen him like that before!'

Even she was a good deal changed, poor little Maria! She had a faint line between her brows, that furrowed subtly into the white purity of her forehead, and sometimes spread like a shadow over all her face.

'Yes, it was a terrible time. I can still feel it inside me like a black knot in my chest, like a painful stitch that I'm almost fond of, it's so deeply rooted in me. It's left a mark on me for ever, and you couldn't take it out without injuring me. Ah, what a moment, when I found my husband with the pistol in his hand! What a moment! And however did I have the strength to cling to him to prevent him killing himself! – he was going to kill himself, he told me later. He hadn't the courage to tell me he couldn't buy me any more horses, nor a box at the Scala, nor jewels, nothing! and he cried like men do when they've never cried before, with tears that burn a track in your soul. Oh, how many things went through my mind in that moment when I felt beating against my heart a heart that was beating still for me, and only for me! and against which I hid my burning face! . . . It is awfully kind of you to come and see me now I've moved up to the fourth floor. It is awfully kind of you.'

'But I must say it's not very kind of you, Maria my dear, making me these speeches of thanks. You can't ever have had a very high opinion of me!'

'No! But then what can you expect! when you've been through all that I've been through! . . . and then the worst of misfortune is that it makes one unjust. . . . Imagine what it would have been like if I'd heard that I was a widow! . . . I felt rather like that when I saw that nobody remembered that I was alone and helpless, away there in Rome . . . nobody, of all those who had professed so much friendship! I don't complain though, you know that. Because I was wrong about you, and I still love you!'

She hesitated a moment, then flung her arms round Erminia's neck impetuously.

'Forgive me! Forgive me! I was unjust to you – to everybody. I've been wrong so often!'

Erminia clasped her closely, herself deeply moved, but she did not speak.

'I was crazy!' Maria murmured after another moment's hesitation, her face pressed against Erminia's breast. 'I don't think of him any more.'

'I never did think of him,' said Erminia conclusively, laughing in her usual way, but with great sincerity of expression and voice.

Maria lifted her head sharply, and looked at her friend with two flaming eyes. 'You never thought of him? never?'

'Never.'

'Then why, then, neither have I, I never loved him, no! No! truly! Never!'

AFTERWORD

Historical background

Giovanni Verga, despite being Italy's greatest novelist remains almost unknown in the UK. At least his major novels and short story collections are now available to the English reader and the day must come when Verga gets the critical attention he deserves and a readership in this country as large as Thomas Hardy or Zola. Despite the success in recent years of some Italian writers, such as Umberto Eco and Italo Calvino, there is little interest in Italian Literature in this country. The days when Italian Literature was accorded the stature of Latin and Greek, as the third classical language are long since gone. Elizabeth I, the most accomplished of English monarchs spoke and wrote Italian fluently, poets such as Milton wrote poems in Italian.

It was Italian that emerged as Europe's first great national culture, when Latin was replaced by the vernacular in Europe. The Florentine writers, Dante, Petrarch and Boccaccio prepared the way for the flowering of the Renaissance, and Ariosto, Macchiavelli, Castiglione and Tasso. The excellence of the Renaissance gave way to the second rate, as the Italian City States declined, with Italy becoming a battle-ground for the French and Spanish. It was the victory of Spain, and their championing of the Counter-Reformation, which made ideas dangerous and literature empty. Italian Literature has yet to recover from the effects of this body blow to its culture. The few writers of excellence it has produced since the Renaissance gaining scant attention outside the confines of the Italian peninsula. Leopardi, Manzoni and Pirandello are known, if not read, while Verga, whose novel *I Malavoglia*, was translated into English for the first time in the 1890s is a stranger to most of the bookshelves of the British Isles.

The world Verga writes of has perhaps more interest for us today than ever, as industrialization and modern technology

303

have swept aside the poverty and neglect of centuries in Sicily. Sicily was one of the poorest of the Italian States in 1840. It was ruled from Naples by the Bourbons, and had little in common with the advances of the Industrial Revolution as its feudal agrarian life continued much the same way it had for centuries. There was little wealth to be shared, so the upper classes exploited the lower classes without compassion.

The Bourbons like the other ruling families in Italy were far from secure. The moderate reforms of the Enlightenment and the advent of Napoleon had created aspirations which the Restoration did little to satisfy. Constitutional government, economic and social reforms were striven for but found little favour with the Italian monarchs. Insecure after their deposition by Napoleon they took refuge in absolutism and repression. Uprising and rebellions culminated in a year of revolutions in the Italian States, which brought back Giuseppe Garibaldi from South America to lead the heroic defence of the newly created Roman Republic. The revolutions of 1848 to 1849 failed but inspired the mood for change. The independent Kingdom of Piedmont in Northern Italy became the focus for the Italian Independence Movement, which aimed for a united Italy under the Piedmont King Victor Emanuel.

By 1859, with French help, the Piedmontese felt strong enough to wage war against the Austrians in Northern Italy. The early successes were brought to a halt, when the Emperor of France, Napoleon III, reached a treaty with Austria ending the war. Public opinion was outraged in Italy, and the government failed to return the conquered territories. There were ideas for extending the war to further parts of Italy, the most unlikely of these was to take the Bourbon Kingdom of the Two Sicilies. Garibaldi's volunteer force of one thousand set off in May 1860, poorly equipped, to Sicily. By his own example and inspiration, popular support and amazingly poor resistance by the vastly superior Bourbon troops, Garibaldi conquered the island in just a few months. Later he crossed the Straits of Messina and completed the rout of the

Bourbons, before the command of the war was taken from him by Victor Emanuel.

With the annexation of Venice in 1866 and Rome in 1870 Italy was united under the rule of Piedmont. The capital of Italy changed from Turin to Florence in 1864 and to Rome in 1871, but despite its approach south the new state was very distant and inexplicable to the Sicilians, many of whom would have been happy to have had the Bourbons back. Higher taxes, compulsory conscription and rule from Rome, with little change in their standard of living led to revolts in Sicily. The Sicilians wanted to be ruled by the charismatic Garibaldi, referred to by some as the second Christ, and not by the uncomprehending northern dynasty of Savoy.

Verga in context

There was not much of a prose tradition for Verga to follow. Foscolo had written the first Italian novel, the 'pathetic' *Ultime Lettere di Jacopo Ortis*, an epistolary novel in the manner of Goethe's *Werther*. A generation later Manzoni published *I Promessi Sposi*, a novel which had for the time, realism, psychological penetration and a wide list of characters, and for its heroes, two peasants. The novel was immediately successful and was rewritten by Manzoni in a new literary language based on modern Florentine, which became a model for later writers to follow. Most Italian critics consider this to be the finest novel of the century, but many readers find the overt moralizing and rose-coloured view of his peasant heroes get in the way of the narrative gifts of Manzoni.

There is nothing in Italian Literature to compare with *I Malavoglia (The House by the Medlar Tree)*, published in 1881, in which Verga had turned realism into high art. In language distorted to echo the dialect of the fishermen, and metaphors limited to those of the sea, Verga tells the story of the Malavoglia family, with very little narrative and with the action coming through the character's own words. What

started out as a document of social realism ends as an epic tale of human endeavour, and the triumph of the spirit.

It was to be the first of a cycle, *I Vinti*, the defeated, in which Verga would progress through society, examining how ambition and a desire for something more would cause the downfall of the *vinti*. In *I Malavoglia* it is Ntoni who is the *vinto*, as he aspires after the greater world of the city and its pleasures, bringing about the downfall of his family, as the harsh struggle for existence left no room for any aspirations. In *Mastro Don Gesualdo* it is the self-made man Gesualdo's attempt to rise socially that brings him unhappiness. Apart from a few pages of the *Duchessa di Leyra* this was as far as Verga got in his cycle. It is on these two novels and his short stories that Verga's fame rests.

Sparrow, Temptation and Cavalleria Rusticana

Sparrow, or to give the novella its Italian name *La Storia di una Capinera*, was published in 1871, having appeared the year before in instalments in a magazine. It was Verga's fourth published work of fiction and the first he had been paid for: one hundred lire from the Milanese publisher A. Lumpgnani. Verga was thirty-one.

Sparrow is a seminal work for Verga. He had begun writing his novels of passion set in the city in 1866 with *Una Peccatrice* and continued in this vein for the next ten years with *Tigre Reale* and *Eros*. This is Verga more in the style that D'Annunzio was to make famous later in the century than the Verga who became Italy's greatest ever novelist. It is *Sparrow* which shows a different side to the young bohemian novelist. A long novella set in Sicily in the world he grew up in with the action taking place in the countryside outside Catania and in a convent inside Catania.

Verga's mother Donna Caterina had been educated by nuns. Two of his aunts had taken the veil and a third, after time in a convent, remained, unmarried in the Verga household. The convent in which his mother had been raised was directly

opposite the family house in Catania and here the family attended mass, hearing but not seeing the singing postulants and nuns. The reality of girls with no dowries being sent to the convent was still commonplace in Sicily despite the legislation of 1867, which tried to curb this practice.

It is an enclosed world, cut off from the reality of the rest of Italy and the characters are left to speak for themselves. We learn of an unconsummated love between the young novice let out of the convent owing to the plague and one of her neighbours, who is intended as a husband for her younger half-sister. It is a love of gestures, glances and barely expressed feelings, which destroys the serenity of the novice's existence and her acceptance of her vocation as a nun. This passion which can't lead anywhere, takes possession of her soul and eventually leads to her insanity. She is as much a victim as the fishermen of the Malavoglia family in *I Malavoglia*. Fate cannot be denied and the desire for more than life has to give, causes disaster. *Sparrow* like the major work of Verga touches the heart without moralising and sentimentalising. The reader feels anger and a strong sense of injustice for the young girl's plight but the characters in the novel accept what happens as just the way life is. So too did the young novice and would have quite happily become a nun except for the plague which allowed her contact with something outside her world: the love for a man.

In Verga, not to accept one's lot, however harsh, leads to disaster. The world beyond the enclosed communities of rural Sicily or even of Catania does not offer a solution to life's problems, merely a dissatisfaction with one's life and one's inability to have a better life. This powerful driving force behind Verga's major work begins in *Sparrow*.

While the women of the Verga family might have supplied the details about life in a convent in Catania an event in Verga's adolescence was the emotional source for *Sparrow*. While at their country property in Vizzini, south-west of Catania to escape the cholera the fifteen year old Verga encountered the daughter of a neighbouring family, still in her convent dress, pale-skinned, dark-haired and beautiful.

After several months of adoring her from afar he was able to put his arm round her waist at a dance, an exciting almost mystical experience for the young Verga. When the cholera abated the girl returned to her convent to become a nun. Later while visiting his aunt at the same convent Verga caught a glimpse of the young girl. It is this event, however apocryphal it might be, which makes *Sparrow* such an emotionally powerful and compelling work.

The appearance of the short story *Nedda* at the end of Verga's period of bohemian novels marks the move away to Sicilian settings and themes and the world of fishermen and peasants. This is something new in Italian literature as Verga was not offering the Italian reading public books about themselves or their social superiors but about the lowest stratum of society living in the back and beyond. The style too was different. There was no authorial comment and you really believed that the characters were on a stage performing the drama of their own lives in their own words. The art, which was there in abundance, was concealed. What makes Verga's short stories so appealing is the battle to survive, against the elements, whether the turbulence of the sea, the overpowering sun destroying the crops or the God-given catastrophes like cholera or the problems created by the encroachment of the outside world into their lives, with higher taxes, military service and war. Verga's stories take on an epic character, becoming Gargantuan struggles and the stuff of Greek tragedies.

In his short stories very often just a few pages long Verga evokes an atmosphere and a mood which creates a very vivid drama which has a beginning, middle and end. In his few pages Verga packs in more than other writers manage in a full-length novel. In *Temptation* we have the story of an excursion for three young men which because of a chance encounter with a young peasant girl en route to the city to seek work ends in disaster as they give in to the temptation to flirt. The flirting gets out of hand and they end by raping the young girl and to hide their crime, murder her. We experience everything through their eyes, there is no moralising, no

condemnation by the author and though the reader shares the horror of their action there is still an element of sympathy for them and the wish that they had resisted temptation. This is one of five stories translated for the first time into English by Christine Donougher and they show that there is still a considerable amount in the Verga oeuvre that needs to be made available in English so we can fully appreciate his vast storytelling gifts.

In *The Schoolmaster* we have the story of a middle-aged brother and sister sharing a modest existence but which is transcended by their aspirations for love. It is painful to read this story of how life passed them by and the only love allowed to them was in their imagination. Both brother and sister are gently mocked for their pretensions, not by the author but by their own actions, however the details of their daily life and their love for each other endear them to the reader and the failure of their humdrum lives has an epic, tragic quality.

This volume includes the D.H. Lawrence translations of the short story collection *Vita Dei Campi*, Life of the Fields, but published in English as *Cavalleria Rusticana* after the lead story, made famous by Verga's play and Mascagni's one act opera. For anyone interested in translation it is a good opportunity to compare two master craftsmen at work. Christine Donougher's contemporary flowing translations with D.H. Lawrence's translations from the 1920s. Translations date and often seem very archaic and stilted as if they are putting a period straitjacket on the work. This is why there is always a strong case for major literature to be translated afresh every fifty years. As Lawrence was a major writer, a master of the short story form and a fine poet it is not surprising that his translations stand the test of time and still have a robust charm. There is the odd expression or word that sounds a bit quaint but the translations bring the originals to life in a way that some modern translations have failed to do.

Many of Verga's stories are set around the village of Vizzini, near his country estate, and the fishing port of Aci-Trezza. A constant theme in Verga is how rational decisions are

overturned by primordial forces, that however much the head rules, the heart will not be denied. In a world of little material comfort and with life a battle for survival, passion cannot be ignored and will have its way. In *Cavalleria Rusticana* Turiddu returns from being a soldier to find his sweetheart, Lola, betrothed to Alfio, the carter from Licodia, who has four mules of his own and so is a much better catch than the peasant Turiddu. In the end the material comfort and the little luxuries Alfio can provide prove insufficient and Lola is drawn back to Turiddu and lets him visit her while her husband is away. In such a small world where everyone knows each other's business Alfio soon finds out.

Honour, pride and manhood demand retribution, yes it is not the world of gentlefolk but amongst the peasantry where these values are strongest. They are more basic, less sophisticated and lack the artifice to justify their shame to themselves. Alfio and Turiddu leave the village early one morning to resolve their dilemma. Someone must die, in the end both die. More moving although less well-known is the story of *Jeli the Herdsman* where the infidelity of Mara leads Jeli to murder his childhood friend, Don Alfonso. Again with Verga one desperately wishes it had been otherwise.

More elemental and overwhelming is the insatiable middle-aged woman in *La Lupa*, with the nickname of she-wolf, which also means prostitute, her desires overcome all rational feeling and respectability. Like a savage animal she forces her daughter to marry a young man she has fallen for and then forces herself repeatedly on her son-in-law. Her cravings can't or won't be controlled and even when he takes the axe to her she won't desist. *La Lupa* remains in the mind long after it has been read and has been successfully turned into a major feature film in Italy.

Just as in Hardy's Wessex Verga's Sicilian world is dominated by heredity, fate and determinism. *Rosso Malpelo*, which translates into English as evil redhead, reflects the superstition that red hair was a kind of curse inflicted on the misbegotten. The little red-haired boy who worked in the sand quarry with his father becomes the evil misbegotten person that fate has

earmarked him out to be. His worth ethic, his befriending of another boy in the mine and his family ties count for nothing, as he is a redhead. He accepts his fate and ends like his father dying in the sand quarry.

In Verga there is no criticism of people's actions, however base, merely a statement that that is how life is. In Verga there are neither villains nor heroes, just actors in life's drama doing what they must. There is respect for the hard suffering peasant, as he is put upon by society, but no programme for social change in Verga. The peasants who rise above their station do not find happiness, only more property, and lose what humanity they had. The decline of the gentry and landed classes is recounted dispassionately as a historical process. The rich exploit as this is what the rich do.

Like Dickens, Verga wants a more human version of the world as it is, and not to change it. It is better to be what you were born to be, than rise upwardly in society; Ntoni in *I Malavoglia*, Gesualdo in *Mastro Don Gesualdo* and a whole assortment of characters in his stories become defeated by their desire for the unknown and a higher social position. Verga's view is that of the patrician, and perhaps this explains how like Orwell, his detachment and balance, prove more effective than the reformers' zeal. All of nineteenth-century Sicily is presented to us and we can but choose to suffer the hardships and indignities with Verga's characters as we aspire for something better even though it will lead only to defeat in Verga's world.

Eric Lane

Dedalus European Classics

Dedalus European Classics began in 1984 with D. H. Lawrence's translation of Verga's *Mastro Don Gesualdo*. In addition to rescuing major works of literature from being out of print, the editors' other major aim was to redefine what constituted a 'classic'.

Titles available include:

Little Angel – Andreyev £4.95
The Red Laugh – Andreyev £4.95
Seraphita (and other tales) – Balzac £6.99
The Quest of the Absolute – Balzac £6.99
The Episodes of Vathek – Beckford £6.99
The Devil in Love – Cazotte £5.99
Undine – Fouqué £6.99
Misericordia – Galdos £8.99
Spirite – Gautier £6.99
The Dark Domain – Grabinski £6.99
The Life of Courage – Grimmelshausen £6.99
Simplicissimus – Grimmelshausen £10.99
Tearaway – Grimmelshausen £6.99
The Cathedral – Huysmans £7.99
En route – Huysmans £7.99
The Oblate – Huysmans £7.99
The Other Side – Kubin £9.99
The Mystery of the Yellow Room – Leroux £7.99
The Perfume of the Lady in Black – Leroux £8.99
The Woman and the Puppet – Louÿs £6.99
Blanquerna – Lull £7.95
The Angel of the West Window – Meyrink £9.99
The Golem – Meyrink £6.99
The Opal (and other stories) – Meyrink £7.99
The White Dominican – Meyrink £6.99
Walpurgisnacht – Meyrink £6.99
Ideal Commonwealths – More/Bacon et al £7.95

Smarra & Trilby – Nodier £6.99
The Late Mattia Pascal – Pirandello £7.99
The Notebooks of Serafino Gubbio – Pirandello £7.99
Tales from the Saragossa Manuscript – Potocki £5.99
Manon Lescaut – Prevost £7.99
Cousin Bazilio – Queiroz £11.99
The Crime of Father Amaro – Queiroz £11.99
The Mandarin – Queiroz £6.99
The Relic – Queiroz £9.99
The Tragedy of the Street of Flowers – Querioz £9.99
Baron Munchausen – Raspe £6.99
The Wandering Jew – Sue £10.99
The Maimed – Ungar £6.99
I Malavoglia (The House by the Medlar Tree) –
 Verga £7.99
Mastro Don Gesualdo – Verga £7.99
Short Sicilian Novels Verga £ 6.99
Sparrow, Temptation &Cavalleria Rusticana –
 Verga £8.99
Micromegas – Voltaire £4.95

I Malavoglia (the House by the Medlar Tree)
by Giovanni Verga

"*I Malavoglia* obsessed me from the moment I read it. And when the chance came I made a film of it, *La Terra Trema*."
 Luchino Visconti

I Malavoglia is one of the great landmarks of Italian Literature. It is so rich in character, emotion and texture that it lives forever in the imagination of all who read it. What Verga called in his preface a 'sincere and dispassionate study of society' is an epic struggle against poverty and the elements by the fishermen of Aci Trezza, told in an expressive language based on their own dialect.

"Giovanni Verga's novel of 1881 *I Malavoglia* presented its translator Judith Landry with formidable problems of dialect and peasant speech which she has solved so unobtrusively that one wonders why this moving and tragic tale is so little known in England."
 Margaret Drabble in The Observer's Books of the Year

"This is a tragic tale of poverty, honour and survival in a society where the weak go to the wall unmourned."
 The Sunday Times

£7.99 ISBN 1 873982 13 5 288p B.Format

Mastro Don Gesualdo – Giovanni Verga

"It's the story of a Sicilian peasant who rises to the aristocracy, ruffling feathers at all social levels, and it's a masterpiece of 19th century realism."
 Scotland on Sunday

On the face of things, *Mastro Don Gesualdo* is a success. Born a peasant but a man 'with an eye for everything going', he becomes one of the richest men in Sicily, marrying an aristocrat with his daughter destined, in time, to wed a duke. But Gesualdo falls foul of the rigid class structure of mid-19th century Sicily. His title Mastro Don, Worker Gentleman', is ironic in itself. Peasants and gentry alike resent his extraordinary success. And when the pattern of society is threatened by revolt, Gesualdo is the rebels first target.

Published in 1888, Verga's classic was first introduced to this country in 1925 by D. H. Lawrence in his own superb translation. Although broad in scope, with a large cast and covering over twenty years *Mastro Don Gesualdo* is exact and concentrated: it cuts from set piece to set piece – from feast-day to funeral to sun white stubble fields – anticipating the narrative techniques of the cinema.

"A fine and beautifully observed book which D. H. Lawrence must have enjoyed translating"
 The Observer

£7.99 ISBN 1 873982 52 6 345p B.Format

Short Sicilian Novels – Giovanni Verga

"The best of these stories (*Liberty*, *The Gentry*) have the directness, even a brutality, to match Cormac McCarthy, and Lawrence's translation is exemplary."
Shaun Whiteside in The Times

"Lawrence's translations of Verga's Sicilian short stories are classics in their genre, perfectly capturing their cunning fusion of artlessness, austere detachment and skilfully engineered spontaneity as well as retaining something of that lofty style for which Verga's Italian contemporaries so admired him. For seekers after the truth at the heart of Sicily's enigma, this is required reading."
The Observer

"In these stories the whole of Sicily of the eighteen-sixties lives before us – poor gentry, priests, rich landowners, farmers, peasants, animals, seasons and scenery; and whether his subjects be the brutal bloodshed of an abortive revolution or the simple human comedy that can even attend deep mourning, Verga never loses his complete artistic mastery of his material. He throws the whole of his pity into the intensity of his art, and with the simplicity only attainable by genius lays bare beneath all the sweat and tears and clamour of day-to-day humanity those mysterious 'mortal things which touch the mind."
The Times Literary Supplement

"*Short Sicilian Novels* have that sense of the wholeness of life, the spare exuberance, the endless inflections and overtones and the magnificent and thrilling vitality of major literature."

£6.99 ISBN 1 873982 40 2 171p B.Format

The Late Mattia Pascal – Luigi Pirandello

"Pascal, a landowner fallen on hard times and trapped in a miserable marriage, runs away from home and wins a lot of money at the gaming tables in Monte Carlo. Meanwhile a body has been found in the millrace of his village and it is assumed that Pascal has killed himself. Seizing what looks like a chance to create a new life, he travels to Rome under an assumed name and struggles to invent a different identity which he can inhabit. He fails, returns home, finds his wife has remarried and has to act out the role of being as it were a living ghost. All these tragic events are recounted with verve and wit and comes across clearly in Simborowski's spirited translation from the Italian."

Robert Nye in The Guardian

"This is Pirandello's third novel, published in 1904, and marks the start of a major theme in his work – the nature of identity."

The Sunday Times

£7.99 ISBN 0 946626 18 9 251p B. Format

The Notebooks of Serafino Gubbio – Luigi Pirandello

Serafino is a typical Pirandellian anti-hero, a spectator rather than a participant in the tragi-comedy of human existence. Indeed he has the perfect job for it, that of a film cameraman. Serafino is an observer, an impersonal tool of a new industry based on make believe. All he has to do is to turn the handle of his camera and watch. He has no part in what he is going on and is so removed from life that the mauling of an actor by a tiger can not deflect him from filming the action. It is set in Rome circa 1915, partly on a film lot, partly in the city.

"His narrator is an early cameraman, 'a hand that turns a handle,' whose alienation comes to stand for the superfluity of human desire in the age of machines, our 'new deities.' The semi-detached Gubbio watches, then manipulates, an erotic quadrangle that forms among the starlets of the Rome studio where he turns the handle. Fittingly, the journals close with one of the feuding actors mauled to death on set by a tiger while Gubbio cranks impassively away, the (literally) dumb-struck creator of the world's first snuff movie."
 Boyd Tonkin in the Observer

£7.99 ISBN 0 946626 58 8 334p B.Format

Senso (and other stories) – Camillo Boito

Boito's stories combined decadence, the macabre, the demonic and depraved female heroines. They were an immediate and popular success in *fin de siècle* Italy. Visconti's film of Senso brought Boito's work international recognition. This selection includes his most celebrated novelle, including *A Corpse*, the bizarre tale of rivalry between an artist and a student of anatomy for the beautiful body of Carlotta, the artist's dead mistress.

"A pity that Boito wrote so little. On the basis of this volume alone, his talent occasionally amounts to a pocket-sized genius."

Jonathan Keates in The Observer

£6.99 ISBN 0 946626 83 9 207p B.Format